The ART of Calligraphy

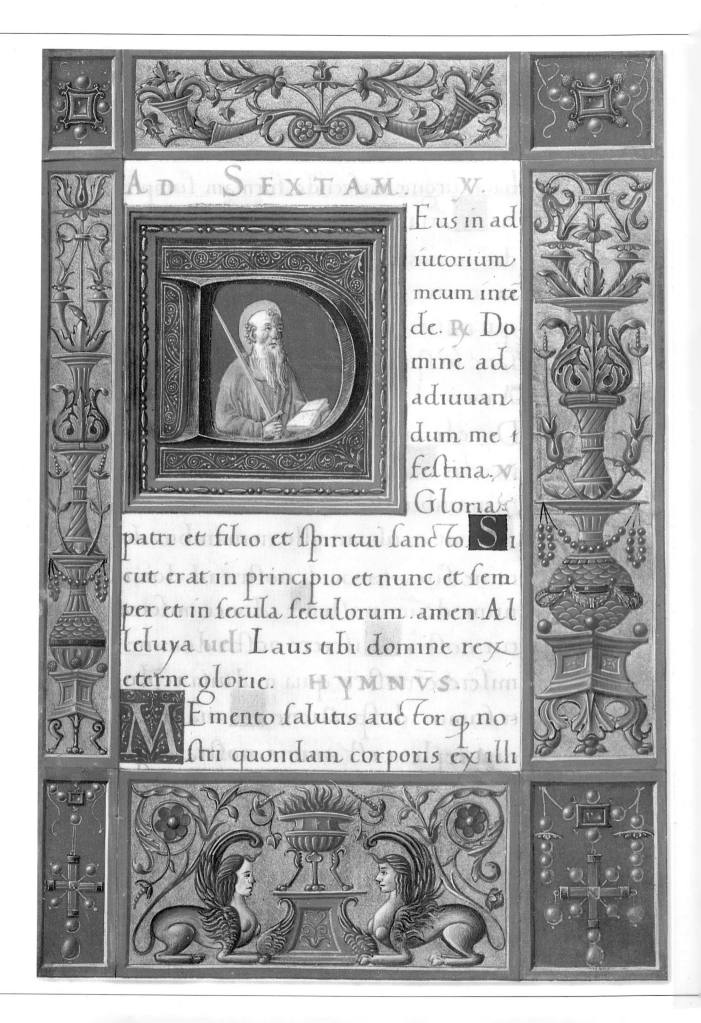

AD SEXTAM. V.

Eus in ad
iutorium
meum inte
de. R. Do
mine ad
adiuuan
dum me f
festina. V.
Gloria
patri et filio et spiritui sancto. Si
cut erat in principio et nunc et sem
per et in secula seculorum. amen. Al
leluya uel Laus tibi domine rex
eterne glorie. HYMNVS.

Emento salutis auctor q no
stri quondam corporis ex illi

The ART of Calligraphy

DAVID HARRIS

A DK PUBLISHING BOOK

Project editor Louise Candlish
Art editor Liz Brown
US editor Mary Sutherland
Assistant editor David T Walton
Assistant designer Carla De Abreu
Senior editor Roger Tritton
Senior art editor Tracy Hambleton-Miles
DTP designer Zirrinia Austin
Managing editor Sean Moore
Managing art editor Toni Kay
Production controller Meryl Silbert
Picture research Julia Harris-Voss, Jo Walton
Photography Steve Gorton, Andy Crawford

First American Edition, 1995
12 13 14 15 16 17 18 19 20
Published in the United States by
DK Publishing, Inc.,
375 Hudson Street,
New York, NY 10014

Visit us on the World Wide Web at
www.dk.com

Published in Great Britain by
Dorling Kindersley Limited.
Distributed by Houghton Mifflin
Company, Boston.

Library of Congress Cataloging-in-Publication Data

Harris, David.
 Calligraphy / by David Harris. -- 1st American ed.
 p. cm .
 Includes index.
 ISNBN 1-56458-849-1
 1. Calligraphy--Technique. I. Title.
NK3600.H28 1995
745.61'97--dc20 94-26722
 CIP

Color reproduction by GRB Editrice s.r.l.

Printed in China by Toppan Printing Co., (Shenzhen) Ltd

Contents

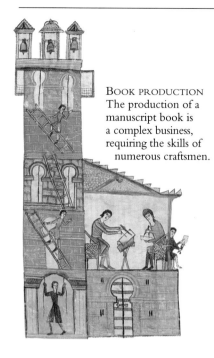

BOOK PRODUCTION
The production of a
manuscript book is
a complex business,
requiring the skills of
numerous craftsmen.

Introduction

FOR 2,000 YEARS, the western Latin alphabet has developed and been modified by a vast range of social and technological changes, providing a rich and varied resource for the modern calligrapher to quarry. This book charts that development, presenting scripts in both historical and practical contexts. Calligraphers of all levels will be able to explore the origins of each script and understand anew the construction of the 26 letters that we use every day.

MAGNIFYING GLASS
A magnifying glass or
eyeglass is a valuable aid to
examining the letterforms
in historical manuscripts
shown in this book.

GENERALLY, LATIN-BASED scripts fall into two categories: formal – the scripts used as the instrument of authority; and informal – the cursive or quickly written scripts used for everyday transactions. History repeatedly shows formal scripts degenerating into cursive forms, which are, in turn, upgraded, finally achieving formal status as new hands in their own right. The pages of historical analysis in this book chart the rise, fall, and revival of these hands, and explain the emergence of other significant scripts.

Practical advice

Following the historical study of each script is a practical guide to the construction of the letters in that hand. A complete alphabet is included, showing the separate strokes needed to produce each letter, and indicating the probable sequence of these strokes. To the left of this alphabet, the chief characteristics of the script are described and demonstrated in a separate panel.

The appearance of a script is influenced by a range of practical factors, including the cut of the nib used to write it. Full information about tools is given for each script.

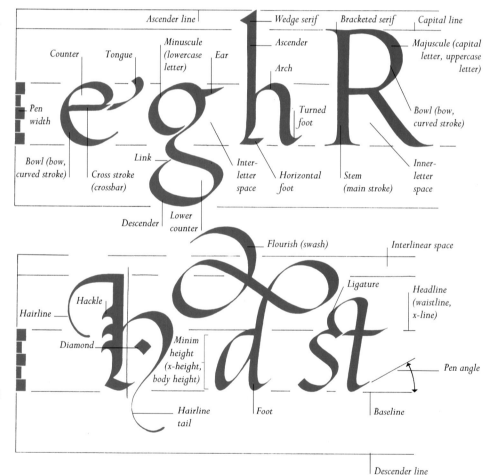

LETTER ANATOMY
In order to identify or construct scripts, it is essential to become familiar with the vocabulary of calligraphy. Unfortunately, there is no agreed standard nomenclature, so terms used in this book are those most commonly favored by calligraphers and paleographers. Alternative terms, including those used by typographers, are shown here in brackets. For example, the headline is known to some calligraphers as the "waistline" and to typographers as the "x-line." Although these letters represent only a few characters, the terms used to describe their components are applicable to all the letters in the alphabet. A full glossary of the calligraphic terms used in this book is also included (*pp. 122–123*).

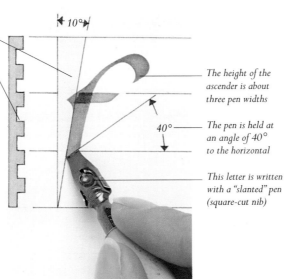

This angle indicates the degree of forward lean of the letter; in this case, the angle is close to 10°

The minim height of this f is four pen widths

10°

The height of the ascender is about three pen widths

40°

The pen is held at an angle of 40° to the horizontal

This letter is written with a "slanted" pen (square-cut nib)

LETTER HEIGHT AND PEN ANGLE
The height of a letter is calculated in pen widths, shown in this book to the left of the letter in the form of a "ladder." Each script is drawn with the pen held at one particular angle. The figures used to indicate this angle refer to degrees to the horizontal. Where relevant, the approximate angle of the forward lean of a letter is also given. This is measured in degrees to the vertical.

STROKE SEQUENCE
A recommended sequence of strokes is given for all 26 letters of each script. The use of transparent colors makes it clear where a stroke crosses or overlaps with another.

An arrowhead indicates where the stroke finishes and the pen is lifted

1

2

3

The first letter in the sequence shows the model that you should follow – in this example, a Caroline Minuscule f (pp. 40–41)

The black arrow indicates the progress of the first stroke; on reaching the baseline, the pen is pushed back over the first stroke and upward

The second stroke creates the ascender of the letter and finally, the crossbar is added with a third stroke

The sensitivity of a quill pen makes it an ideal tool for drawing hairlines

WRITING TOOLS
Some materials and implements are more suitable for an accurate representation of a script than others. For instance, most scribes writing before 1500 used either parchment or vellum, which remain to this day two of the finest writing surfaces. Frequently, the writing implement is of equal importance. For a Bâtarde letter (*left*), it would be difficult to achieve the very fine lines with any other implement than a sharply cut quill. Advice on the selection of surfaces and writing tools is given in "Getting Started" (*pp. 14–15*).

The quill has been shorn of most of its barbs, making it easier to handle

Model scripts
The search for a definitive model for any particular hand is virtually impossible. Within each script there are endless variations, ranging from the excessively formal to the almost indecipherable. Therefore the scripts included in the practical pages of this book are actually a synthesis of various different styles, and should be used to prompt your own personal redefinition of the hands.

Manuscript sources
By definition, a script is a system of handwritten characters, and the majority of the scripts included in this book come from manuscript sources. Where appropriate, an enlargement of a section from an important manuscript is shown, often revealing the basic ductus of the script under scrutiny and giving invaluable clues to the construction of letterforms.

Imperial Capitals
One significant script included in this book must be regarded separately from the rest – the Roman Imperial Capital. A product of the brush and not the pen, it was, until recently, not accepted as a script at all. Due to its complexity and importance to modern calligraphy and typography, it is explored in depth in a section at the end of the book. For the first time, the origins and structure of all 26 letters are demonstrated in an easily accessible way (*pp. 108–119*).

Left-handed work
The step-by-step letters demonstrated in this book are the work of a right-handed calligrapher. Left-handed calligraphers can follow the same angles and stroke sequences, but might find it useful to adjust their normal writing position to the "underarm" position: tuck the arm inwards, turn the hand to the left, and shift the paper down to the right. Nibs cut obliquely from top right to bottom left can also be very useful.

The Development of Western Script

T HE FIRST ALPHABET evolved in Phoenicia in about 1200 BC. This was adapted in the eighth century BC by the Greeks, whose letterforms were borrowed by the Etruscans and, in turn, by the Romans. All subsequent Western scripts have evolved from Roman originals. The scripts in this book are grouped in six categories: Roman and Late Roman Scripts (*pp. 16–27, 108–119*), Insular and National Scripts (*pp. 28–37*), Caroline and Early Gothic Scripts (*pp. 38–49*), Gothic Scripts (*pp. 50–83*), Italian and Humanist Scripts (*pp. 84–101*), and Post-Renaissance Scripts (*pp. 102–107*). The duration of each script is shown in a timeline (*pp. 12–13*).

PROBABLY the most important event in the history of Western script was the Roman adoption of the Etruscan alphabet. By the first century BC, the Romans had developed several scripts. One was a quickly penned, cursive script used for correspondence, scratched onto a wax tablet or written with a reed pen on papyrus. This hand was influential in the development of the minuscule letter, including the Half Uncial (*pp. 38–39*). Another key script was the Rustic Capital, used in manuscript, signwritten, and inscribed forms (*pp. 16–17*).

Imperial Capitals

The third Roman hand produced by the first century BC, now known as the Imperial Capital, was used in both stone-carved and brush-drawn form (*pp. 108–109*). More than 2,000 years later, the letters of the script provide the basis of our modern capitals.

By the fourth century, the Square Capital, a modified deluxe bookhand, had also emerged (*pp. 20–21*).

Another important script that had its origins during the Roman period was the Uncial (*pp. 24–25*). Similar in form to the Greek Uncial that preceded it, this was developed for use by the early Christian Church.

ETRUSCAN LETTERS
These letters have been written in Oscan, an ancient Italian language derived from Etruscan. In addition to the writing system, almost every aspect of Etruscan culture was adopted by the Romans, including the legal and military systems.

This terra-cotta tablet, of a type used to mark property and land, shows clearly recognizable letterforms, such as this character, which resembles an overturned E

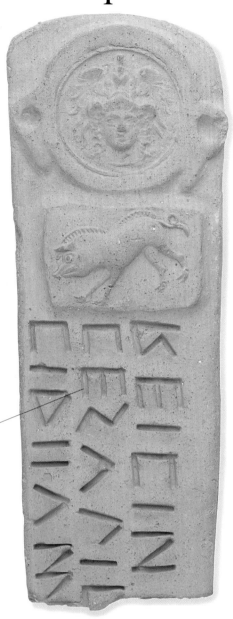

THE LATIN ALPHABET
This inscription from the base of the Trajan Column, Rome, is one of the finest surviving examples of Imperial Capitals (*pp. 108–109*). The oldest Latin alphabet contained 21 characters, as opposed to the Etruscan 20. By late Roman times, the Latin alphabet had 23 characters, the two additional characters – *Y* and *Z* – having been taken from the Greek Upsilon and Zeta. All of these characters have survived for modern use, with the addition in medieval times of letters *J*, *U*, and *W*.

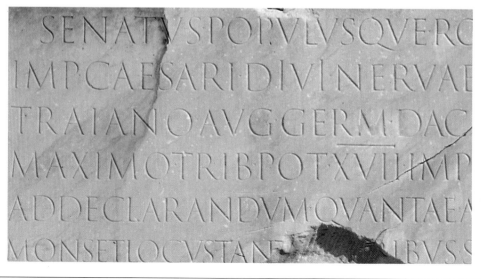

CHARLEMAGNE AND ALCUIN

In many ways, the eighth-century Emperor Charlemagne modeled himself and his court on his Roman forebears. Roman influence in the Frankish Empire was particularly important in the areas of learning and scholarship, in which the emperor was aided by a prominent monk from York named Alcuin. Under Alcuin's abbotship from 796-804, the great scriptorium at Tours, France, was founded. Here, the Caroline Minuscule was created (*pp. 38–39*).

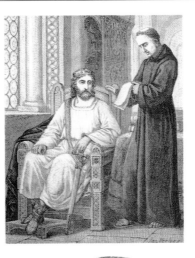

The rounded tip of the penknife suggests that it was also used for scoring lines on the page

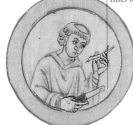

The scribe casts a critical eye over the newly sharpened nib of the quill

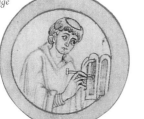

The production of book covers was a separate craft requiring the skills of a team of workers

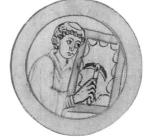

The parchment is stretched on a wooden frame and scraped with a curved knife

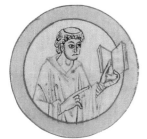

The finished manuscript book lends authority to the monk's preaching

THE PRODUCTION OF MANUSCRIPTS

These 12th-century illustrations show some of the processes involved in the production of a medieval book. First, the parchment maker would soak the skin and then stretch and scrape it. Next, the dried parchment would be trimmed and scored in preparation for the scribe. The text would be planned in detail, with spaces left for the work of the illustrator and illuminator. After the scribe had completed his text, the illuminator would apply the gold leaf, which was then overdrawn by the illustrator. Finally, separate leaves were gathered and bound, and the cover fitted.

Once dried and cleaned, the parchment is trimmed to size

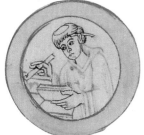

The book is bound and the scribe prepares to make any necessary annotations to the text

Teaching from written manuscripts was a key aspect of monastic life

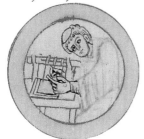

Once the leaves of the manuscript are placed in order, they are stitched together

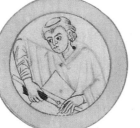

The punched holes are joined by scored lines, between which the scribe would then write the text

Small holes are punched through the parchment, probably to provide guidelines for spacing

Insular and National scripts

After the demise of the western Roman Empire in the fifth century, numerous hands developed in the kingdoms carved out of the remains of the Empire. Irish scripts, such as the Insular Majuscule (*pp. 28–31*), derived from Uncial and Half Uncial forms, are now known as "insular" scripts. Elsewhere in Europe, national scripts included the Visigothic in Spain and the Merovingian in France.

The most important means of communication between different nations was the Christian Church, which kept the torch of literacy and learning alive. Irish monks formed many monastic centers in Scotland and northern England, as well as in Luxeuil and Corbie in France, and Bobbio in Italy. Meanwhile, monks from Rome entered southern England and were responsible for the widespread conversion to Christianity there.

Caroline and Early Gothic scripts

The first empire in the West to emerge from the remains of the Roman Empire was that of Charles the Great (Charlemagne). By the ninth century, his Frankish Empire stretched from the Pyrenees to the Baltic. A reformed hand devised by Alcuin of York became the established hand of the empire – it is now known as the Caroline Minuscule (*pp. 38–39*).

Outside the Frankish Empire, national hands persisted. In Italy, the Beneventan script was one of the longest surviving post-Roman scripts, used from the mid-eighth century until 1300 (*pp. 84–85*). In England, the Insular and Anglo-Saxon Minuscules sufficed until the tenth century (*pp. 34–35*), when the Caroline Minuscule was introduced. Over time, the Caroline Minuscule became more compressed, anticipating the angular, uniform aspect of Gothic letters. This compressed script is known as Late Caroline or Early Gothic (*pp. 46–47*).

Et erit tanquam lignum qd plan tatum est secus decursus aquarū

Textura Prescisus is characterized by the "cut off" feet of certain letters, such as this r from the Windmill Psalter

Gothic scripts

By the end of the 12th century, a complex system of Gothic scripts had evolved throughout Europe. For simplicity, these are often divided into two groups: the high-quality (deluxe), formal hands used for both religious and secular book text, and the cursive hands used for documentary work and, from the late 13th century, for vernacular book production. The two most important deluxe bookhands were the Textura Quadrata (*pp. 50–51*) and its twin, the Prescisus (*pp. 54–55*).

Bastard scripts

Gothic cursive scripts are known as bastard scripts, and they remained in use until supplanted by the Copperplate in the 18th century (*pp. 102–103*), some 200 years after the demise of the formal Gothic bookhands. Bastard hands are difficult to categorize, differing from country to country, town to town, and trade to trade. However, general differences can easily be discerned between English (*pp. 66–67*), French (*pp. 70–71*), and German (*pp. 74–75*) models. It was in bastard text script that minuscules and capitals of the same hand first appeared together – with the Gothic Capitals used to begin new sentences and denote proper nouns (*pp. 58–59*).

HUMANIST MINUSCULE
This manuscript page from a translation of Pliny's *Natural History* shows beautifully penned Humanist Minuscule letters. The handwritten Renaissance script was used as a model for type by 15th-century Venetian printers. It quickly replaced the Gothic models favored by Johann Gutenberg, the German inventor of printing with movable type.

GOTHIC TEXTURA SCRIPTS
This detail from the 13th-century Windmill Psalter shows Gothic Textura Prescisus script (*pp. 54–55*). Both the Prescisus and its twin script, the Quadrata, were reserved for prestige religious book work.

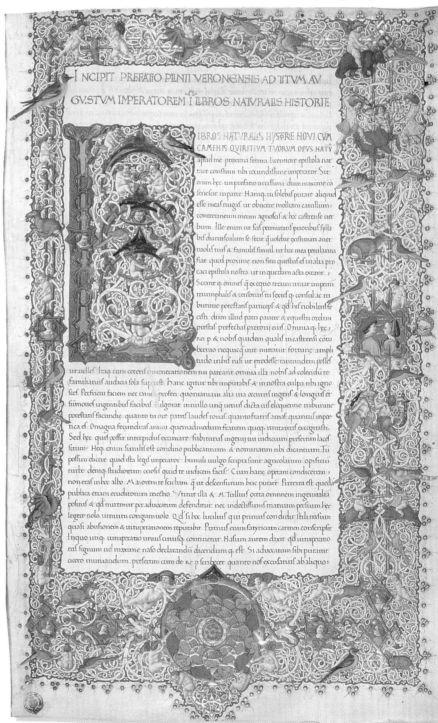

This page is from a Book of Hours produced in France after the introduction of printing. Ownership of a handwritten book at this time was an indication of high social status. The elegant script is a late Bâtarde hand known as *Lettre Bourguignonne* (*pp. 70–71*), which contains a mixture of cursive and Textura elements.

The Bâtarde letter f often has a distinctive forward lean, as does the long form of s

MODERN CALLIGRAPHY
This three-dimensional work, which measures 9½ by 14 by 2 inches (24 by 35 by 5 centimeters), was created in 1993 by Denis Brown. Entitled *Phoenix*, the page of Insular letters – reminiscent of the great manuscripts of Kells and Lindisfarne (*pp. 28–31*) – has been penetrated by electric wires as a metaphor of the phoenix creating new life from the old.

Italian and Humanist scripts

In Italy, the formal Gothic scripts never really secured a footing. Italian letterforms of this period – generally known by the name of Rotunda (*pp. 84–85*) – were rounder, with a much more open aspect than their Gothic contemporaries.

By 1400, a revised version of the Caroline Minuscule script known as the Humanist Minuscule had become the established writing hand of the Renaissance (*pp. 90–91*). Eventually, its adaption for type made it the preeminent letterform in Europe, and its use continues to the present day. A variant of the Humanist Minuscule that also remains in use is the Italic (*pp. 94–95*). Devised as a manuscript hand in 1420, it was adapted for type by 1500.

Post-Renaissance scripts

The final script of significance is the Copperplate (*pp. 102–103*). As the name suggests, this was originally hand engraved or etched on sheets of copper. Typified by delicately joined loops and exotic proportions, this cursive letter could be engraved with far greater ease than it could be drawn. However, in its simpler handwritten form, the Copperplate did have the advantage of being very fast to pen. By the 19th century, it was the standard script of business and education.

Modern calligraphy

A modern calligraphy revival began at the beginning of the 20th century with the pioneering work of Edward Johnston in England (*pp. 42–43*) and Rudolf von Larisch and Rudolf Koch in Germany (*pp. 74–75*). Since the 1950s, interest in calligraphy has proliferated in many cultures, both those with and without Latin-based alphabets. During the last 20 years, as calligraphers have explored and redefined letterforms, calligraphy has become an art form in its own right.

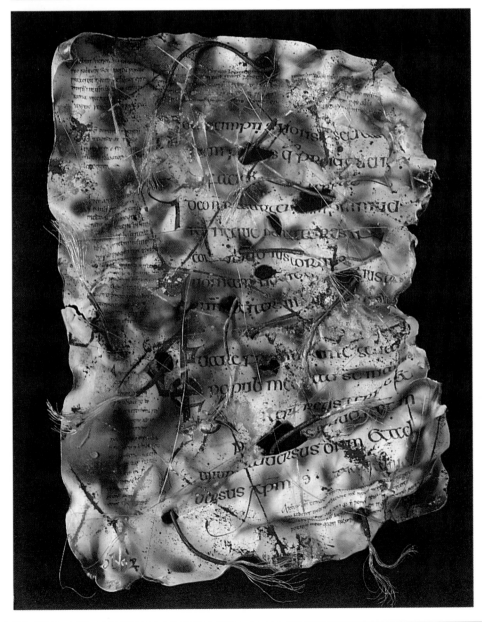

Script Timeline

Key
Gray line: Chief line of influence
Dotted line: Duration of script for text
White line: Duration of script for use
other than for text

Date (AD)

100

200

300

400

500

600

700

800

900

1000

1100

1200

1300

1400

1500

1600

1700

1800

1900

2000

OLD ROMAN
CURSIVE

GREEK UNCIAL

UNCIAL

NEW ROMAN
CURSIVE

HALF UNCIAL

CURSIVE HALF UNCIAL

INSULAR MINUSCULE

VISIGOTHIC
MINUSCULE

BENEVENTAN MINUSCULE

LUXEUIL
MINUSCULE

INSULAR
MAJUSCULE

CAROLINE
MINUSCULE

ROTUNDA

EARLY
GOTHIC

TEXTURA
PRESCISUS

TEXTURA
QUADRATA

FOUNDATIONAL HAND
(BRITISH CALLIGRAPHIC
REVIVAL)

SENATVSPOPV

IMPERIAL
CAPITALS

FORMONSVM·CO

RUSTIC CAPITALS

IMPROB·ΕΙDVR

SQUARE CAPITALS

RUNIC CAPITALS

INSULAR DISPLAY
CAPITALS

F COO·E ST·IN·T

LOMBARDIC CAPITALS

inwardly and lone

BASTARD
SECRETARY

HUMANIST MINUSCULE

Venerable docteu

BATARDE

de·Domine ad adim

FRAKTUR

gulas noctes lect

Molto signor mi

Elegance of

ITALIC

COPPERPLATE

GERMAN
CALLIGRAPHIC
REVIVAL

Fehle vergebet/sor

Getting Started

THE ART OF CALLIGRAPHY begins with the tools and materials, and these should be selected with great care. Often, a struggle to achieve a good result is an indication that the chosen surface or writing tool is unsuitable. Due to a widespread revival of interest in calligraphy, there is now an enormous range of pens, paper, and other equipment available. Here, basic information is given on the types of surfaces and writing implements you can use, and also on how to make the two traditional types of pen – the reed pen and the quill.

The reed pen

The reed pen and the quill (*opposite*) have been used since antiquity. Although both have now been superseded by other writing implements, the reed pen remains an ideal tool for expressive calligraphy. It is usually made from a hollow-stemmed garden cane (*Phragmitis communis*), but some calligraphers use a synthetic material, such as plastic tubing, instead. A sharp craft knife is required to make a reed pen – always take the greatest care when using it.

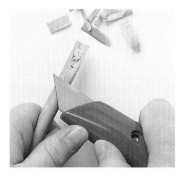

1. Cut a length of cane about 7 inches (18 centimeters) long. Use a strong craft knife to make a cut about 1½ inches (4 centimeters) long to reveal the hollow center of the cane.

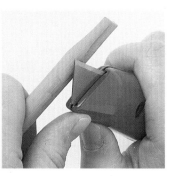

2. On the reverse side of the cane, directly underneath the first cut, make a shorter cut to create the flat top of the pen nib. Next, remove any pith from the core of the cane.

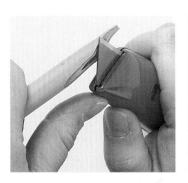

3. Return to the underside of the pen and carve shoulders between the two cuts. Make a square or oblique cut across the top of the nib as desired (see "Straight" and "slanted" pens, *opposite*).

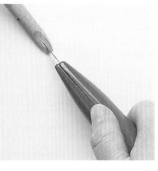

4. Finally, make a longitudinal cut about ½ inch (1.5 centimeters) long through the center of the nib – this will make the flow of ink easy. The reed pen is now ready to use.

SURFACES
For practice and trying out initial ideas, a lightweight designer's layout paper is ideal. For more formal work, good-quality paper is important – preferably a smooth, close-grained and acid-free type. Vellum, made from calfskin or goatskin, is the finest material for writing, with parchment a close second.

A selection of handmade and machine-made papers

WRITING IMPLEMENTS
In addition to the reed pen and quill, there is a huge range of writing implements from which the calligrapher can choose. Felt-tipped pens are ideal for trying out ideas, but for flexibility and economy, detachable nibs are an excellent option. The use of a fountain pen guarantees a constant supply of ink, although a spring-loaded dip pen is more convenient for changing ink colors easily. A broad-edged brush is essential for constructing Imperial Capitals (*pp. 110–119*).

Use a small pointed sable brush for drawing built-up letters

A felt-tipped pen is ideal for preliminary work

A standard pen holder can fit a variety of detachable nibs (opposite)

The calligraphic fountain pen is one of the most convenient tools

Spring-loaded dip pens are ideal for large-scale work

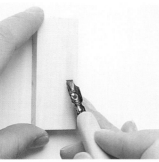

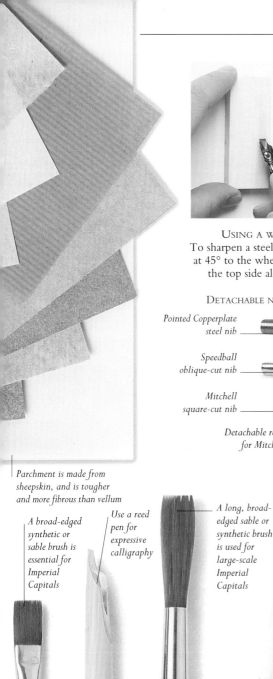

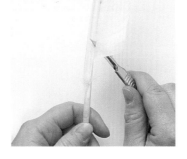

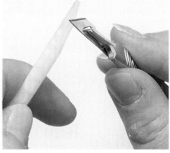

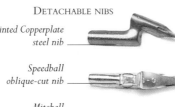

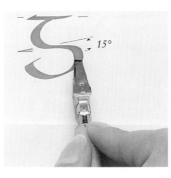

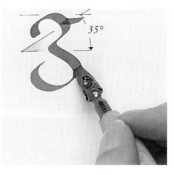

USING A WHETSTONE
To sharpen a steel nib, hold the pen at 45° to the whetstone and stroke the top side along the stone.

DETACHABLE NIBS

Pointed Copperplate steel nib

Speedball oblique-cut nib

Mitchell square-cut nib

Detachable reservoir for Mitchell nib

Parchment is made from sheepskin, and is tougher and more fibrous than vellum

A broad-edged synthetic or sable brush is essential for Imperial Capitals

Use a reed pen for expressive calligraphy

A long, broad-edged sable or synthetic brush is used for large-scale Imperial Capitals

The quill is the most traditional of tools

The quill

Although the quill is probably the finest of all writing tools, it is not as convenient as other implements and requires more practice in handling. Being of a softer material than a steel nib or a reed pen, it requires gentler pressure than you would expect, but the subtlety of line that it produces is far superior to that of other pens. Turkey, goose, or swan feathers are the most useful, and duck or crow may also be used for formal work.

1. Cut the shaft of the feather to a length of about 7¾ inches (20 centimeters) and carefully strip the barbs from it using a scalpel or sharp craft knife.

2. Holding the shaft firmly, make a long, sweeping cut on the underside of the quill. Carefully make a second cut to shape the shoulders and pare the edges to form the tip.

3. Make a short longitudinal cut through the center of the nib to ease the flow of ink. Remove the pith from the center of the pen and any remaining material on the outside.

4. Place the tip of the quill on a cutting surface and carefully cut across the shaft to create the nib edge. Make a square cut for a "slanted" pen and an oblique cut for a "straight" pen (below).

"STRAIGHT" AND "SLANTED" PENS
Throughout this book, there are references to "straight" and "slanted" pens. This can cause confusion, as the meaning of these terms appears to be contradictory. The "straight" pen is held horizontally, producing thick stems and thin horizontal strokes. The "slanted" pen is held at an angle of about 30°, creating horizontal and vertical strokes of similar weight.

15°

35°

A "straight" pen has an oblique-cut nib, cut at an angle of about 70° to the shaft – it is ideal for scripts such as the Half Uncial (pp. 40–41)

A "slanted" pen has a square nib, cut at right angles to the shaft – it is ideal for scripts such as the Caroline Minuscule (pp. 40–41)

Rustic Capitals

IF THE CALLIGRAPHER of today is sometimes confused by the rich variety of scripts available, both modern and historical, then the opposite must have been true for the scribe of the early Roman period, who had only three basic hands. The first was the magnificent Imperial Capital – the most complex of all scripts, used in stone-cut form on the great monuments of state (*pp. 108–109*). Second, for everyday needs, there was the cursive script – the quickly executed hand used by everyone writing in the Latin language. Third, there was the Rustic Capital, an elegant alternative to the Imperial Capital and popular with both signwriter and scribe.

FROM THE FIRST TO the fifth century, the Rustic Capital was used for deluxe manuscripts, particularly works by Virgil. After the fifth century, it lost favor as a manuscript hand, although its use for titles continued for centuries afterward. As far as is known, the script was not used for Christian literature, and the conversion of Rome to Christianity in AD 313, with its attendant use of the Uncial (*pp. 24–25*), may be one reason for the demise of the Rustic as a bookhand.

Rustic Capitals also served as stone-cut letters, often used in conjunction with Imperial Capitals on the less prestigious monuments.

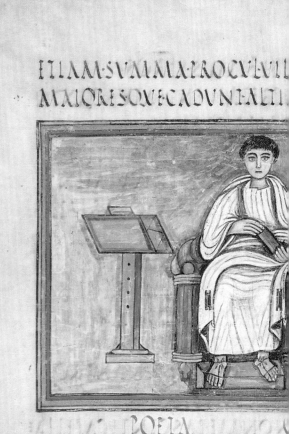

The nib would have been held at a near vertical for the upright strokes

VERGILIUS ROMANUS, *ECLOGA II*
This magnificent and rare example of a Virgil manuscript in Rustic Capitals dates from the second half of the fifth century. The words are separated by a *punctus* (midpoint), instead of the *scriptura continua* (continuous script) typical of this period.

THE HIERARCHY OF SCRIPTS Rustic Capitals were used for titles until the late 12th century as part of a so-called "hierarchy of scripts." Rustics were used for chapter openings, Uncials for the first lines, followed in this example by a fine Caroline Minuscule text (*pp. 38–39*).

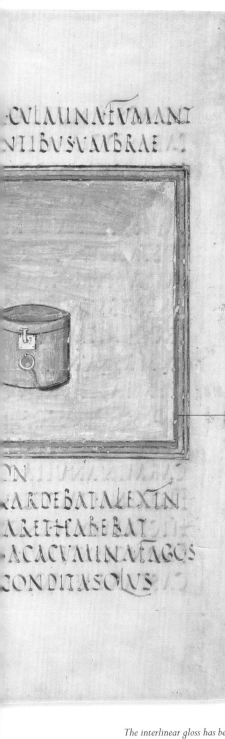

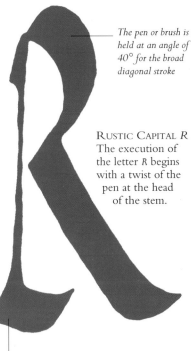

The pen or brush is held at an angle of 40° for the broad diagonal stroke

RUSTIC CAPITAL *R*
The execution of the letter *R* begins with a twist of the pen at the head of the stem.

The feet of the letter turn slightly downward before finishing with an upward flick

The portrait illustration shows Virgil sitting beside a lectern, with a capsa for storing scrolls to his left

Calligraphic flourishes occur on the F, X, and L

Writing materials
The fact that we have evidence of the Rustic Capital in both manuscript and signwritten form shows that two different writing implements were used. The script would have been written with equal fluency with either a reed pen – or after the fourth century, a quill – or a brush. The brush would have been a broad-edged, flexible sable, held at a near-upright angle to create the thin stems and broad horizontal strokes.

A simple ductus
The basic difference between the Imperial and the Rustic lies in the complexity of the stroke weight. The strokes of the Imperial are even, with no sharp contrasts in weight. This effect requires numerous changes in tool angle (*pp. 110–119*). The ductus of the Rustic is simpler to pen, with a pronounced difference in stroke weight between the thick and thin strokes.

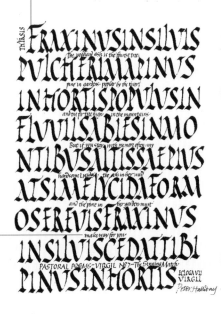

The interlinear gloss has been written in a modern Italic hand (pp. 94–95)

PETER HALLIDAY
This modern version of Virgil's *Eclogue VII*, written in black ink on cream paper, was penned by Peter Halliday in 1983. Note the contrast he achieves between the broad horizontal and diagonal strokes and the thin verticals.

PAPYRUS LEAF
Papyrus was the principal writing surface for more than 3,000 years until the late Roman period. It was made by pounding together two strips of papyrus leaf laid at right angles to each other.

DETAIL FROM VERGILIUS ROMANUS, *ECLOGA II*

Rustic Capitals

THE DUCTUS OF the Rustic Capital is different from the other hands shown in this book in that the pen angle can be as steep as 85° to the horizontal for the thin vertical strokes. This angle is relaxed to nearer 45° for the foot serifs and diagonal strokes. Therefore, from the top of the stem to the beginning of the foot, the pen must twist as much as 40°, and this transition is the key to well-executed Rustic Capitals. With its serif, thin stem, and broad foot, the L (below) typifies many Rustic letters. The letter height is generally between four and six pen widths, but can reach seven.

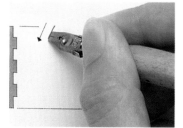

1. Using a square-cut pen nib, begin the serif of the letter *L* by pushing downward with the broad edge of the nib. The pen angle should be about 65° for this stroke.

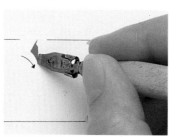

2. Pull the pen downward to the right, while twisting the nib from 65° to almost vertical at the line of the stem. Without lifting the pen, begin drawing the fine stroke of the stem.

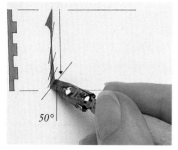

3. At about halfway to the baseline, anticipate the foot serif by gradually turning the pen to about 50°. This will create the distinctive Rustic thickening of the stem base.

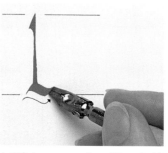

4. Lift the pen, turn it to 45°, and add the foot serif in one firm, downward diagonal sweep. The foot is a major element in the script for it leads the eye forward to the next letter.

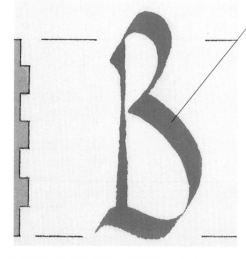

This broad sweeping curve is drawn in one smooth stroke with a pen angle of 45–50°

Diagonal sweep
It is the repetition of the downward sweeping strokes, combined with the near-diagonal strokes of the feet, that gives the Rustic Capital its characteristic rhythm. These strong strokes provide a counterpoint to the fine vertical stems.

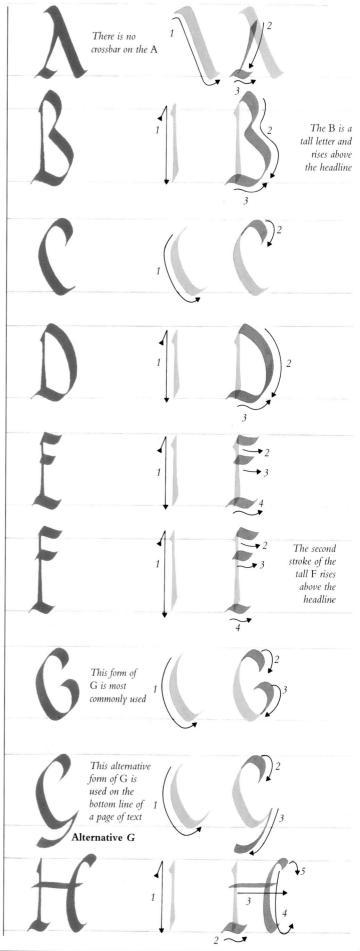

There is no crossbar on the A

The B is a tall letter and rises above the headline

This form of G is most commonly used

This alternative form of G is used on the bottom line of a page of text

Alternative G

The second stroke of the tall F rises above the headline

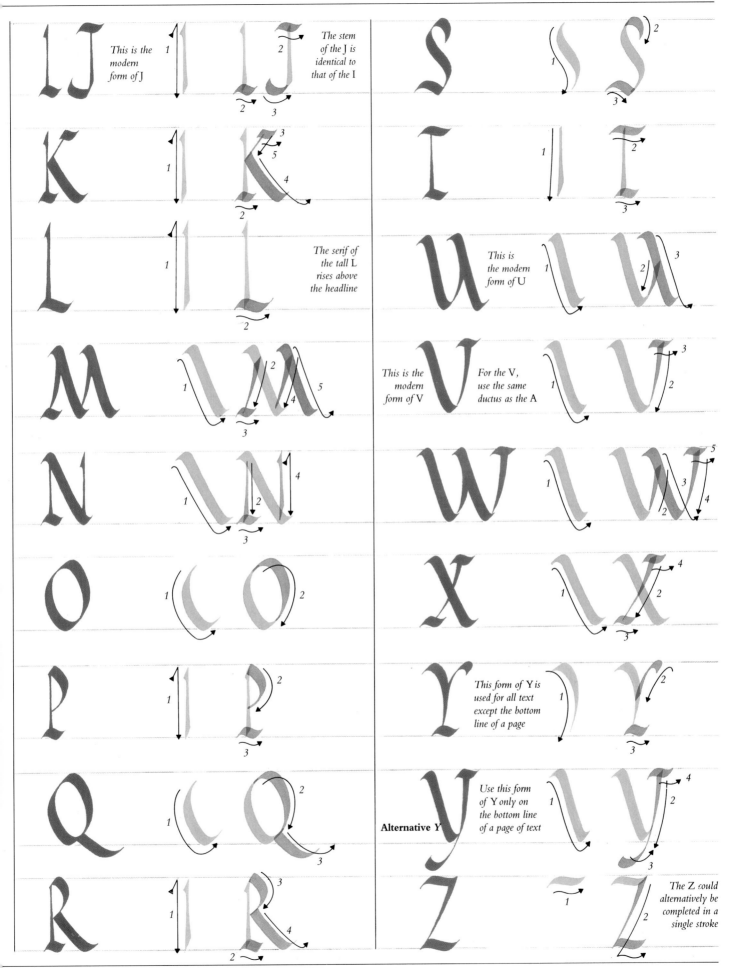

This is the modern form of J

The stem of the J is identical to that of the I

The serif of the tall L rises above the headline

This is the modern form of U

This is the modern form of V

For the V, use the same ductus as the A

This form of Y is used for all text except the bottom line of a page

Alternative Y

Use this form of Y only on the bottom line of a page of text

The Z could alternatively be completed in a single stroke

Square Capitals

As A LATE FOURTH-CENTURY Roman hand without precedent or descendents, the stately Square Capital (*Capitalis Quadrata*) falls awkwardly into the evolutionary pattern of Roman scripts. Because very few examples survive from this period, the duration of its use and the development of its style is subject to conjecture. The script remains, however, one of great dignity, its grace owing largely to the openness of the letterforms and the clear letter separation.

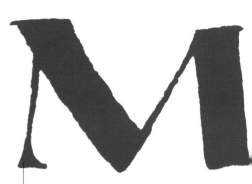

Small serifs are drawn with the corner of the pen nib

SQUARE CAPITAL *M*
The broad downward strokes of the *M* typify the Square Capital letter.

It is often believed that the Square Capital originated as an attempt to interpret the brush-drawn Roman Imperial Capital (*pp. 108–109*) in pen-drawn form. However, the thick downstrokes and hairline horizontal strokes of the Square Capital point to the use of a horizontally held pen, in contrast to the angle of 30° required to produce the visually balanced vertical and horizontal strokes of the Imperial Capital. This suggests that the Square Capital may have been derived from another source.

Contemporary influences

It is perhaps more likely that scribes writing in Square Capitals looked for inspiration to contemporary carved lettering, rather than to the brush-created capitals of their predecessors. One such example is the fourth-century plaque in the Church of San Sebastiano, Rome (*right*), in which stroke angle and letter proportion coincide with the manuscript hand.

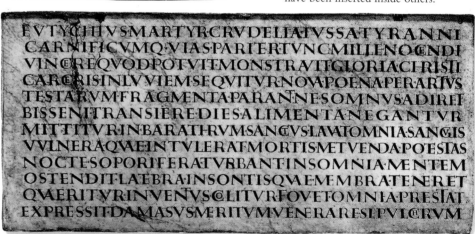

Parchment was stretched across a wooden frame and the residual flesh removed with a circular knife

PARCHMENT MAKER
In Rome, parchment was an established rival to papyrus by AD 300 and was the principal surface for writing late Roman manuscripts, such as the *Codex Vaticanus 3256* (*opposite*). It was invented in Pergamon, Asia Minor, in response to an Egyptian trade embargo in 197–158 BC that cut off the supply of papyrus.

SAN SEBASTIANO PLAQUE
The inscription on this plaque in the Church of San Sebastiano, Rome, dates from between the years 366 and 384. Notice the imaginative ligatures of certain letters, such as *N-T*, *H-R*, *V-A*, and *T-E*, and the way some letters have been inserted inside others.

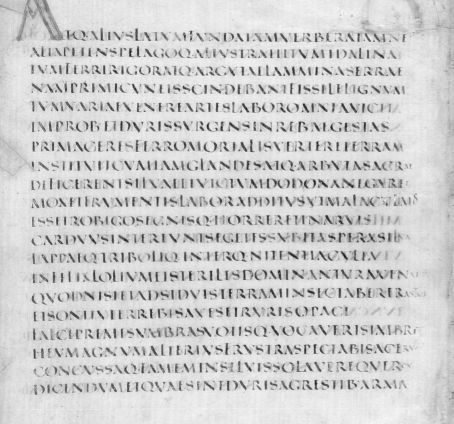

This manuscript of Virgil's *Georgics* was written in Square Capitals in the late fourth century. Perhaps one reason why it has survived is that it was written on parchment instead of the more fragile papyrus. Because of the scarcity of examples of Square Capitals, it is difficult to assess the duration of the hand, and there is no evidence to suggest that it survived beyond the early fifth century.

Surviving examples

Only two known surviving examples of Square Capitals exist, compared to some 400 of the other late Roman bookhand, the Uncial (*pp. 24–25*). Both manuscripts are deluxe texts of Virgil dating from the fourth century. One is the *Codex Vaticanus 3256* (*left*), housed in the Vatican Library, the other a text from the monastery of St. Gall, Switzerland. From this scant evidence, it is clear that the Square Capital was the most shortlived of Roman scripts, and paleographers are forced to conclude that in terms of the evolution of calligraphy the hand represents a blind alley.

Time-consuming work

One reason for the short life of the Square Capital is the time it would have taken scribes to write each letter. The multiple angle changes and difficult serif constructions require considerable patience (*pp. 22–23*). While such time-consuming labor may have been acceptable for titles, it would have been highly uneconomical for text, particularly in comparison with the more practical Uncial or the Rustic Capital (*pp. 16–17*).

Instead of the more common thick first stroke of the letter R, a hairline stroke has been used

The tall L is often found in inscriptions and manuscripts from the late fourth century

DETAIL FROM *CODEX VATICANUS 3256*
In this detail, it is clear that the script is written without word division and punctuation. On the fine upright strokes of *A*, *N*, *M*, *R*, and *V*, the pen is turned from horizontal to vertical, which produces a strong contrast in stroke proportions. The triangular serifs that terminate the hairline strokes have been added with the corner of the pen nib.

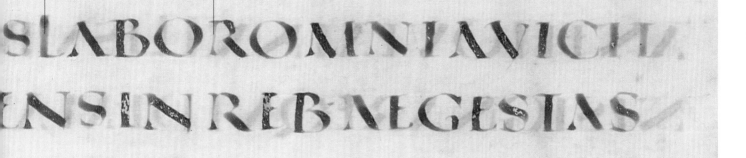

Square Capitals

THE SQUARE CAPITAL is characterized by a combination of broad strokes (both straight and curved), delicate hairlines, and neat serifs. Of the dominant broad strokes, the diagonal is the most difficult to draw, involving a pen twist as great as 45°. The simpler vertical strokes are made with a single movement of the pen, held almost horizontally. Upright hairline strokes occur on the letters *A*, *M*, *N*, *R*, *W*, and *X* and can be made by skating the wet ink from the main stem stroke.

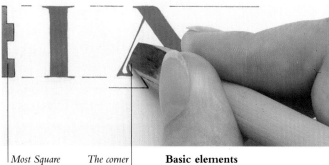

Most Square Capitals are about four pen widths high

The corner of the nib is used for adding the serifs

Basic elements
The Square Capital letter is about four pen widths high, with the letters *F* and *L* drawn slightly higher than the rest. The script is best drawn with a reed pen or a square-cut steel nib.

Complex letters
The perfectly balanced letter *N* is one of the most complex letters in the hand. It consists of one broad diagonal, two hairline verticals and three serifs. A series of angle changes is required for its construction.

1. Begin the N with a pen angle of about 45°, progressively turning the pen to the vertical as it reaches the baseline.

2. Make a small horizontal stroke on the headline, then pull the wet ink downward with the edge of the nib.

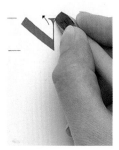
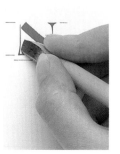

3. Return to the headline and build up the serif under the horizontal stroke.

4. Now draw the leading vertical stroke with the corner of the nib and add the serif.

5. Still using the corner of the nib, add the serif at the head of the diagonal stroke.

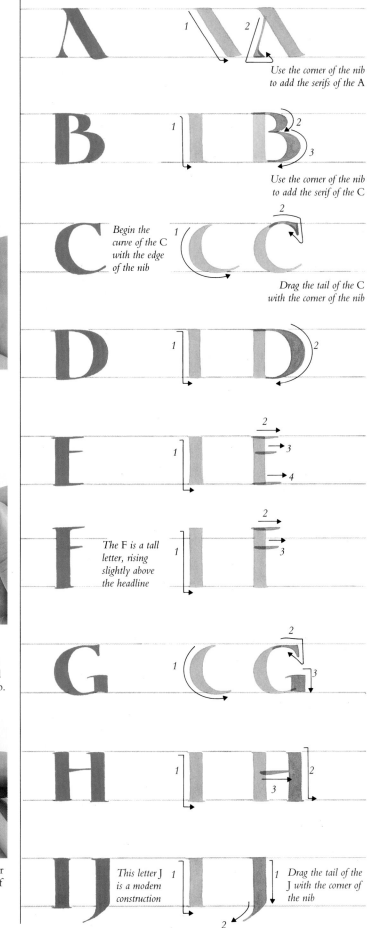

Use the corner of the nib to add the serifs of the A

Use the corner of the nib to add the serif of the C

Begin the curve of the C with the edge of the nib

Drag the tail of the C with the corner of the nib

The F is a tall letter, rising slightly above the headline

This letter J is a modern construction

Drag the tail of the J with the corner of the nib

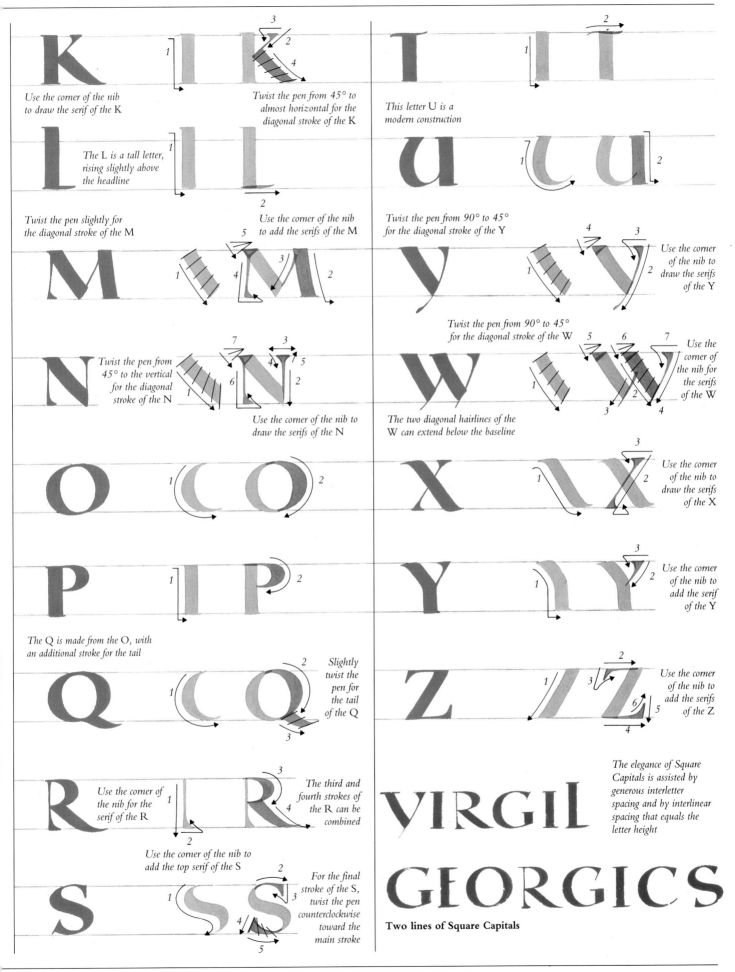

Use the corner of the nib to draw the serif of the K

Twist the pen from 45° to almost horizontal for the diagonal stroke of the K

This letter U is a modern construction

The L is a tall letter, rising slightly above the headline

Twist the pen slightly for the diagonal stroke of the M

Use the corner of the nib to add the serifs of the M

Twist the pen from 90° to 45° for the diagonal stroke of the Y

Use the corner of the nib to draw the serifs of the Y

Twist the pen from 45° to the vertical for the diagonal stroke of the N

Use the corner of the nib to draw the serifs of the N

Twist the pen from 90° to 45° for the diagonal stroke of the W

Use the corner of the nib for the serifs of the W

The two diagonal hairlines of the W can extend below the baseline

Use the corner of the nib to draw the serifs of the X

Use the corner of the nib to add the serif of the Y

The Q is made from the O, with an additional stroke for the tail

Slightly twist the pen for the tail of the Q

Use the corner of the nib to add the serifs of the Z

The elegance of Square Capitals is assisted by generous interletter spacing and by interlinear spacing that equals the letter height

Use the corner of the nib for the serif of the R

The third and fourth strokes of the R can be combined

VIRGIL

Use the corner of the nib to add the top serif of the S

GEORGICS

For the final stroke of the S, twist the pen counterclockwise toward the main stroke

Two lines of Square Capitals

Uncial & Artificial Uncial

THE ROMAN UNCIAL script (*Littera Uncialis*) originated in the second or third century AD, possibly in North Africa. Although its beginnings are subject to conjecture, there are noticeable similarities with the Greek Uncial – a curved, functional script that had been used since the third century BC and was the official hand of the Christian Church. By the second century, Christianity was increasing in influence throughout the Roman Empire, and it is likely that the early Christians consciously adapted the Greek Uncial to the Latin language as a script appropriate for their new religion.

ARTIFICIAL UNCIAL *A*
Broad diagonal and vertical strokes, contrasted with delicate hairlines, typify Artificial Uncial letters.

The Artificial Uncial form of a *is drawn with the pen held near to the horizontal*

Hairline strokes should be drawn as finely as possible, using the left corner of the nib

Paragraph openings are preceded by a larger letter in the margin

UNCIAL SCRIPT
This economical Uncial script was written in about 450. The pen is held at 30°, giving a well-mannered, flowing quality to the text. The text is written as *scriptura continua* (without spaces between words), which was common for this period.

THE UNCIAL SCRIPT was brought to southern England from Rome by the missionary St. Augustine in the year 597. Its name, meaning "inch" or "inch-high letter," is attributed to St. Jerome, a translator and compiler of the Vulgate (common) Bible. He possibly used it as a term of derision, in objection to the common practice of wasting parchment by using large letters for deluxe books.

Origins of minuscules

The beginnings of our modern lower-case letters can be discerned in the Uncial script. The letters *d*, *h*, and *l* rise above capital height while *i*, *f*, *n*, *p*, *q*, and *r* drop below the baseline. A further departure from the capitular form is the absence of any elaborate serif constructions. This simplicity makes the Uncial, together with the Caroline Minuscule (*pp. 38–39*) and the Foundational Hand (*pp. 42–43*), ideal for learning the basics of pen handling and calligraphy.

The revisions in the first line seem to have been made by a later, untutored hand

The dedicatory verse from the Codex Amiatinus *shows typically fine serifed Artificial Uncial letters*

CODEX AMIATINUS
The *Codex Amiatinus* Bible was written in Wearmouth and Jarrow before 716. Initiated by Abbot Coefrid, this imposing book is the earliest known Bible in Latin and was produced for presentation to Pope Gregory II. Although mistakes occur in the first, second, and fifth lines, the remaining script is a *tour de force* of the Artificial Uncial. The finely drawn hairlines and delicate serifs are of a superior quality to those in the Vespasian Psalter (*opposite*).

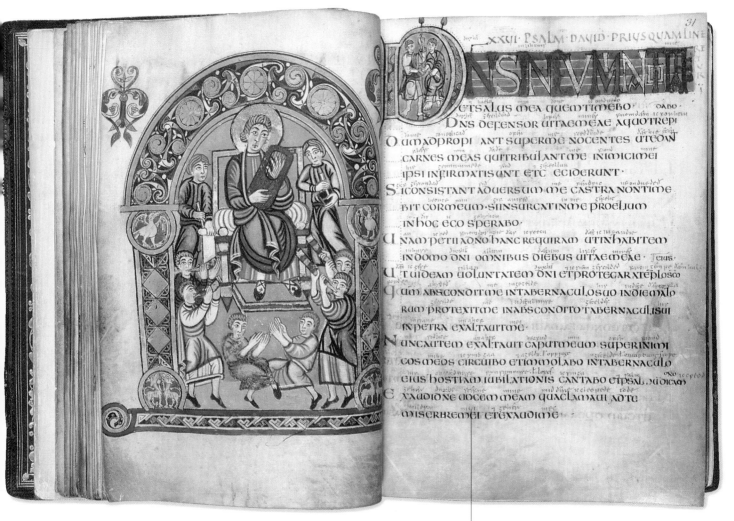

THE VESPASIAN PSALTER
The Vespasian Psalter was written at St. Augustine's Abbey, Canterbury, in the early eighth century. The interlinear gloss contains the earliest known copy of the Psalms in English. The opening *D* from Psalm 26, showing the figures of David and Jonathan, is the earliest example of a historiated initial in Western manuscripts. The illuminated title is written in built-up Roman capitals.

The interlinear gloss was added in the ninth century

DETAIL FROM THE VESPASIAN PSALTER
The serifs in this detail are slightly bolder than those in the *Codex Amiatinus* (*opposite*), which indicates the use of a less sharply cut quill.

Artificial Uncial

The Uncial hand was well established in Britain by the time the twin abbeys of Wearmouth and Jarrow were founded in 674 and 682 respectively. Soon, the monks of Wearmouth, Jarrow, and Southumbria (England south of the Humber River) were producing manuscripts of a quality equal to that anywhere else in Europe. Their work included the landmark Bible, the *Codex Amiatinus* (*opposite*). However, the hand they were using was not the Uncial of St. Jerome, but a highly intricate and serifed version, with thin horizontal and thick vertical strokes, and serifs reminiscent of those on Square Capitals (*pp. 20–21*). This extremely beautiful calligraphic hand is known variously as Artificial Uncial, Late Uncial, or Romanizing Uncial of the Canterbury Style.

Uncial & Artificial Uncial

THE UNCIAL IS A practical writing hand and as such presents no difficulties to pen. The Artificial Uncial, however, is subject to considerable elaboration involving many pen twists and changes of angle. Both forms of the script are regarded as bilinear – written between two horizontal lines – but they show the beginnings of a tendency that ultimately leads to the development of our lowercase letters: *F, I, N, P, Q,* and *R* drop below the baseline, and *D, H,* and *L* rise above the headline.

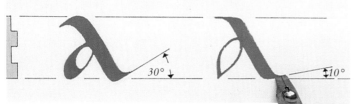

Uncial *Artificial Uncial*

Basic differences
The Uncial letter is written with a pen angle of 30°. Simpler in construction than the Artificial variety, it can be quickly and easily penned with a steel nib. The more complex Artificial Uncial letter is written with a pen angle of 10°. It can be penned with a steel nib or a quill.

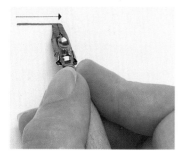

Pen twists
In the Artificial Uncial, the characteristic pen twist that occurs on the serifs of letters *C, E, F, G, K, L, N,* and *T* can be executed simply and quickly.

1. Begin by drawing a horizontal hairline stroke, using the full length of the nib.

2. On reaching the end of the stroke, gradually twist the pen counterclockwise from the horizontal to near vertical and lift. The resultant serif is indented, with a small blob visible at the top right-hand corner.

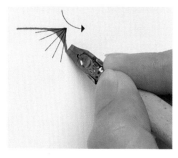

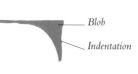

Blob

Indentation

The serif can be left with the blob and indentation still visible

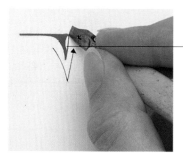

3. The serif can be tidied up by using the corner of the pen nib to draw a hairline stroke back up to the headline. This extension is then filled in with ink.

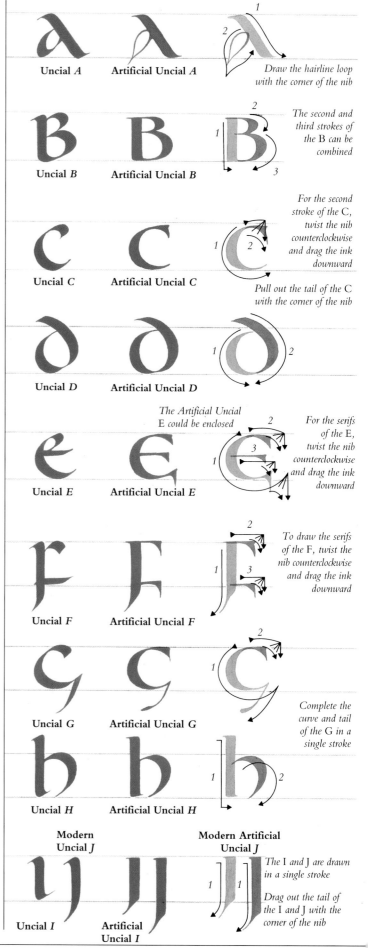

Uncial *A* Artificial Uncial *A*

Draw the hairline loop with the corner of the nib

Uncial *B* Artificial Uncial *B*

The second and third strokes of the B can be combined

Uncial *C* Artificial Uncial *C*

For the second stroke of the C, twist the nib counterclockwise and drag the ink downward

Pull out the tail of the C with the corner of the nib

Uncial *D* Artificial Uncial *D*

The Artificial Uncial E could be enclosed

Uncial *E* Artificial Uncial *E*

For the serifs of the E, twist the nib counterclockwise and drag the ink downward

Uncial *F* Artificial Uncial *F*

To draw the serifs of the F, twist the nib counterclockwise and drag the ink downward

Uncial *G* Artificial Uncial *G*

Complete the curve and tail of the G in a single stroke

Uncial *H* Artificial Uncial *H*

Modern Uncial *J* **Modern Artificial Uncial *J***

The I and J are drawn in a single stroke

Drag out the tail of the I and J with the corner of the nib

Uncial *I* Artificial Uncial *I*

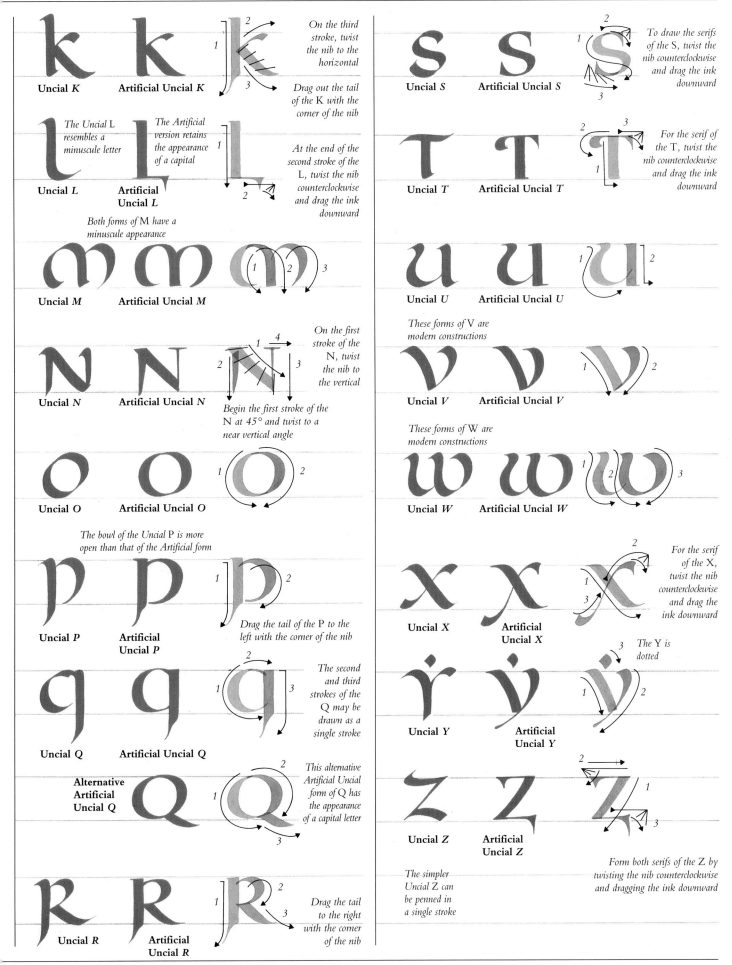

Uncial K Artificial Uncial K

On the third stroke, twist the nib to the horizontal

Drag out the tail of the K with the corner of the nib

The Uncial L resembles a minuscule letter

The Artificial version retains the appearance of a capital

Uncial L Artificial Uncial L

At the end of the second stroke of the L, twist the nib counterclockwise and drag the ink downward

Both forms of M have a minuscule appearance

Uncial M Artificial Uncial M

On the first stroke of the N, twist the nib to the vertical

Uncial N Artificial Uncial N

Begin the first stroke of the N at 45° and twist to a near vertical angle

Uncial O Artificial Uncial O

The bowl of the Uncial P is more open than that of the Artificial form

Uncial P Artificial Uncial P

Drag the tail of the P to the left with the corner of the nib

Uncial Q Artificial Uncial Q

The second and third strokes of the Q may be drawn as a single stroke

Alternative Artificial Uncial Q

This alternative Artificial Uncial form of Q has the appearance of a capital letter

Uncial R Artificial Uncial R

Drag the tail to the right with the corner of the nib

Uncial S Artificial Uncial S

To draw the serifs of the S, twist the nib counterclockwise and drag the ink downward

Uncial T Artificial Uncial T

For the serif of the T, twist the nib counterclockwise and drag the ink downward

Uncial U Artificial Uncial U

These forms of V are modern constructions

Uncial V Artificial Uncial V

These forms of W are modern constructions

Uncial W Artificial Uncial W

Uncial X Artificial Uncial X

For the serif of the X, twist the nib counterclockwise and drag the ink downward

The Y is dotted

Uncial Y Artificial Uncial Y

Uncial Z Artificial Uncial Z

The simpler Uncial Z can be penned in a single stroke

Form both serifs of the Z by twisting the nib counterclockwise and dragging the ink downward

Beati pauperes spū quoniam
ipsorum est regnum caelorum·
Beati mites quoniam ipsi possi
debunt terram :
Beati qui lugent nunc quoniam
ipsi consulabuntur
Beati quiessuriunt & siciunt
iusticiam quoniam ipsi satu
rabuntur
Beati misericordes quoniam
ipsi misericordiam conseqūtr
Beati mundo corde quoniam
ipsi dm̄ uidebunt
Beati pacifici quoniam filii dī
uocabuntur
Beati qui persecutionem pati
untur propter iusticiam quoni

Insular Majuscule

THE INSULAR MAJUSCULE (Insular Half Uncial) derives its name from its origins in the islands of Britain and Ireland. "Insular" is from the Latin for "island," and "Majuscule" refers to the height of the letters, much larger and bolder than those of the complementary Insular Minuscule (*pp. 34–35*). As a prestige hand, the Insular Majuscule is characterized by letters drawn slowly and carefully, with many lifts of the pen (*pp. 32–33*). In early medieval Britain and Ireland, it was the favored hand for sacred manuscripts written in Latin, including two of the most beautiful books ever produced, the Lindisfarne Gospels and the Book of Kells.

INSULAR MAJUSCULE *F*
The principal characteristic of the Insular Majuscule letter is the wedge-shaped serif on the headline (*pp. 32–33*).

The thickened base is created by moving the pen slightly to the right of the stem and then pushing it up to the midway point

BEATITUDES PAGE FROM THE BOOK OF KELLS
The border of this page from the Book of Kells combines the eight initial *b*s and incorporates both zoomorphic and anthropomorphic decoration. The horizontal stroke over "*spu*" in the first line denotes an abbreviation of "*spiritu*" ("breath of God"). The horizontal stroke is used by scribes for frequently repeated words. Also typical is the letter *n* in the 13th line, which has been extravagantly extended in order to fill space. The use of red dots to outline initials and ornament text is more sensitive and restrained here than in the Lindisfarne Gospels (*pp. 30–31*).

Careful study of the thinner ink on the f gives clues to the construction of Insular Majuscule letters

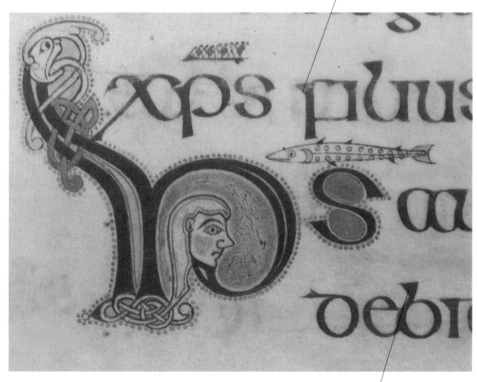

THE GOSPEL OF ST. MARK
The Insular Majuscule is without capitals as they are used in the modern sense. Chapter openings, such as this detail from the Gospel of St. Mark in the Book of Kells, began with a line of display capitals, a Versal (*pp. 58–59*), or a combination of both. Verses would open with a larger character, which was often decorated or filled with color.

The ascender of the letter b slants to the right, with the wedge serif balancing over the bowl of the letter

IF EVER THERE WAS a golden age of calligraphy, it was the beginning of the eighth century, when Northumbria was one of the most flourishing centers of art and scholarship in western Europe. Interaction between scriptoriums of the twin Augustinian monasteries Jarrow and Wearmouth (see the *Codex Amiatinus, p. 24*) and that at Celtic Lindisfarne (see the Lindisfarne Gospels, *pp. 30–31*) led to the production of some of the greatest achievements of medieval art.

The Book of Kells

The Book of Kells was written at some time in the second half of the eighth century and the early years of the ninth century, probably by Irish-Northumbrian monks. Its place of origin is shrouded in uncertainty and the first record we have of its existence is an account of its theft in 1006 from the monastery of Kells in Ireland.

The four illuminated Gospel texts in the Book of Kells were written by at least three scribes in insular versions of Uncial (*pp. 24–25*) and Half Uncial (*pp. 38–39*) letters. These would have derived from characters originally introduced into Ireland from the ancient region of Gaul by St. Patrick and his missionaries.

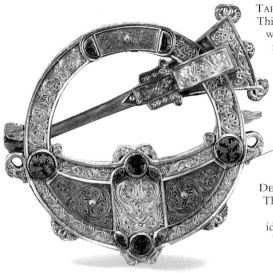

Tara brooch
This intricately decorated brooch was found in Ireland in 1850 not far from ancient Tara. The date of its construction is unknown, although striking design similarities with some decorated initials in the Lindisfarne Gospels suggest an early medieval date.

These curvilinear patterns are very similar to those in the Lindisfarne Gospels (right)

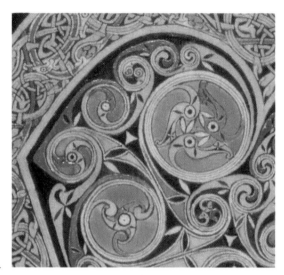

Detail from the Chi-Rho page
The interlaced birds and curvilinear patterns in this detail are almost identical to decoration on the Tara brooch. This style of zoomorphic interlacing is of Germanic origin.

Chi-Rho page
These ornate display capitals on the Chi-Rho page of the Lindisfarne Gospels make this one of the most impressive leaves in the book. A variety of influences are evident, including Greek, Roman, Half Uncial, and runic. Eadfrith's use of the capitals is highly creative. There are three different forms of the letter *A* on this page: two on the second line, and a third, *OC* form on the bottom line (*pp. 32–33*).

The Lindisfarne Gospels

The richly illuminated Lindisfarne Gospels date from the end of the seventh century, when the scribes of the Northumbrian monasteries were entering their most productive phase. The Gospels were written in Latin by a single scribe, Eadfrith, who became Bishop of Lindisfarne in 698. An interlinear gloss, providing a translation of the text into English, was added in the tenth century.

The Durham Gospels

In addition to the Gospels from Lindisfarne and Kells, there are a number of other books and fragments from this period that reveal well-executed Insular Majuscules. Among the most outstanding are the Durham Gospels, which are contemporary with those of Lindisfarne and may even have been written in the Lindisfarne scriptorium. The elegant, well-balanced hand is markedly similar to Eadfrith's. Other examples include the Echternach Gospels and the Book of Durrow.

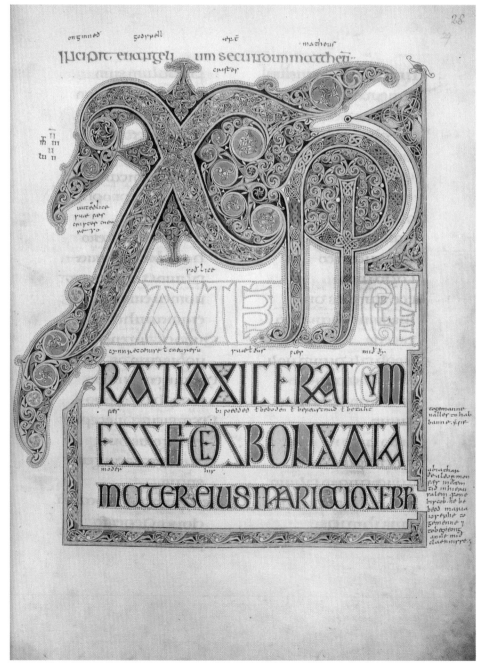

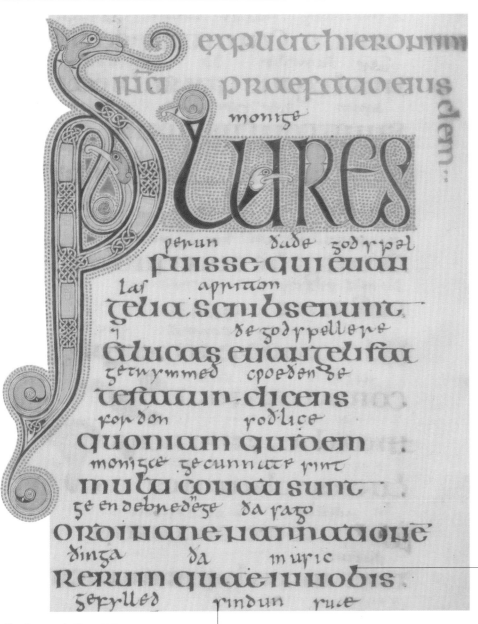

Manuscript decoration

The scholar Giraldus Cambrensis, writing in 1185, remarked: "…you may say this was the work of an angel, not of man…the more I study, the more I am lost in fresh amazement." He was describing, in all probability, the decoration of the Book of Kells (*pp. 28–29*). This, along with the illustrations in the Lindisfarne Gospels and other works from the early medieval period, represents the highest achievement of Western manuscript decoration. From the carpet pages (pages without text and filled entirely with intricate designs) to the decorated initials and display capitals, and from the shields, trumpets, spirals, and knots to the labyrinthine interlaces that dissolve into fanciful animal forms, the craftsmanship has remained unsurpassed. Today, we view the work with the same wonderment as Cambrensis, often requiring a magnifying glass to study the fine detail.

In this Insular Majuscule text, the distinctive wedge serifs have been executed with a horizontal flick of the pen

ST. JEROME'S PREFACE
This beautifully decorated page from the Lindisfarne Gospels shows the preface to the text of St. Jerome. The abundant use of red dots around the initial letters is a common design feature of the book. As well as outlining the letters, the dots provide a background of delicate color. One folio in the Lindisfarne Gospels is decorated with over 10,000 such dots. The rubricated letters at the top of the page indicate the end of one text and the beginning of another.

The interlinear gloss, written in an Anglo-Saxon minuscule (pp. 34–35), is the earliest surviving translation into Anglo-Saxon of the Four Gospels

In this work by Denis Brown, the medieval Insular Majuscule letters have been recreated in a modern context

DENIS BROWN
This calligraphic piece, entitled *Cultural Decomposition*, was created by the Irish calligrapher Denis Brown in 1993. At 47¼ by 63 inches (1.2 by 1.6 meters), it is a work of great scale and power. The medieval artistry of the Insular Majuscule letters is seen to be systematically corroded by the symbols of modernity, the electric cables.

Insular Majuscule

THE INSULAR MAJUSCULE is among the most prestigious of scripts. Most letters in this hand are built up from a series of composite strokes and involve multiple pen lifts. Ascenders and descenders are minimal. The script tends to be bold, with a letter height of between three and five pen widths. Clear spaces should be allowed both within and between letters, and interlinear space is generally equal to about two minim heights.

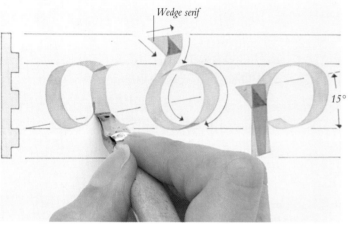

Wedge serif

15°

Pen angle and wedge serifs
Insular Majuscule letters are written with an oblique-cut nib, with the pen angle between the horizontal and 15°. The distinctive wedge serif, such as

that on the *b*, is made by drawing a short downward stroke at about 45° into the main stem. This can be preceded or followed by a hairline stroke along the top of the wedge.

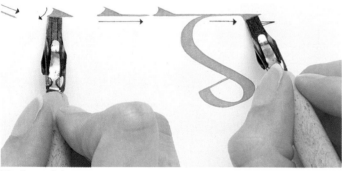

Horizontal darts
To create the darts that appear on letters *d*, *g*, *t*, and *z*, use the back of the pen nib. Begin by drawing a diagonal stroke to the right, followed by a short

downward stroke, then pull the pen to the right to make a long horizontal stroke. Letters *g* and *t* have a second dart; create this by twisting the pen downward to an angle of about 15°.

The corner of the nib can be used to draw the short dart

Alternative dart
An alternative technique to that described above is to use the corner of the pen nib to define the dart before filling in the outline with ink.

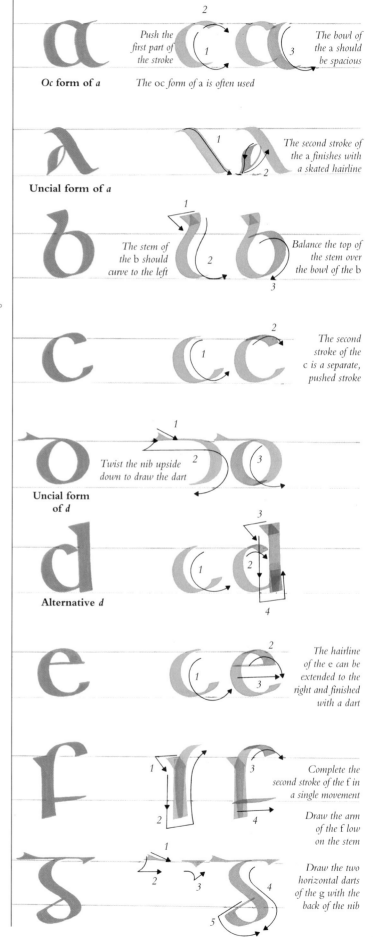

Oc form of a
Push the first part of the stroke
The oc form of a is often used
2
1
3
The bowl of the a should be spacious

Uncial form of a
1
2
The second stroke of the a finishes with a skated hairline

1
The stem of the b should curve to the left
2
Balance the top of the stem over the bowl of the b
3

1
2
The second stroke of the c is a separate, pushed stroke

Uncial form of d
1
Twist the nib upside down to draw the dart
2
3

Alternative d
1
2
3
4

1
2
3
The hairline of the e can be extended to the right and finished with a dart

1
3
2
4
Complete the second stroke of the f in a single movement
Draw the arm of the f low on the stem

1
2
3
4
5
Draw the two horizontal darts of the g with the back of the nib

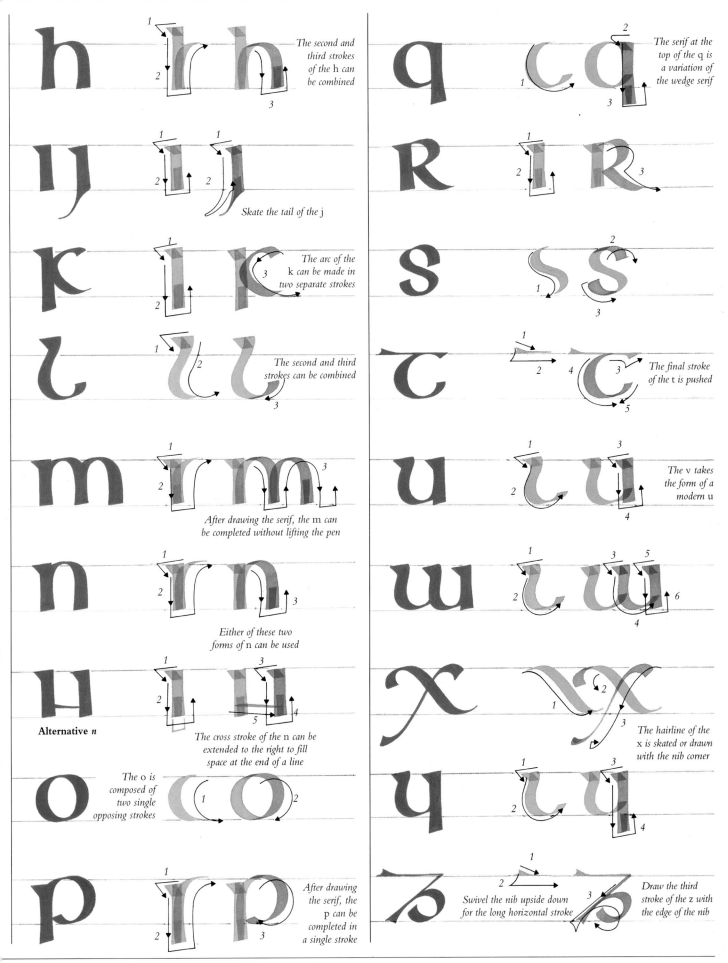

The second and third strokes of the h can be combined

The serif at the top of the q is a variation of the wedge serif

Skate the tail of the j

The arc of the k can be made in two separate strokes

The second and third strokes can be combined

The final stroke of the t is pushed

After drawing the serif, the m can be completed without lifting the pen

The v takes the form of a modern u

Either of these two forms of n can be used

Alternative *n*

The cross stroke of the n can be extended to the right to fill space at the end of a line

The hairline of the x is skated or drawn with the nib corner

The o is composed of two single opposing strokes

After drawing the serif, the p can be completed in a single stroke

Swivel the nib upside down for the long horizontal stroke

Draw the third stroke of the z with the edge of the nib

Insular Minuscule

ALONGSIDE EACH OF THE MAJOR prestige formal hands, there has usually developed a functional complementary hand for use in everyday transactions and for writing non-sacred manuscripts. In the case of the Insular Majuscule, the complementary script is the Insular Minuscule, which dates from the late fifth or early sixth century. Its use continued in England until after the Norman Conquest of 1066, and in Ireland it has survived for Gaelic use into the 20th century, making it one of the most enduring of all Latin scripts.

POINTED MINUSCULE *P*
The name derives from the characteristic long sweep of the descenders. This is in contrast to the squarer descenders of the set minuscule.

The descender tapers to a point

THE INSULAR MINUSCULE was brought to the British mainland from Ireland by St. Columba and was taught at the monasteries of Iona and Lindisfarne. As with the Insular Majuscule, the script was then disseminated on the Continent by missionary Irish monks. The term "insular" is applied by paleographers to indicate a shared culture between Ireland and Britain, free from Continental influence.

Anglo-Saxon hand

After the Council of Whitby in 664, the influence of the Celtic Church weakened in England, Scotland, and Wales and a more distinctive Anglo-Saxon hand began to emerge. Its quality is classed in four grades: hybrid, which contains half-uncial elements and the *oc* form of *a*; set, a carefully executed, formal hand; cursive, the basic, functional hand; and currens, the quickly penned, informal hand. By the early ninth century, the most favored hand in southern Britain was the pointed cursive minuscule, and it is this that we use as our model (*pp. 36–37*).

LINDISFARNE
The Priory of Lindisfarne was founded in 1083, on the site of the earlier Anglo-Saxon monastery.

IN PROVERBIA SALAMONIS
In Proverbia Salamonis, a work by the great Anglo-Saxon historian Bede, was written in an Insular Minuscule script that had been perfected in Wearmouth-Jarrow by 750.

MERCIAN PRAYER BOOK
This page of set minuscule from a Mercian prayer book was written in the early ninth century, possibly in Worcester, Britain. Compare the relatively restrained decoration of the initial letter with that of Bede's *Historia Ecclesiastica* (*opposite*), which features spirals, frets, and knot interlaces.

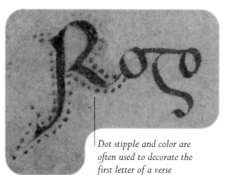

Dot stipple and color are often used to decorate the first letter of a verse

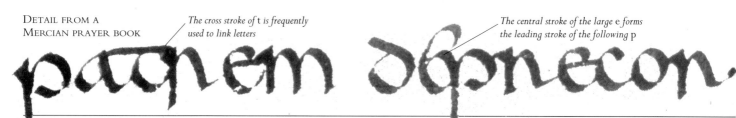

DETAIL FROM A
MERCIAN PRAYER BOOK

The cross stroke of t *is frequently used to link letters*

The central stroke of the large e *forms the leading stroke of the following* p

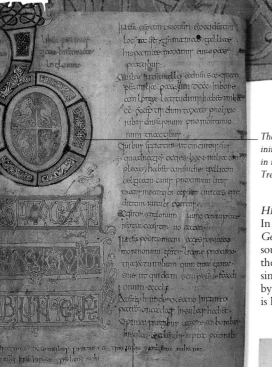

The decoration around the initial b resembles that found in metalwork on a cache in Trewhiddle, Cornwall

This whimsical decoration, with letters transforming into animals, is less formal than that used for capitals in the Lindisfarne Gospels (pp. 30–31)

HISTORIA ECCLESIASTICA
In Bede's *Historia Ecclesiastica Gentis Anglorum*, written in southern England in about 820, the descenders are made in a single stroke and terminated by an upward flick. The pen is lifted between each stroke.

The boxed capital letters demonstrate runic influences

The short s is used both medially and terminally

DETAIL FROM THE *HISTORIA ECCLESIASTICA*
Note the two different forms of r that occur at the end of the first and second words of this detail. The use of the upright form of the letter d in the second line is a departure from the Uncial form (pp. 24–25).

EXETER BOOK
Written during the second half of the tenth century in a fine Anglo-Saxon square minuscule, the Exeter Book is an anthology of vernacular poetry.

Carolingian influences

By the tenth century, the Insular Minuscule was undergoing changes, first becoming angular and upright and then, under the influence of the Caroline Minuscule (*pp. 38–39*), becoming more rounded. By the 11th century, the script had entered its final phase of change, with the letters gaining a squarer aspect.

Changes of pen angle

Throughout the development of the early Insular Minuscule, it was the changes of pen angle that allowed the scribes to express their calligraphic virtuosity. This element of play seems progressively to have diminished as the hand became squarer.

To the modern eye, the long, spiky descenders of the pointed cursive minuscule are made all the more dominant by their appearance on letters r and s (*pp. 36–37*). The other minim characters are rounded and compressed, which gives a more flowing texture to the page than any of the later Insular Minuscules.

Compare this form of a with the oc form used in the Historia Ecclesiastica

A decorative sweep on the final leg of m may occur at the end of a word or line

Insular Minuscule

CALLIGRAPHERS MAY WELL find the ductus of the Insular Minuscule one of the most satisfying to accomplish. In the Anglo-Saxon pointed minuscule shown here, the characteristic pointed aspect – most noticeable on the descenders – is created by progressively turning the pen to a steeper angle as the stroke is drawn. The pen begins at the headline at an angle of about 40° and on reaching the bottom of the descender has turned to a near vertical. The minim height is about five or six nib widths.

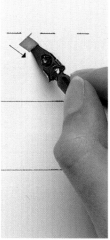

1. Using the edge of a square-cut nib, begin at the headline with a short downward diagonal stroke.

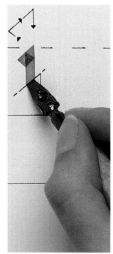

2. Return to the headline and begin the downward stroke with the pen at an angle of about 40°.

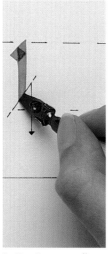

3. Continue to pull the pen downward, gradually turning the nib counterclockwise.

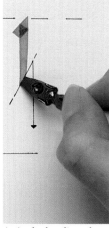

4. At the baseline, the pen angle should be about 65°, reaching 75° at the tip of the descender.

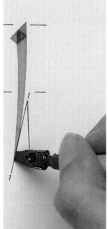

5. Once the descender has tapered to a point, begin retracing the stroke before separating at the baseline.

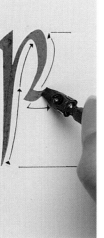

6. On reaching the headline, the pen should be at its original angle. Now proceed with the next part of the letter.

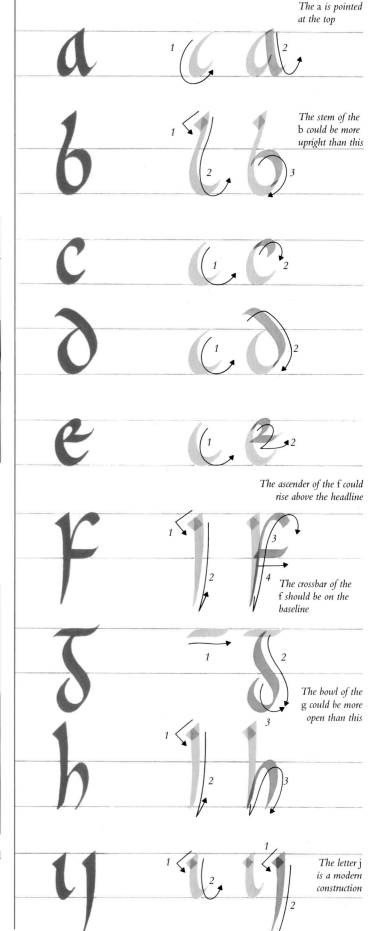

The a is pointed at the top

The stem of the b could be more upright than this

The ascender of the f could rise above the headline

The crossbar of the f should be on the baseline

The bowl of the g could be more open than this

The letter j is a modern construction

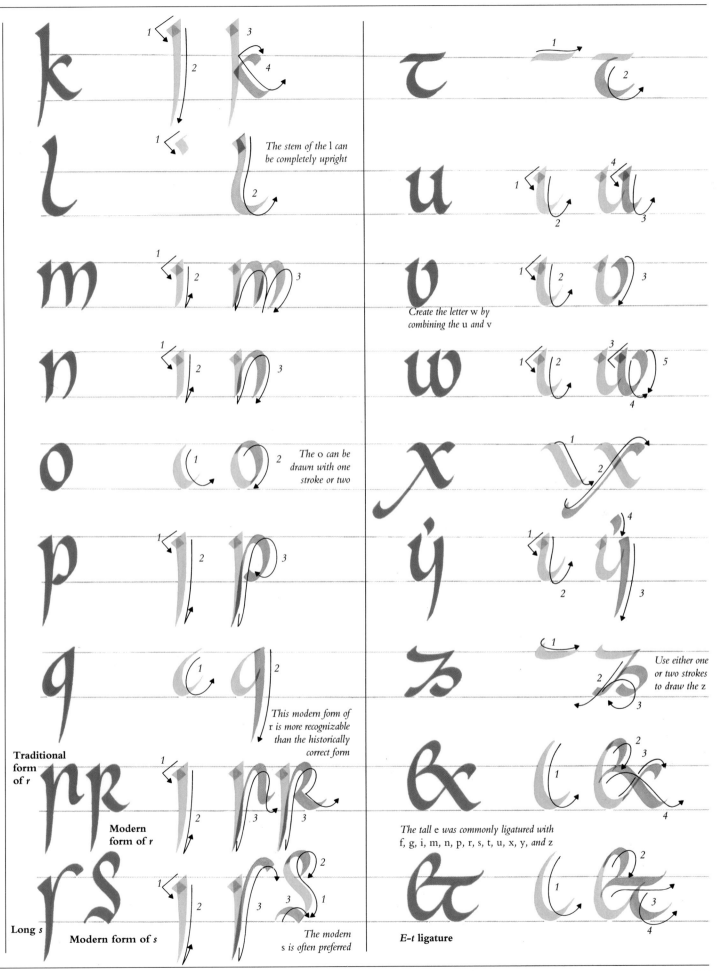

The stem of the l can be completely upright

Create the letter w by combining the u and v

The o can be drawn with one stroke or two

This modern form of r is more recognizable than the historically correct form

Use either one or two strokes to draw the z

Traditional form of r

Modern form of r

Long s

Modern form of s

The modern s is often preferred

The tall e was commonly ligatured with f, g, i, m, n, p, r, s, t, u, x, y, and z

E-t ligature

Caroline Minuscule

At first sight, the differences between the Caroline Minuscule (Carolingian Minuscule) and the late Half Uncial scripts (see Vatican Basilicanus, *below*) are not clear. The main distinction between the two is in the pen used to write them, the Half Uncial using a "straight" pen and the Caroline a "slanted" pen (*pp. 40–41*). In fact, the Caroline Minuscule was developed in the eighth century as a reformed version of the Half Uncial. It survived in this form until the 11th century, before evolving into the Early Gothic (*pp. 46–47*) and Rotunda (*pp. 84–85*).

The ascender is equal in height to the minim

CAROLINE MINUSCULE *H* The Caroline Minuscule is written with a square-cut nib, with the pen held at 30° (*pp. 40–41*).

The minims adhere strictly to the headline and baseline, creating neat, legible lines of text

BY THE LATE eighth century, Charlemagne (Charles the Great, King of the Franks), had created a Frankish Empire that stretched from the Baltic to northern Italy.

Inspired by the glories of antiquity, Charlemagne instigated a great cultural revival. The prominent scholar Alcuin of York was made Abbot of St. Martins in Tours, France, where he established a scriptorium and Court School. It was here that the existing Half Uncial was reformed to create the Caroline Minuscule.

A dominant script

Characterized by its clarity and uniformity, the Caroline Minuscule gradually became the dominant script in Europe. It arrived late in England, but was adopted in the tenth century for Latin texts, such as the Ramsey Psalter (*pp. 42–43*).

More than 400 years later, it was rediscovered by Renaissance scribes and, in turn, adapted by Nicholas Jenson and other type designers in Venice for their early printing types (*pp. 90–91*).

VATICAN BASILICANUS
The Half Uncial is usually defined by its capital form of *N* and by the oblique-cut nib used to write it (*p. 40*). Although lacking in subtlety, this early example, probably from the late fifth century, shows clear and unambiguous letterforms. Note how vertical the script is compared to the slanted Caroline of the Grandval Bible (*opposite*).

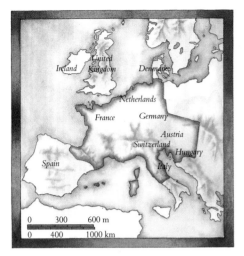

FRANKISH EMPIRE
The extent of Charlemagne's Frankish Empire in the early ninth century is marked in red on this map of modern Europe. As the empire expanded north of the Alps, Latin and Greek learning was carried with it.

These modern Caroline letters have been written in gouache on a background of watercolor

Capital letters, loosely derived from Uncial and Roman models, have been created to harmonize with the minuscule hand

CLOUD CONCEPTIONS FROM ABOVE

THREE WHITE TREES,
equidistant, arise like plumes
from the gray-white floor of mist
Between the mountain chains
In morning sun, which slowly burns
the valley fog away.
The three trees change to sinister mushroom shapes
which stay awhile, and then dissolve.
In morning light, a snowfield I could walk upon.
My trees are gone, miles past,
Returned to parent vapor

SHEILA WATERS
Composed in 1990 by the English-born calligrapher Sheila Waters, this work is part of a triptych entitled *Cloud Conceptions from Above*. The text is arranged asymmetrically in a stretched, modern version of Caroline Minuscule. The even height and straightness of the lines allow subtle color changes to be made to the letters without the overall design becoming too busy.

INCIPIT LIBER
EXODVS

AEC SUNT Cap·1.
NOMINA
FILIORŪ
ISRAHEL
QUIINGRES
SISUNTIN IJ
AEGYPTU
CUMIACOB
SINGULI
CUMDOMI
BUS SUIS
INTROIE
RUNT

Ruben. Symeon. leui. Iuda. issachar. zabulon
et beniamin. dan et nepthalim. gad et aser
Erant igitur omnes animae eorum quae egres
sae sunt de femore iacob. septuaginta quinque
Joseph autem. in aegypto erat Quomortuo et
uniuersis fratrib: eius omniq: cognatione sua.

A square-cut nib

The major difference between the Half Uncial and the Caroline Minuscule is in the cut of the pen nib. The earlier hand is written with an oblique-cut nib, which produces an upright letter with contrasting thick and thin strokes. The Caroline is written with a square-cut nib, which produces letters with strokes of even proportions (*pp. 40–41*).

Textural color

When viewed as a page of text, the textural color of the Caroline Minuscule is quite distinct from that of the Half Uncial. While the Half Uncial letters have a static aspect, the Caroline letters have a slight forward thrust, an element most noticeable on the ascenders and descenders. Minims adhere sharply to the headlines and baselines, which emphasizes the script's ordered and logical aspect.

The square-cut pen nib gives the Caroline Minuscule letters a slight forward thrust

THE GRANDVAL BIBLE
There is a subtle forward thrust to these exemplary Caroline Minuscule letters. They are written between four imaginary lines: the minims adhere to the central two lines, the ascenders reach the top line, and the descenders reach the bottom line. The ascenders and descenders are exactly the same height as the minims.

Caroline Minuscule

THE CAROLINE MINUSCULE is one of the easiest hands for a calligrapher to master. As a reformed script, its original function was to communicate legibly (*pp. 38–39*). The letters are without embellishments, the word spaces clear, and the ligatures minimal. Although closely related to the Half Uncial, from which it derives (*below*), the Caroline is always written with a "slanted" pen whereas the Half Uncial is usually written with a "straight" pen.

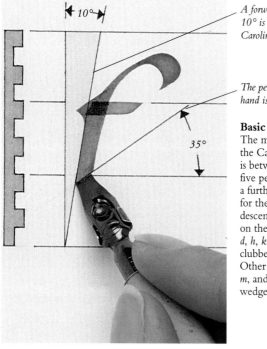

A forward slant of about 10° is characteristic of the Caroline Minuscule letter

The pen angle for the hand is about 35°

Basic elements

The minim height of the Caroline Minuscule is between three and five pen widths, with a further two or three for the ascenders and descenders. The serifs on the ascenders of *b*, *d*, *h*, *k*, and *l* have a clubbed appearance. Other letters, such as *i*, *m*, and *n*, have slightly wedge-shaped serifs.

Caroline Minuscule

The Caroline Minuscule a is a two-level, open letter

The Caroline n takes a recognizably lowercase form

The Caroline Minuscule is written with a "slanted" pen (square-cut nib)

Half Uncial

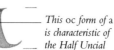

This oc form of a is characteristic of the Half Uncial

The Half Uncial hand retains the Uncial capital n

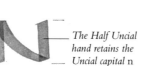

The Half Uncial is written with a "straight" pen (oblique-cut nib)

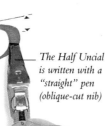

The third stroke of the d *could be a continuation of the second*

The sweep of the third stroke of the e *could continue upward to join the bowl*

The stem of the f *can also be made with a single downward stroke*

The bowl of the g *should be left open*

Finish the h *with this inward sweep or with a foot (see alternative* n, *opposite)*

Skate the tail of the i *to form a* j

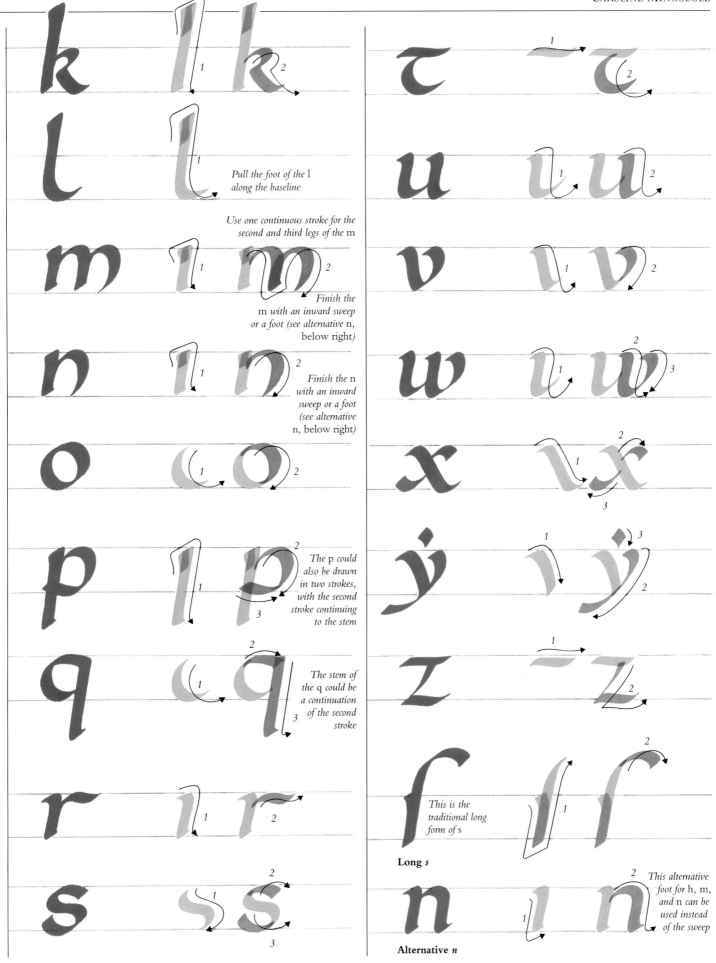

Pull the foot of the l along the baseline

Use one continuous stroke for the second and third legs of the m

Finish the m with an inward sweep or a foot (see alternative n, below right)

Finish the n with an inward sweep or a foot (see alternative n, below right)

The p could also be drawn in two strokes, with the second stroke continuing to the stem

The stem of the q could be a continuation of the second stroke

This is the traditional long form of s

Long *s*

This alternative foot for h, m, and n can be used instead of the sweep

Alternative *n*

Foundational Hand

N O BOOK ON THE mechanics of calligraphy is complete without a reference to Edward Johnston's Foundational Hand and its simplicity and integrity. Historically, it belongs to the early 20th century. However, the basis for the script is a manuscript dating from the year 966, the Ramsey Psalter. Believed to have been produced by scribes at Winchester, the Ramsey Psalter was written in a hand now known as the English Caroline Minuscule, an Anglicized version of Frankish Caroline Minuscule (*pp. 38–39*).

FOUNDATIONAL *P*
With the pen held at 30°, the weight of each Foundational letter appears to be evenly distributed between horizontal and vertical strokes.

The strokes are drawn with a broad-edged "slanted" pen

BY THE END OF the 19th century, under the influence of the Arts and Crafts movement in England, a whole new philosophy was emerging among artists and craftsmen. The basis of this philosophy was that the honest construction of an artifact was achieved only by the correct interaction of tool and material. Medical student Edward Johnston readily endorsed this idea and began, in 1897, to experiment in writing letters with a broad-edged pen. In 1899, his work came to the attention of W.R. Lethaby, Principal of the Central School of Arts and Crafts in London, who invited him to teach classes in Calligraphy and Illumination. In 1901, Johnston also began lecturing at the Royal College of Art, London.

In this detail, the "lumped" serif on the l has been completed after the stem has been drawn

THE RAMSEY PSALTER
The Caroline Minuscule of the Ramsey Psalter was one of the hands on which Johnston's calligraphic work was based. In *Writing and Illuminating and Lettering*, he stated, "it has all the qualities of good writing in a marked degree, and I consider it, taken all round, the most perfect and satisfactory penmanship which I have seen."

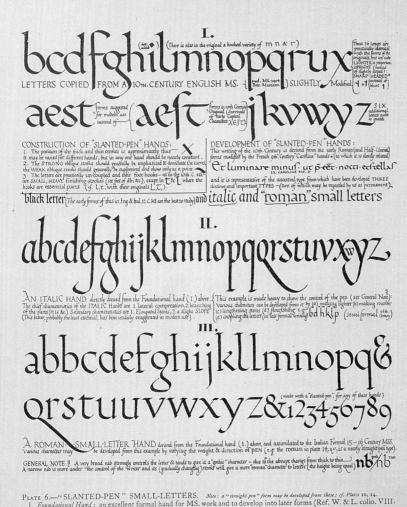

EDWARD JOHNSTON
Through his calligraphy, design, writing, and teaching, Edward Johnston became one of the the most influential pensmen of the early 20th century. He is pictured here using his favorite writing instrument, the quill.

"Slanted" pen letters

Johnston was encouraged in his work by Sidney Cockerell, the former secretary to William Morris, who introduced him to the Ramsey Psalter. It was then that he wrote to a friend: "And so the idea came – to make living letters with a formal pen." In his great instructional work *Writing and Illuminating and Lettering*, published in 1906, he explained his preference for "slanted" pen letters, such as those in the Ramsey Psalter, over the Half Uncial letters written with a "straight" pen (*pp. 38–39*). Drawn with a broad-edged pen held at 30°, the "slanted" letters had the greater strength and legibility, and the text they produced was of an even weight.

"Sharp-headed" serifs

The most marked difference between Johnston's letters and those of the Caroline Minuscule is the serif on ascenders. Regarding the "pushed" pen strokes used for "lumped" serifs as forced, Johnston advocated the use of "sharp-headed" serifs made from "pulled" pen strokes.

WORKSHEET
In 1909, in collaboration with the artist Eric Gill, Johnston produced a series of student worksheets on which he described the Foundational Hand as "excellent for formal MS work and to develop into later forms." On the sheets, he modified the Ramsey Psalter script by making it lighter and more upright, and he included his characteristic "sharp-headed" serifs.

Careful consideration of text size, letter weight, and spacing is demonstrated in this mature work by Johnston

STUDY SHEET
The main text of this study sheet from 1919 is written in Johnston's own fully developed Foundational Hand. The ascenders are more ordered and shorter than those demonstrated on the earlier worksheet (*above*). Johnston's mastery of Italics (*pp. 94–95*) is also clear.

Foundational Hand

ALMOST AS IMPORTANT in calligraphy as the letterforms is the manner in which the words are laid out on the page and the textural effect that they achieve. With its regularity of ductus, in which arches, curves, widths of letters, and internal spaces all relate, the Foundational Hand demonstrates a perfect evenness of texture (see Interletter spacing, *below*). The pen angle is about 30°, increasing to about 45° for diagonal strokes. Minim height is four or five nib widths, with a further three for ascenders and descenders.

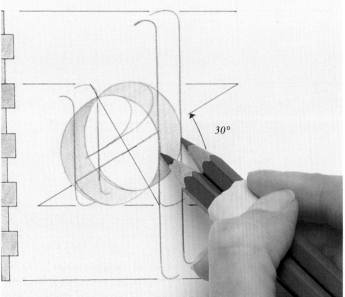

30°

The key letter
As this composite character of *a, d, e, n,* and *q* shows, the *o* is the key letter of the hand. Take time and care to compose its two curved strokes. It is useful to explore the construction of Foundational letters by drawing them with two pencils taped together. The pencil points relate to the corners of a pen nib.

Internal spaces
The elegant oval of space within the letter *o* provides the model to which all other spaces in the hand should ideally conform.

Interletter spacing
The spaces between letters should be as consistent as possible. Many scribes train their eyes to study interletter spacing as keenly as the letterforms themselves.

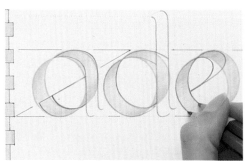

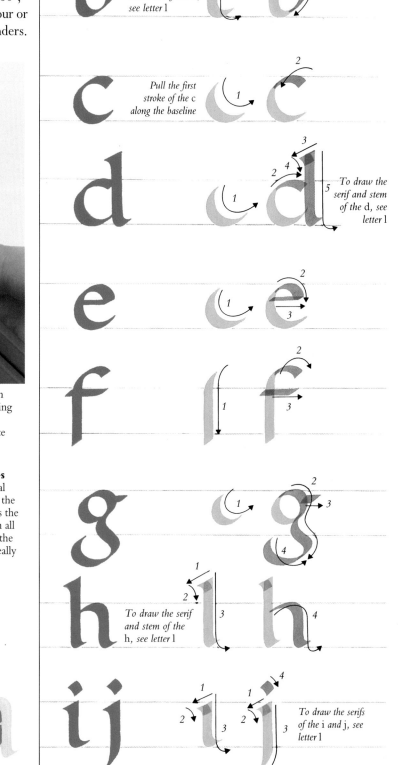

To draw the serif and stem of the b, see letter l

Pull the first stroke of the c along the baseline

To draw the serif and stem of the d, see letter l

To draw the serif and stem of the h, see letter l

To draw the serifs of the i and j, see letter l

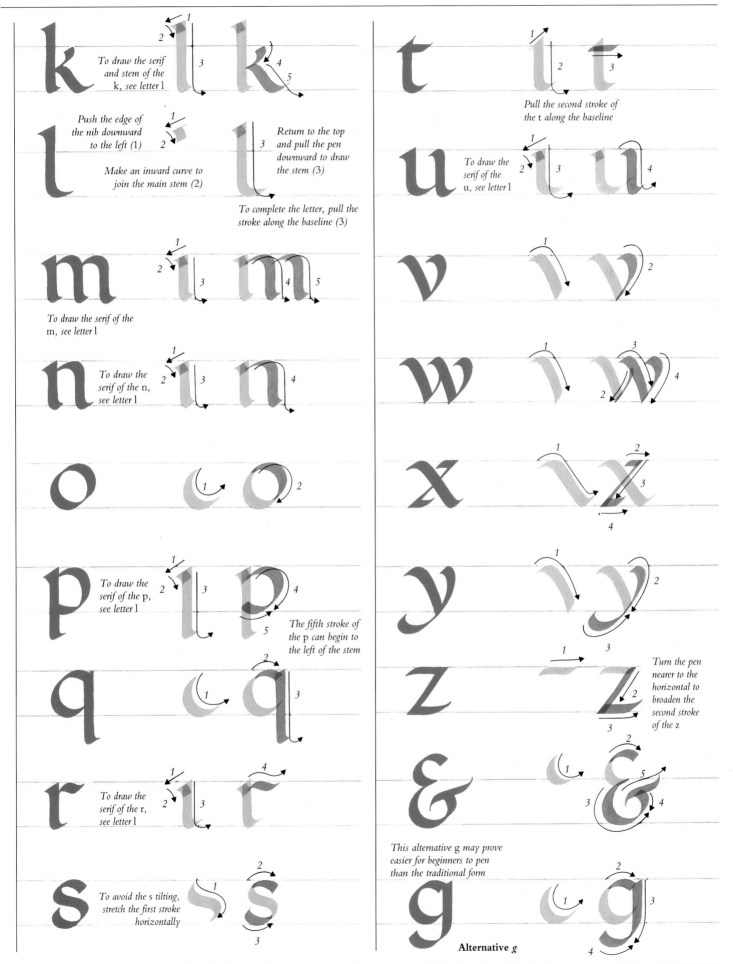

To draw the serif and stem of the k, see letter l

Push the edge of the nib downward to the left (1)

Make an inward curve to join the main stem (2)

Return to the top and pull the pen downward to draw the stem (3)

To complete the letter, pull the stroke along the baseline (3)

To draw the serif of the m, see letter l

To draw the serif of the n, see letter l

To draw the serif of the p, see letter l

The fifth stroke of the p can begin to the left of the stem

To draw the serif of the r, see letter l

To avoid the s tilting, stretch the first stroke horizontally

Pull the second stroke of the t along the baseline

To draw the serif of the u, see letter l

Turn the pen nearer to the horizontal to broaden the second stroke of the z

This alternative g may prove easier for beginners to pen than the traditional form

Alternative g

45

Early Gothic

THE EARLY GOTHIC script (Proto-Gothic, Late Caroline) was used widely in most of western Europe from the late 11th century to the mid-13th century, a period that fell between the end of the Caroline era and the beginning of the Gothic. In retrospect, the script can be seen as transitional between the Caroline Minuscule (*pp. 38–39*) and the Gothic Textura hands (*pp. 50–57*), for it contains characteristics of each, including the rounded bows of the Caroline and the split ascenders of the Quadrata.

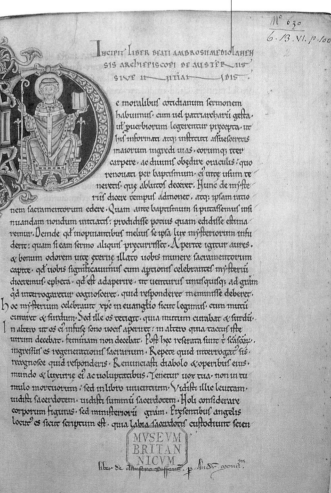

The flick at the head of the stem can either be drawn as an initial stroke or added on completion

The bow is quite compressed, giving it an oval aspect

EARLY GOTHIC B
This Early Gothic letter is written with the pen at an angle of about 40°.

THE EARLY GOTHIC script evolved directly from the Caroline Minuscule. It was more compressed and oval than its predecessor and greater attention was paid to such details as serifs and the feet of minims. Its development was possibly the simple result of scribes altering their pen nibs from square-cut to oblique-cut. This produces more angular letters and gives an upright aspect to a page of text. The difference between letters written with a square-cut nib and those written with an oblique-cut nib can be seen when comparing the Winchester Bible with the Grandval Bible (*p. 39*).

The Winchester Bible

The Winchester Bible is one of the most outstanding books of the Early Gothic period. Commissioned by Henry of Blois, the Bishop of Winchester, Britain, it dates from about 1150. Written with a "straight" pen held at an angle close to the horizontal, the script features short, neat ascenders and descenders. These create more interlinear space than longer ascenders and descenders would, and so aid the reading of the line. Many of the Lombardic Capitals in the Winchester Bible, used both as display capitals and as capitals within the text, are among the finest of their kind (*pp. 62–63*).

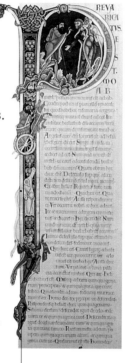

The initial illuminated P *is extended to fill the length of the column of text*

THE WINCHESTER BIBLE
The illuminated initials in the Winchester Bible represent a high point in medieval artistry and are the work of six different illuminators. This initial letter *P* from the Book of Kings shows Elijah being consulted by the messengers of Ahaziah.

These rubricated capitals reflect the use of Rustic Capitals for titles, (see The hierarchy of scripts, p. 16)

ST. AMBROSE, DE MISTERIIS I
This page is from a theological tract probably penned at Rochester Priory, Britain, in 1130. The Early Gothic hand used is in complete contrast to that of the Winchester Bible (*above*). Although the nib is square, the pen is held at an angle close to 40°, which results in a strong headline, reinforced by a sturdy baseline.

This Versal letter I departs from Gothic conventions in the extreme informality of its decoration

The pen is held at a shallower angle than in the St. Ambrose, De Misteriis I manuscript (opposite), resulting in less legible lines of text

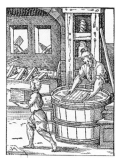

PAPER MAKER
The earliest European paper was made from rags of cotton or linen, which were chopped, soaked, and laid on a sieve before being pressed and dried. In Britain, relatively fine paper was available by the 12th century.

MORALIA IN JOB
The *Moralia in Job* volumes were completed in 1111 by scribes and illuminators at Cîteaux, France, one year before St. Bernard arrived and imposed the hard discipline for which the Cistercian order became known. The humor and vibrant color in the illustration of this page from the manuscript are in sharp contrast to the work produced in the austere times that followed.

These letters are less compressed than is typical for Early Gothic script

Development of Early Gothic

The Early Gothic script originated in the areas that were subject to Norman and Angevin influence — mainly England and France — before spreading to northern Germany, Scandinavia, Spain, Sicily, and part of Italy. As a result of English influence, more attention was paid to the feet of the minims, which were formally applied, as opposed to the upward flick favored on the Continent. As the script developed, minims generally became more compressed.

The demise of the hand

The hand is perhaps best regarded as the midpoint of the pendulum swing between the Caroline Minuscule, with its clearly defined letterforms, and the Gothic Textura hands, in which the overall textural effect is of the greatest importance. Although influenced by the Caroline, scribes quickly realized that if they increased the compression of letters, they could alter the textural color of the page. This reached its extreme form in the Gothic Textura hands, which quickly grew in popularity and displaced the Early Gothic.

Early Gothic

EARLY GOTHIC SCRIPT is written with a "straight" pen and
has an upright, compressed aspect. The wedge serifs on
the headline of the minim characters help create a strong
horizontal stress to the text. The minim height varies between
approximately four and six pen widths, and ascenders and
descenders frequently equal the minim height. Because of the
great variation in pen angle – between 10° and 40° – various
types of serifs are included in the hand. The most distinctive of
all is the split serif on the ascenders of letters *b*, *d*, *h*, *k*, and *l*.

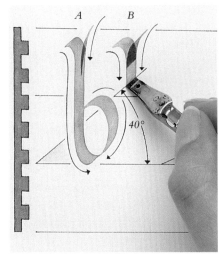

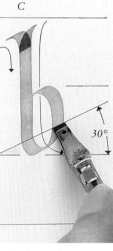

Split serifs
Create the split ascender with a pen angle of 40°,
drawing the left serif and main stem first, then
adding the thinner right serif (*A*). Alternatively,
extend the thin serif into the stem (*B*).

"Filled" serifs
A third method involves
"filling" the split serif (*C*).
The pen is held at a constant
30° for the whole letter.

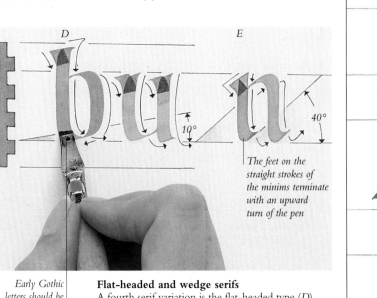

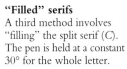

*The feet on the
straight strokes of
the minims terminate
with an upward
turn of the pen*

*Early Gothic
letters should be
written with an
oblique-cut nib*

Flat-headed and wedge serifs
A fourth serif variation is the flat-headed type (*D*),
created by overlapping two strokes, with a pen angle
of about 10°. A fifth serif type is the wedge serif (*E*),
which appears on the letters *i*, *m*, *n*, *p*, *r*, and *u*, as well
as the modern letters *j*, *v*, and *w*. This can be drawn
in one or two strokes, with a pen angle of about 40°.

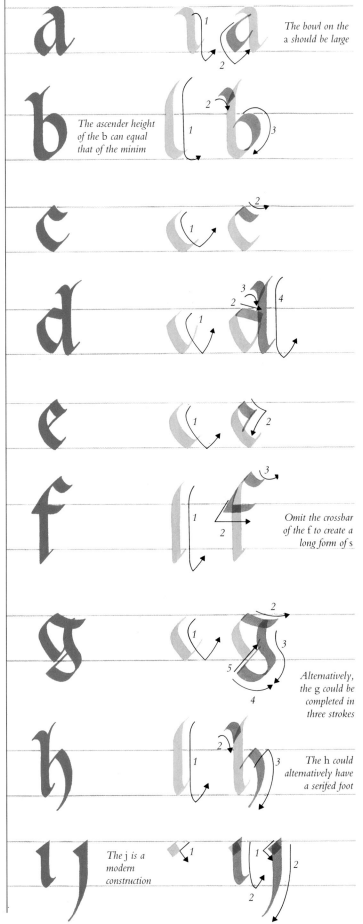

*The bowl on the
a should be large*

*The ascender height
of the b can equal
that of the minim*

*Omit the crossbar
of the f to create a
long form of s*

*Alternatively,
the g could be
completed in
three strokes*

*The h could
alternatively have
a serifed foot*

*The j is a
modern
construction*

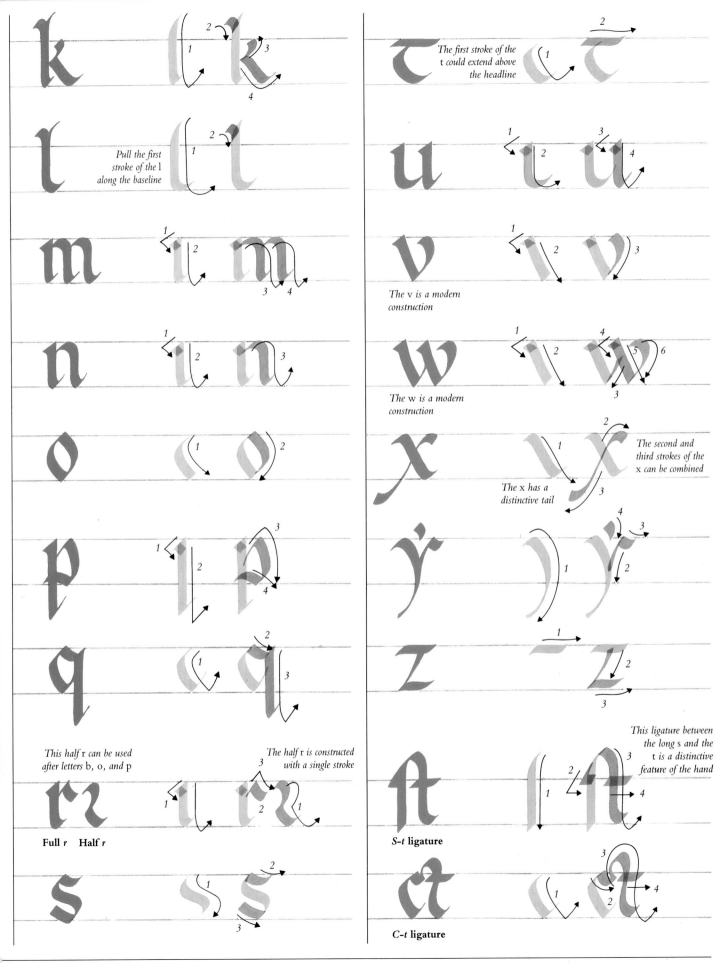

Pull the first stroke of the l along the baseline

The first stroke of the t could extend above the headline

The v is a modern construction

The w is a modern construction

The x has a distinctive tail

The second and third strokes of the x can be combined

This half r can be used after letters b, o, and p

The half r is constructed with a single stroke

Full r Half r

This ligature between the long s and the t is a distinctive feature of the hand

S-t ligature

C-t ligature

Textura Quadrata

B Y THE BEGINNING of the 13th century, the Early Gothic script had evolved into a noncursive, angular hand known as the Textura Quadrata (Black Letter, Old English). The name indicates the woven appearance of the lines of text, "Textura" meaning "an even effect in weaving." The script represented a revolutionary change in calligraphy – after centuries of emphasis on clear letter recognition, individual letters were suddenly subservient to overall textural effect.

TEXTURA QUADRATA *N*
The script's most distinctive feature is the diamond-shaped terminals of the minim strokes.

WITH ITS DENSE, angular strokes and diamond-shaped heads and feet, the Quadrata letter is to many people a graphic embodiment of the Middle Ages. In northern Europe, it was used into the 16th century for high-grade liturgical manuscripts, second only in prestige to its twin script the Prescisus (*pp. 54–55*). The Quadrata's decline as a deluxe bookhand may have been partly due to its large size; the demand for smaller, handheld books meant that more modestly sized scripts such as the Schwabacher (*pp. 74–75*) and Humanist Minuscule (*pp. 90–91*) were more suitable.

However, the Quadrata did survive into the 20th century in the form of cut letters, stained glass letters, and titles on deeds, as well as being much favored in Europe by signwriters, shop owners, and designers of newspaper mastheads.

The outlines of Versals and illustrations were drawn in the spaces provided by the scribe. Here, they have been outlined in metalpoint, with the gold and color still to be applied

THE METZ PONTIFICAL
This beautifully crafted page from an early 14th-century French manuscript shows Textura Quadrata at its finest. The even, textured effect of the page is created by the scribe's meticulous regulation of spacing and minim height. The scribe may have used an oblique-cut nib, which would have made the production of fine hairlines particularly easy (*pp. 14–15*). Note the rubricated capitals *S* and *I*, preceded by the capital *P*. The stroke through the stem of the *P* denotes the contraction of "par," "per," or "por."

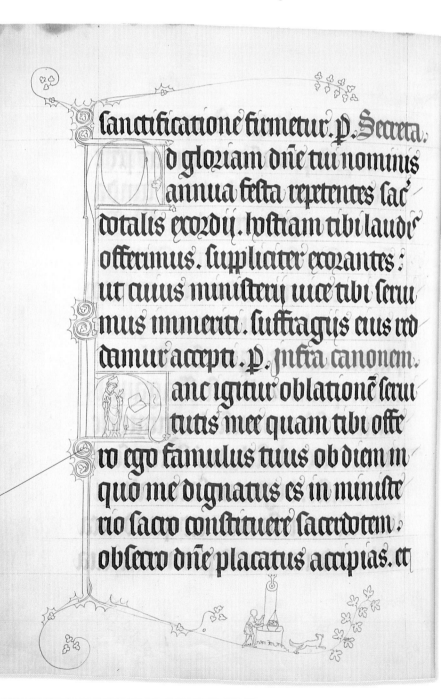

PAINTING IN CHICHESTER CATHEDRAL
This painting shows Bishop Sherbourne asking King Henry VIII to confirm the charter for Chichester Cathedral. By the time the work was painted in 1519, the Quadrata would have been obsolete as a text hand, appearing only occasionally in brush-drawn form. The artist has padded out the text on the top line with awkward word breaks. The inelegance of these breaks is possibly exacerbated by the requirement to place the word "*Rex*" above the King's head.

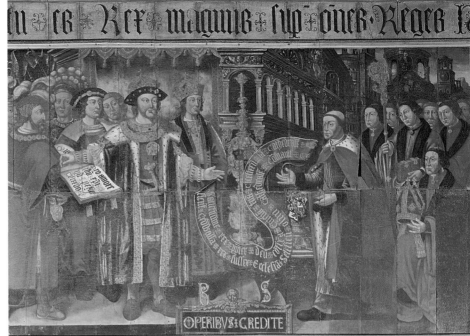

The split ascenders and descenders have been exaggerated, particuarly on the descender of the p

The text on the book includes the alternative Gothic a, which features a double crossbar through the counter

DETAIL FROM PAINTING IN CHICHESTER CATHEDRAL
The split ascenders and descenders are particularly developed in this brush-drawn version of Quadrata, but they have caused the artist difficulties – the ascenders of letters *d* and *t* clash with the descenders of the *p*s.

Many strokes, such as those on the s, terminate with hairline flourishes – evidence of the scribe's virtuosity

The counter of this large Versal P is used to display the coat of arms of the d'Orgemont family

GOTHIC ALPHABET
This page from a combination calendar, hymnal, and prayer book belonging to Guillaume d'Orgemont dates from about 1386. It shows an almost complete alphabet of Textura Quadrata letters, including two versions of *a*, *r*, and *s*. Close examination of the letters suggests that the pen may have been cut obliquely. This would explain the thickness of the stem strokes, compared to the diagonal and diamond strokes.

Dotting the i and j

The characteristic uniformity of the Textura Quadrata letter produced an interesting innovation that remains in use today. Having been easily mistaken for other letters, the *i* was distinguished from other letters by a flick (by the late 14th century, this had developed into a dot). The letter *i* also doubled up as a *j*, acquiring a tail when so used. This change, along with the late medieval inclusion of the *w* and the differentiation of *v* and *u*, gave us our 26-letter modern alphabet.

Script status

The status of a script is generally determined by the number of separate strokes and pen lifts used in its creation, a distinction particularly discernible in the Quadrata. Generally, the more angular and compressed the letters, the more strokes will have been used in their construction. A useful indicator of the status of a script is the bowl of the letter *a*, which can range from a low-status, almost cursive form (see the Painting in Chichester Cathedral, *above*) to a high-status, rigidly geometric form (see the Gothic alphabet, *left*).

Textura Quadrata

THE ESSENCE OF THE Quadrata is the formal, upright letter with strokes differing as little as possible from one another. Curves are practically eliminated and the formality is only broken by the use of hairlines. These include the skating strokes that occur on letters *a*, *e*, and *r*, created by dragging the wet ink with the corner of the nib. The Quadrata's other distinctive features are the split ascenders and the diamond feet on the minims, applied with only a small space between each one.

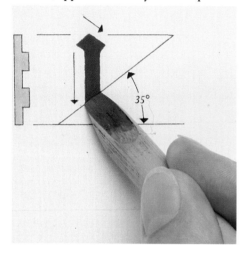

Basic elements
A "slanted" pen (square-cut nib) is used for the Quadrata. The pen is held at an angle of between 35° and 45° for stem strokes, adjusted to a shallower angle for connecting strokes. Minim height is generally about five pen widths. The relatively large size of the letters makes the use of a reed pen ideal.

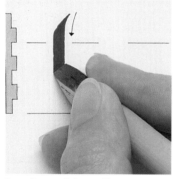

Drawing a right serif
The split ascender is drawn in two strokes. Begin the right serif above the headline, pulling the pen down to the left to complete the stem in one stroke.

Adding a left serif
The pointed left serif should be a little shorter than the right one. Turn the nib onto its left corner and use the wet ink from the previous stroke.

Textural effect
To achieve the ideal textural effect of Quadrata, innerletter spaces and interletter spaces should each equal the width of one stroke.

Interword space should be equal to about two nib widths

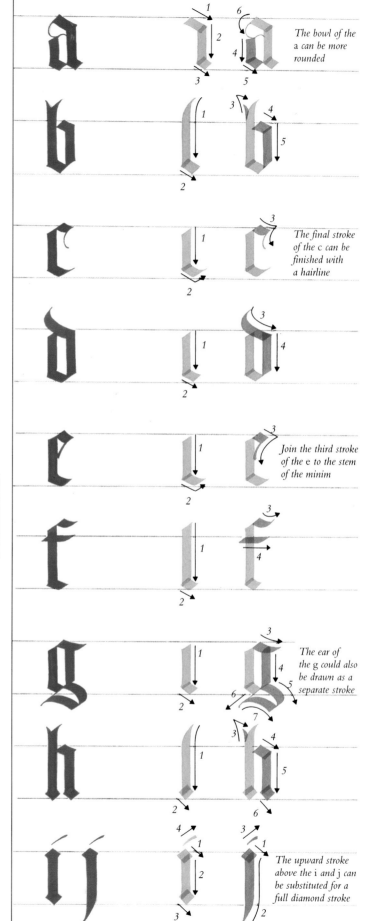

The bowl of the a can be more rounded

The final stroke of the c can be finished with a hairline

Join the third stroke of the e to the stem of the minim

The ear of the g could also be drawn as a separate stroke

The upward stroke above the i and j can be substituted for a full diamond stroke

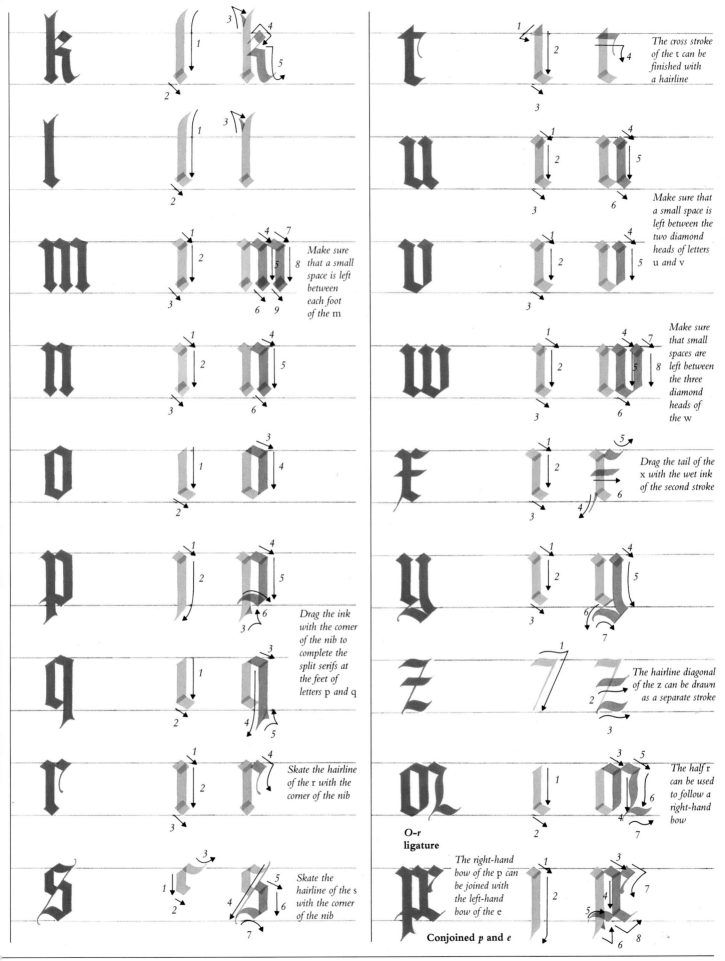

Make sure that a small space is left between each foot of the m

Drag the ink with the corner of the nib to complete the split serifs at the feet of letters p and q

Skate the hairline of the r with the corner of the nib

Skate the hairline of the s with the corner of the nib

The cross stroke of the t can be finished with a hairline

Make sure that a small space is left between the two diamond heads of letters u and v

Make sure that small spaces are left between the three diamond heads of the w

Drag the tail of the x with the wet ink of the second stroke

The hairline diagonal of the z can be drawn as a separate stroke

The half r can be used to follow a right-hand bow

O-r ligature

The right-hand bow of the p can be joined with the left-hand bow of the e

Conjoined p and e

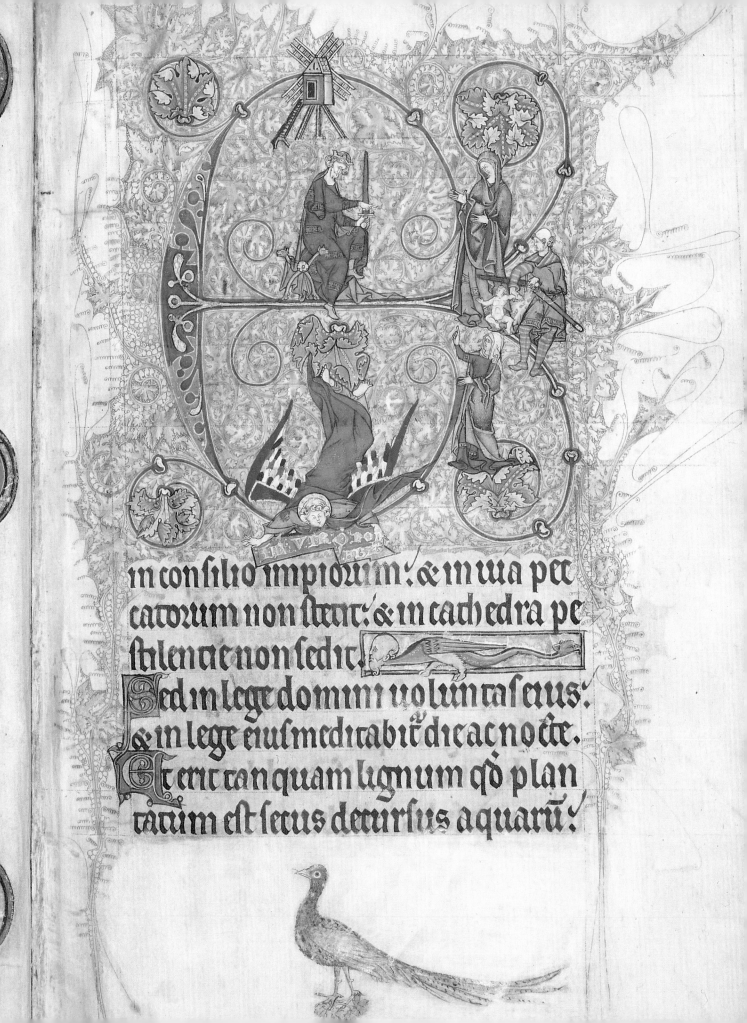

in consilio impiorum: & in uia pec
catorum non stetit: & in cathedra pe
stilentie non sedit.
Sed in lege domini uoluntas eius:
& in lege eius meditabitur die ac nocte.
Et erit tanquam lignum qd plan
tatum est secus decursus aquaru!

Textura Prescisus

USE OF THE TEXTURA PRESCISUS (*Textualis Prescissa*, Black Letter) paralleled that of the Quadrata (*pp. 50–51*), both in its duration as a bookhand and in the development of its textural style. The two scripts even used the same Capitals and Versals (*pp. 58–59*). The chief difference between them is indicated by the adjunct to the Prescisus's name, *vel sine pedibus*, which translates as "with its feet cut off." This refers to the square-ended bases of the minims and descenders in the hand.

The square-ended Prescisus feet contrast with the diamond feet of the Quadrata

TEXTURA PRESCISUS M
The flat feet of the Prescisus are the script's most characteristic feature.

THE WINDMILL PSALTER
The Windmill Psalter was written in England in about 1290. In this folio from The Judgement of Solomon, the fine filigree work is done with a sharply pointed quill. The steep pen angle used for the text produces typically angular letters with strong diamond heads and narrow minim strokes. Stroke width and inner letter spacing are equal.

THE ORMESBY PSALTER
The Ormesby Psalter, written in East Anglia in about 1300, reveals a more relaxed form of Prescisus than that used in the Luttrell Psalter.

THE LUTTRELL PSALTER
The Luttrell Psalter, written for a wealthy Lincolnshire landowner in about 1325-35, is Prescisus writing at its finest. The lines of text are uniform and condensed, each stroke neat and precise. The thickening of minims toward their base may indicate a twisting of the pen (*pp. 56–57*).

BOTH THE QUADRATA and the Prescisus evolved from the Early Gothic script (*pp. 46–47*) and date from the end of the 12th century. Paleographers are uncertain which of the two came first. It is possible that the Prescisus originated in southern England and spread to France, where scribes were inspired to develop the Quadrata. The arrival of the Prescisus was most likely the result of a creative burst from a calligraphic virtuoso. But, whatever its origins, the script rapidly became a more prestigious bookhand than did the Early Gothic.

A precise hand
As a script, the Prescisus was a *tour de force*. It was as precise as its name suggests and scribes needed a particular dexterity to use a "slanted" pen to produce the artificially constructed feet that imitated the work of a "straight" pen (*pp. 56–57*). The length of time it took to write the script meant that it could be used only for large, prestigious books. Use started to decline during the late Gothic period, and the introduction of printing saw its final demise.

The half r *is used when following a curved stroke*

The diamond heads of minims are characteristic of both Textura scripts

DETAIL FROM THE LUTTRELL PSALTER

Textura Prescisus

THE PRINCIPAL DIFFERENCE between the Quadrata and Prescisus is the latter's absence of diamond feet on letters *a*, *f*, *h*, *i*, *k*, *l*, *m*, *n*, *r*, *t*, and *u*. The split ascenders on *b*, *h*, *k*, and *l* are reduced or flat-headed (square-ended) and, in the extreme form of the script, letters *a*, *c*, *d*, and *e* are even deprived of a baseline stroke. Prescisus has a more clearly delineated base than the Quadrata and interlinear spacing is approximately equal to the minim height.

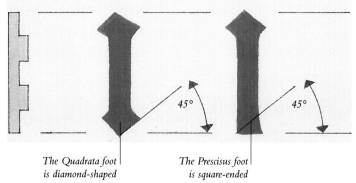

The Quadrata foot is diamond-shaped

The Prescisus foot is square-ended

Common elements
The Quadrata and Prescisus have a number of elements in common. Both have a minim height of approximately five pen widths and both are written with a "slanted" pen (square-cut nib). A pen angle of 45° is usual for both Textura scripts.

Outline the foot by drawing along the baseline and up to join the stem

Twist the pen 45° at the bottom of the stem

Twist from the top of the stem

Numerous tools are suitable for writing Prescisus letters, including the reed pen

Filled feet
To make the square foot, draw the stem at an angle of 45°, then add the outline of the foot by dragging the ink with the corner of the nib. This is then filled in with ink.

Pen twist
A second method involves twisting the pen from 45° to the horizontal in a short, swift movement (*above*). Alternatively, begin twisting at the top of the stem (*above right*).

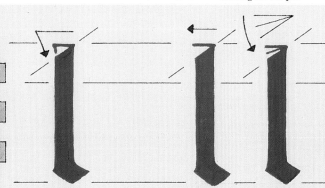

Flat-headed serifs
Like the square feet, the flat-headed serifs are created artificially with a "slanted" pen. One method is to outline the serif with the corner of the nib before filling it in with ink (*above left*). Alternatively, add the serif by twisting the pen downward from the horizontal of the ascender line to the 45° angle of the stem stroke (*above*).

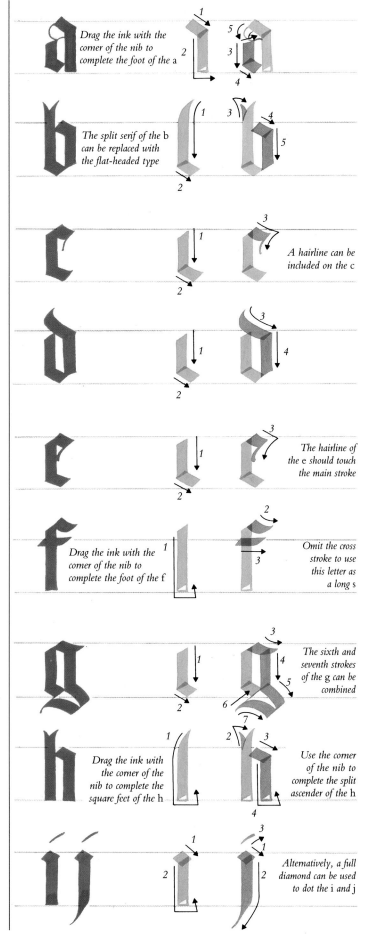

Drag the ink with the corner of the nib to complete the foot of the a

The split serif of the b can be replaced with the flat-headed type

A hairline can be included on the c

The hairline of the e should touch the main stroke

Drag the ink with the corner of the nib to complete the foot of the f

Omit the cross stroke to use this letter as a long s

The sixth and seventh strokes of the g can be combined

Drag the ink with the corner of the nib to complete the square feet of the h

Use the corner of the nib to complete the split ascender of the h

Alternatively, a full diamond can be used to dot the i and j

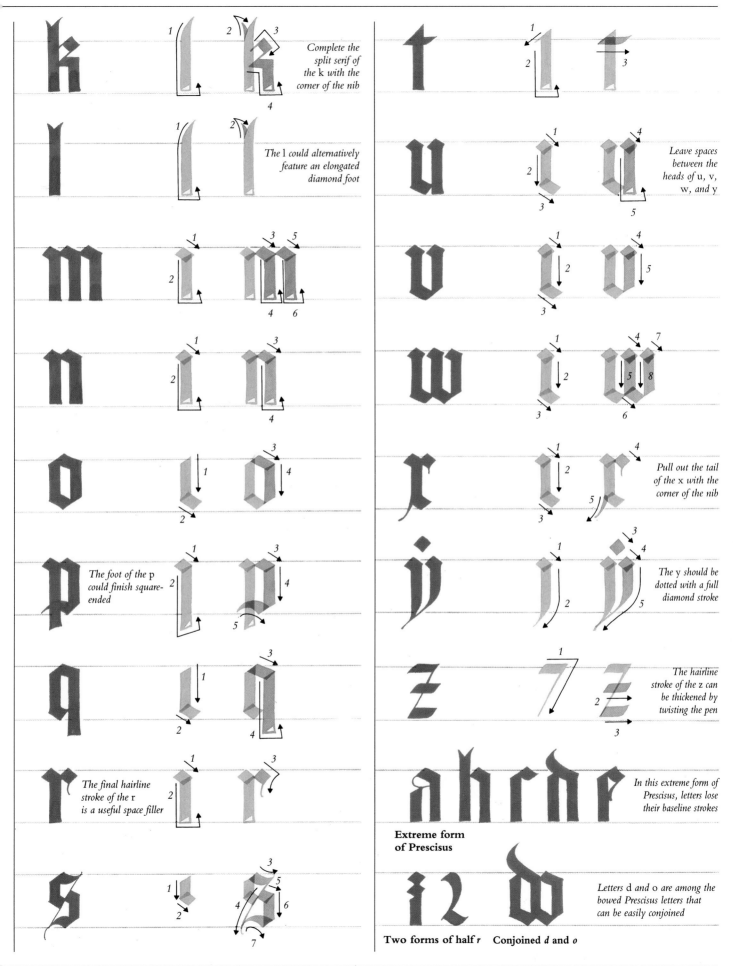

Complete the split serif of the k with the corner of the nib

The l could alternatively feature an elongated diamond foot

The foot of the p could finish square-ended

The final hairline stroke of the r is a useful space filler

Leave spaces between the heads of u, v, w, and y

Pull out the tail of the x with the corner of the nib

The y should be dotted with a full diamond stroke

The hairline stroke of the z can be thickened by twisting the pen

In this extreme form of Prescisus, letters lose their baseline strokes

Extreme form of Prescisus

Letters d and o are among the bowed Prescisus letters that can be easily conjoined

Two forms of half *r* Conjoined *d* and *o*

Gothic Capitals & Versals

THE PRINCIPAL DIFFERENCE between Gothic Capitals and Versals lies in their construction: Gothic Capitals are written with single strokes, whereas Versals are composed of several built-up strokes. A Versal is a single initial letter, drawn larger than the text script and used to indicate a title, chapter, or paragraph opening. The size of the Versal and the amount of gold and color used to decorate it is directly proportional to the perceived status of the initial within the text. Although less impressive than Versals, the Gothic Capital is far from plain, with elaboration in the form of hairline verticals and diagonals.

Exuberant flourishes of this kind are limited to opening letters or letters on the top line of a page of text

GOTHIC CAPITAL *P* Decorative diagonal strokes and hairlines reduce the amount of white space in the letter's counter and enhance its status in a page of text. In this *P*, the thick diagonal is complemented by hairlines above and below it.

IT WAS IN GOTHIC text that capital and minuscule letters of the same hand first appeared together. Gothic Capitals, which used the same ductus as the minuscules (*pp. 50–57*), were used within text script to begin a sentence or denote a proper noun.

In important sentences or verses, Gothic Capitals were frequently usurped by Versals. In its simplest form, a Versal can be an outline letter filled with a splash of color. In more sophisticated forms, it can be historiated (see the Winchester Bible, *p. 46*), zoomorphic (see the Book of Kells, *pp. 28–29*), or floriated (see the Book of Hours, *p. 84*). Alternatively, the decoration can be abstract, with spirals, frets, and interlaced knots (see the Lindisfarne Gospels, *pp. 30–31*).

Rounded bulges have been added to the stems to give extra emphasis to the letter

The counter of each letter has been decorated with vertical and diagonal hairlines

SAMPLE ALPHABET
Two sets of Gothic Capitals have been drawn on this incomplete sample alphabet, which dates from about 1400. Although the letters are not the finest examples of Gothic Capitals, each stroke is clearly shown, making them useful models for the modern calligrapher to follow. Note how the scribe has created extra weight on some bowed letters by adding an extra stroke.

THE ST. VAAST BIBLE
Written in northern France in the early 11th century, the St. Vaast Bible is a product of the Franco-Saxon school, which had been producing books of the highest order since the mid-ninth century. At first glance, the manuscript looks ahead of its time, so sophisticated is the page design. However, the plait and knot decoration around the Versal betrays the manuscript's Saxon pedigree (*pp. 28–31*).

The suggestion of a bracketed serif shows that these capitals were modeled on Imperial letters (pp. 108–109)

In this Versal, the initial letters E and T have been combined (this combination is the origin of our modern ampersand)

SIMPLE VERSALS
These Versals may be by the scribe responsible for the sample alphabet (*opposite*). They have been freely penned, with the letters drawn first and the decoration added afterward.

Models for Versals

Over the centuries, Versals have been modeled on a variety of letterforms. During the Gothic period, they were generally based on Lombardic Capitals (*pp. 62–63*). In the Caroline and the Renaissance eras, Imperial Capitals were often used as models (*pp. 108–109*). Possibly the most ornate Versals ever drawn were those in the deluxe Northumbrian manuscripts of the early medieval period (*pp. 28–31*). These were derived from Roman, Greek, and runic models.

Cadels

The other important model for Versals was the Bastard Capital (*pp. 78–79*). Enlarged and embellished by a series of interlacing strokes, this type of Versal is known as a Cadel (*pp. 80–81*). Cadels were later revived for use with Italic (*pp. 94–95*) and Copperplate (*pp. 102–103*) scripts.

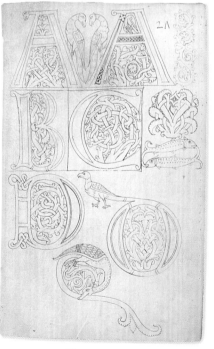

PATTERN BOOK
Designs for Versals were chosen by the patron from pattern books such as this one from the 12th century. This page shows a final working pattern, in which the intertwining stems have been accurately worked out.

Gothic Capitals

G OTHIC CAPITALS USE the same ductus as the minuscules (*pp. 52–53, 56–57*) and are written with the same "slanted" pen. However, the capitals have a wider, rounder aspect than the rigidly formal minuscules, and the two forms contrast strikingly when used together. The number of calligraphic flourishes in each Gothic Capital make it an unsuitable script for writing a whole word or a full page of text. For this, Lombardic Capitals provide a less flamboyant alternative (*pp. 64–65*).

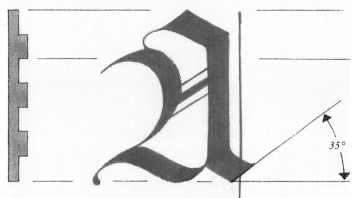

35°

Letter height
The letter height of the Gothic Capital is approximately seven pen widths, two higher than the minuscule height.

Hairlines
The inner-letter space is reduced by the use of hairlines, drawn with the corner of the nib. There are usually one or two vertical hairlines, and a single diagonal hairline on either side of a thicker diagonal stroke.

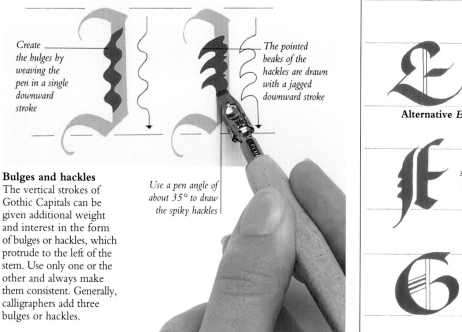

Create the bulges by weaving the pen in a single downward stroke

The pointed beaks of the hackles are drawn with a jagged downward stroke

Bulges and hackles
The vertical strokes of Gothic Capitals can be given additional weight and interest in the form of bulges or hackles, which protrude to the left of the stem. Use only one or the other and always make them consistent. Generally, calligraphers add three bulges or hackles.

Use a pen angle of about 35° to draw the spiky hackles

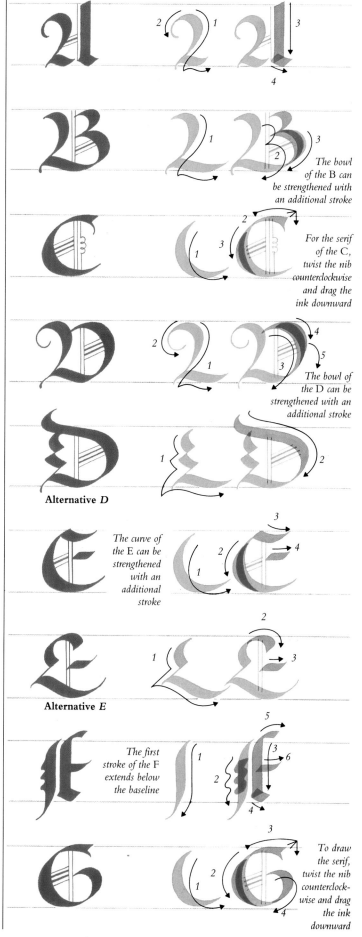

The bowl of the B can be strengthened with an additional stroke

For the serif of the C, twist the nib counterclockwise and drag the ink downward

The bowl of the D can be strengthened with an additional stroke

Alternative *D*

The curve of the E can be strengthened with an additional stroke

Alternative *E*

The first stroke of the F extends below the baseline

To draw the serif, twist the nib counterclockwise and drag the ink downward

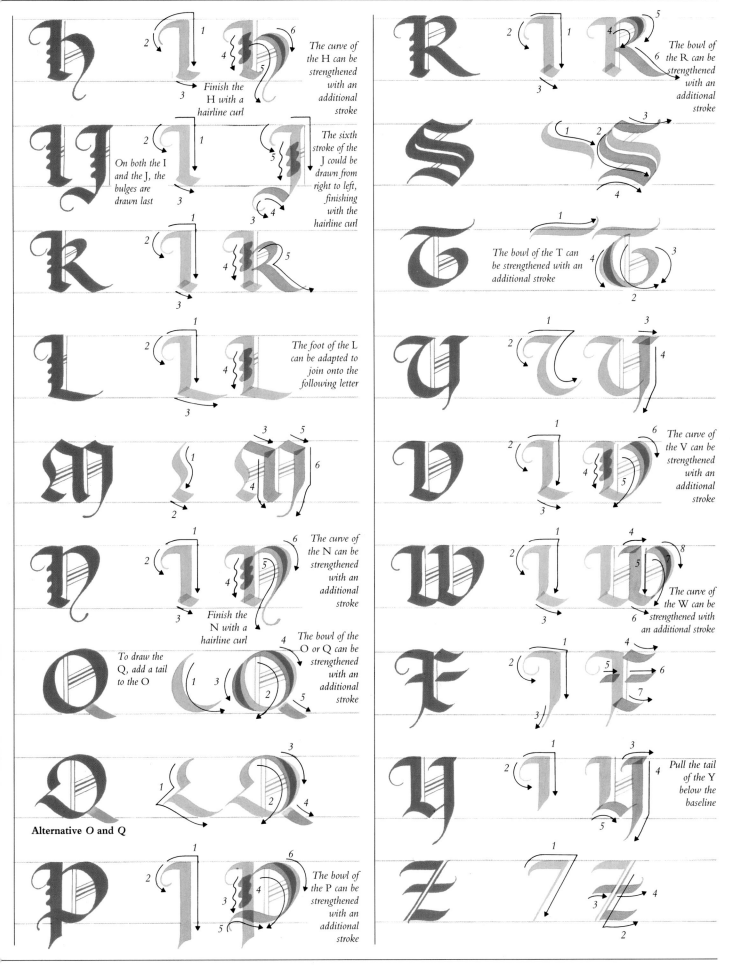

The curve of the H can be strengthened with an additional stroke

Finish the H with a hairline curl

On both the I and the J, the bulges are drawn last

The sixth stroke of the J could be drawn from right to left, finishing with the hairline curl

The foot of the L can be adapted to join onto the following letter

The curve of the N can be strengthened with an additional stroke

Finish the N with a hairline curl

To draw the Q, add a tail to the O

The bowl of the O or Q can be strengthened with an additional stroke

Alternative O and Q

The bowl of the P can be strengthened with an additional stroke

The bowl of the R can be strengthened with an additional stroke

The bowl of the T can be strengthened with an additional stroke

The curve of the V can be strengthened with an additional stroke

The curve of the W can be strengthened with an additional stroke

Pull the tail of the Y below the baseline

Lombardic Capitals

A LOMBARDIC CAPITAL is a built-up letter characterized by curved stems and distinctive monoline serifs. Unlike Gothic Capitals (*pp. 58–59*), Lombardic letters worked well in sequence and so were used for whole words and phrases. They were successful both in penned form as display capitals and carved form for monumental work. The script was increasingly prevalent by the mid-11th century, and finally ousted by the Humanist Capital in the 16th century (*pp. 98–99*). However, it enjoyed a resurgence, particularly as a monumental letter, during the 19th-century Gothic revival in England, under the influence of the architect and designer A.W.N. Pugin.

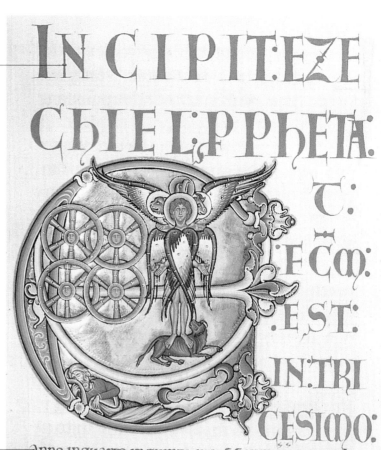

LOMBARDIC CAPITAL *M*
A square-cut nib is used to draw Lombardic Capitals, with the pen held close to the horizontal (*pp. 64–65*).

The letter M can alternatively adhere to a baseline cross stroke, making the right-hand stroke a mirror image of the left-hand one (pp. 64–65)

THERE IS A RELUCTANCE among some authorities to use the adjective "Lombardic" in relation to this script, because the letters have little specifically to do with the northern Italian region of Lombardy. However, over the centuries, the term has been widely used and accepted by calligraphers, typographers, and letterers, and has come to represent the particular combination of Imperial and Uncial elements that make up this distinctive hand of capital letters.

A simplified Imperial

Lombardic Capitals can be seen as simplified, pen-drawn versions of the Roman Imperial Capital. The multiple strokes of the Imperial (*pp. 110–119*) are reduced to a minimum, producing a letter that is relatively easy to execute (*pp. 64–65*). The Lombardic script usually includes Uncial forms of *A, D, E, M,* and *T* (*pp. 24–25*).

Dots are used on the letter N to give the strokes extra weight

The text is written in a very fine Early Gothic script (pp. 46–47)

THE WINCHESTER BIBLE
The Vision of Ezekiel, from the Winchester Bible (*pp. 46–47*), includes a series of meticulously crafted Lombardic Capitals. In common with other works from the mid-12th century, the scribe has shown little concern about breaking words at the end of a line: for instance, "*INCIPIT EZECHIEL*" reads "*INCIPIT:EZE/CHIEL.*" In the illuminated initial, Ezekiel is depicted dreaming by the Chobar River. The four interlocking wheels are symbolic of the four Evangelists.

In this early example of a historiated Versal (pp. 58–59), the Virgin is shown in the form of a capital letter I

These display letters read: "IN NM DNI NRI IIIU PS INCPT LIB SACRAMTR." This is an abbreviation of: "IN NOMINE DOMINI NOSTRI JESU CHRISTI. INCIPIT LIBER SACRA MATRIS"

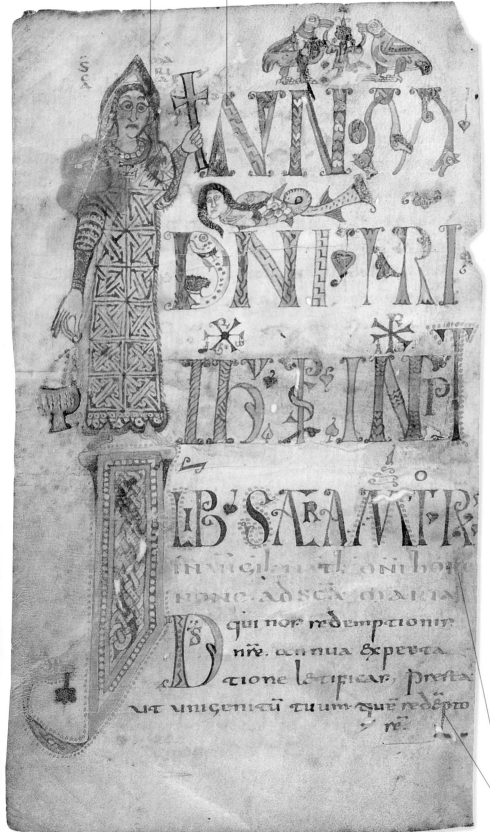

THE GELLONE SACRAMENTARY

In the title letters of this eighth-century text for Christmas Eve Mass, produced in northern France, we can discern the crude beginnings of Lombardic Capitals. The scribe has used Imperial Capitals as his models, drawing the outline of each letter in a single stroke with a narrow pen nib. In the first three lines, letters feature internal decoration. The words of the title have been considerably abbreviated. On the second line the abbreviation of "DOMINI" as "DNI" has been indicated with a mermaid instead of the traditional horizontal stroke.

Built-up letters

Unlike most other capital scripts included in this book, the Lombardic letter is not the product of a natural movement of the hand. While each basic component of the Gothic Capital, for instance, is made from a single stroke (*pp. 60–61*), a Lombardic component is built up from several composite strokes. The sides of the stems curve inward, usually drawn with the pen held horizontally. The monoline serifs are also the product of the horizontal pen; they are generally slightly concave and are not bracketed to the main stem as they are in the Roman Imperial Capital.

Embellishments

The Lombardic Capital forms the basis for many Versals (*pp. 58–59*), and the amount of embellishment and decoration is limited only by the scribe's imagination (*p. 64*). However, the stone-cut Lombardic letterform is often modified as a result of the nature of the surface – for instance, the fine serifs are either thickened or omitted altogether.

The Lombardic has been used extensively on other surfaces: textiles, metals, glass, and ceramics.

Below the title capitals, the chapter opening has been written in rubricated Uncial letters (pp. 24–25)

Below the chapter opening, the text script has been penned in a Half Uncial hand (pp. 38–39), recognizable by its upright aspect

Lombardic Capitals

THERE IS NO HISTORICAL precedent for a full set of Lombardic Capitals and those shown here have been compiled from a variety of sources. Unlike Gothic Capitals (*pp. 60–61*), they are used for writing complete words and phrases and so consistency is of great importance. Concentrate on making the weight of stroke, the level of compression or expansion, and the serif construction exactly the same in each letter you draw.

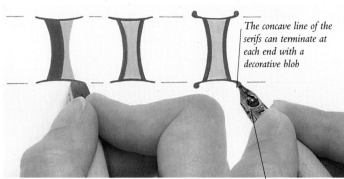

The concave line of the serifs can terminate at each end with a decorative blob

Use a narrow pen nib to add the decorative blobs at the end of the serifs

Waisted stems
Waisted stems can be created by overlapping two broad, curved vertical strokes and then adding the hairline horizontals at the top and bottom (*above left*). A more precise method is to draw the whole outline with a narrow nib and then fill it in with ink (*above center*).

Rounded letters
Define the form of rounded letters by drawing either the outer or inner circle first. The latter often proves more practical (see letter O, *opposite*).

Outer circle

Inner circle

Expanded and compressed letters
To regulate the chosen level of expansion or compression, use the spaces enclosed within characters as guides. Compressed letters have shorter serifs than expanded letters. Bows can be fully rounded or pointed.

Rounded bow

Pointed bow

Expanded letter

Compressed letter

Basic form of letter

Caseline and shadow

Floral decoration

Display capitals
Since the 12th century, the Lombardic Capital has often been heavily elaborated when used as a display capital. Decoration can range from simple additional caselines to complex illustrations that are gilded and in color.

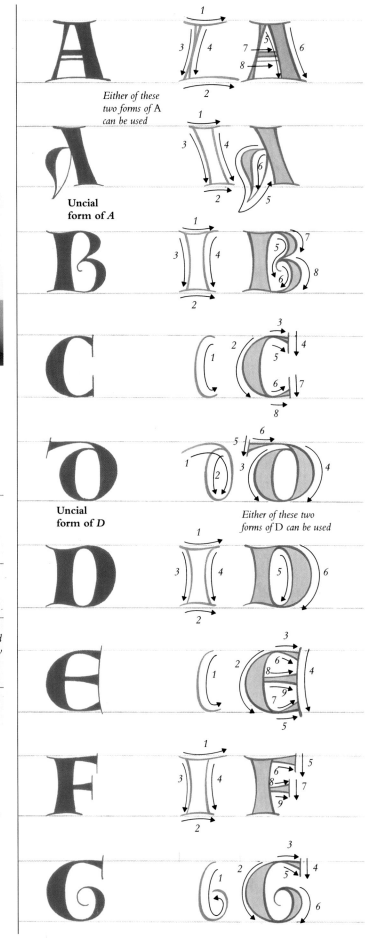

Either of these two forms of A can be used

Uncial form of A

Uncial form of D

Either of these two forms of D can be used

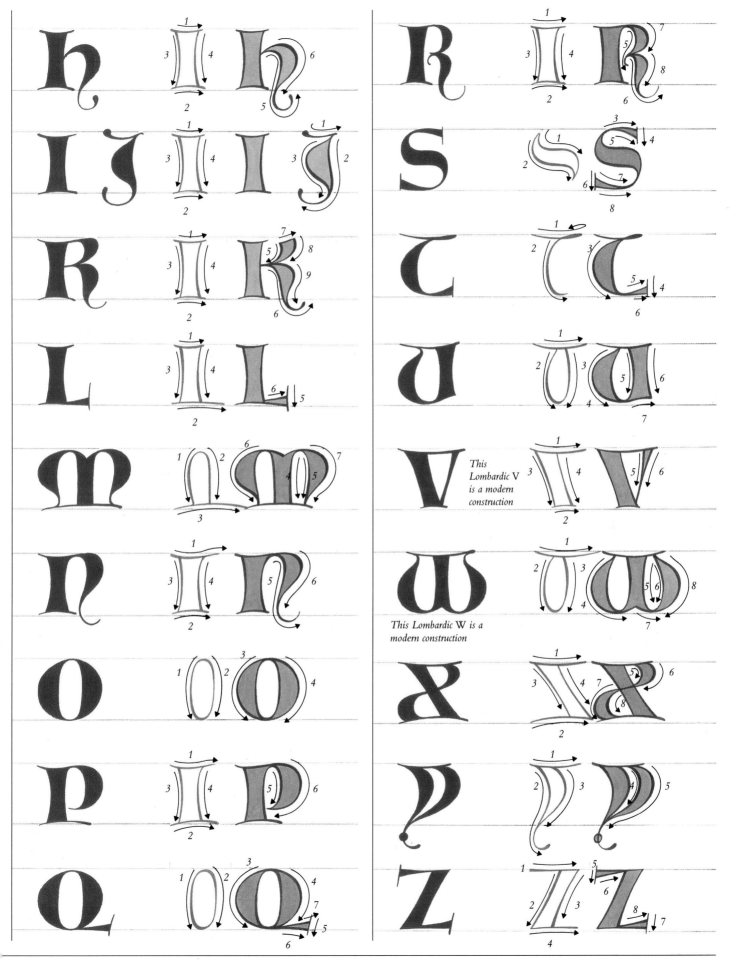

This Lombardic V is a modern construction

This Lombardic W is a modern construction

Bastard Secretary

H ISTORICALLY, THE MORE FORMAL a manuscript hand has become, the greater the need has been for a functional cursive script to complement it. Just as the Insular Majuscule spawned the Insular Minuscule in the eighth century (*pp. 28–37*), so the prestige Texturas of the 13th century (*pp. 50–57*) gave rise to parallel hands for the less prestigious work of the day. A series of complementary cursive scripts evolved both regionally and nationally, quickly developing into fully fledged hands in their own right. They are classified under the generic title of "bastard" (*bastarda*) scripts, the term denoting a mixed cursive and Textura parentage.

THE CURSIVE SCRIPT (*pp. 34–35*) had probably been rediscovered for documentary use in England toward the end of the 12th century. Although speed was the most important consideration, the script was also designed to impress, as the loops and linking letters testify. The French form of cursive, called Secretary or Chancery, was introduced into England and Germany at the end of the 14th century. When Textura features were incorporated, it became known as Bastard Secretary in English, Bâtarde in French (*pp. 70–71*).

The top loop of the *w* should not exceed minim height

BASTARD SECRETARY *w*
The *w* reaches ascender height and is identical in both minuscule and capital form.

The illuminated border and Versal are characteristic of 15th-century English manuscript work

The downward flick from the ascenders is known as an "elephant's trunk"

The feet of the minims turn upward

The horizontal stroke over the ampersand denotes the abbreviation of a word

MEDITATIONS ON THE LIFE OF CHRIST
This manuscript page shows the translation into Middle English by Nicholas Lowe of a popular 13th-century Latin work attributed to St. Bonaventura. One of 49 versions of the text known to exist, it dates from about 1450. The script includes the Anglo-Saxon thorn sign, a character that resembles a *y* and represents a "th" sound (*pp. 68–69*). This sign remained in use until the 16th century.

The Anglo-Saxon thorn sign has been used throughout the text

KANE MEDIEVAL MANUSCRIPT
Dating from about 1430, this earlier translation of St. Bonaventura's *Meditations on the Life of Christ* is also the work of Nicholas Lowe. In this version, the scribe has made use of both the Anglo-Saxon thorn sign and the modern *th* for writing the word "the." Notice also the serifs at the feet of the minims, which are turned upward and not broken as they are in the Bastard Secretary of the Adam and Eve text (*opposite*).

The text includes a set of capital letters written with the same ductus as the lowercase text (pp. 78–79)

The impressive height and looping form of the Bastard Secretary w *make it the most striking letter in this page of text*

DETAIL FROM ADAM AND EVE
In this valuable detail, a split in the quill allows us to see very clearly both sides of each stroke. Notice particularly the letter *f*: this is constructed with a single stroke, the pen beginning at the vertical, then turning to about 30° at midstem before returning to the vertical for the descender (*pp. 68–69*).

French and German features
There are certain features that help identify a bastard script by its nationality. The French form, for instance, is most distinctive for the calligraphic feast made of the *f* and long form of *s* (*pp. 70–71*). Early German cursive scripts were characterized by bold, expanded minims and tall ascenders and descenders. When they were contaminated with Textura features at the end of the 15th century, the Fraktur and Schwabacher hands emerged, featuring "broken" letterforms (*pp. 74–75*).

English characteristics
In English models, it is the letter *w* that attracts the most attention – the same impressive, looped form is used for both minuscules and capitals (*opposite*). Another English feature is the long, downward terminating flick from ascenders, sometimes called an "elephant's trunk."

Generally, the English Bastard Secretary tends to be staid and prosaic, lacking the subtle shifts of pen angle that characterize its French counterpart. As a result, it was highly practical, and so had a long life as a document hand. It was used well into the 18th century.

ADAM AND EVE
This text of the story of Adam and Eve was written in English in about 1415. A fine upright aspect to the letters suggests that they were written with an oblique-cut nib. In the best English Bastard script traditions, the *w* is well pronounced and the "elephant's trunks" are boldly drawn.

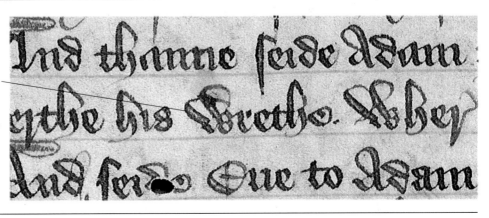

Bastard Secretary

As a functional, cursive script, the Bastard Secretary is written with as few pen lifts as possible, with letters linked wherever practical. Consequently, the hand can be penned far more quickly than the formal Gothic scripts, such as the Textura Quadrata (*pp. 52–53*). Ascenders are complemented by strong, downward diagonal strokes known as "elephant's trunks," drawn to the right of the stem at an angle of about 45°. These echo the downward diagonal strokes of the minim feet.

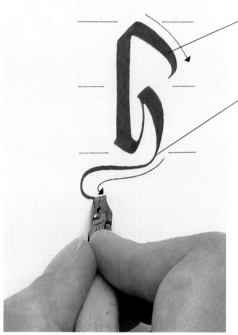

The angle of the "elephant's trunks" should be consistent throughout the text

The tail of the h *is usually dragged to the left of the letter, almost at a parallel to the baseline*

Key letter
The *h* is a useful letter with which to start practicing the Bastard Secretary. It includes both the "elephant's trunk" that sweeps from the head of the ascender almost to the headline and the characteristic downward pull of the pen at the foot of the stem.

Drawing an upward loop
With its sweeping hairline loop, the *d* is one of the most distinctive letters in the hand. After drawing the bowl, create a large arc by pushing the pen upward in one sweeping movement.

Adding a downward diagonal
Without lifting the pen, make a strong downward diagonal stroke, curving it to the left to join the bowl at its midway point. This stroke will echo the shape of the loop.

Basic elements
The pen angle for the hand is about 40–45° and a square-cut nib is generally used. Minim height is four pen widths, with the ascender equal to a further four widths.

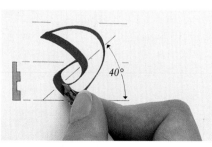

40°

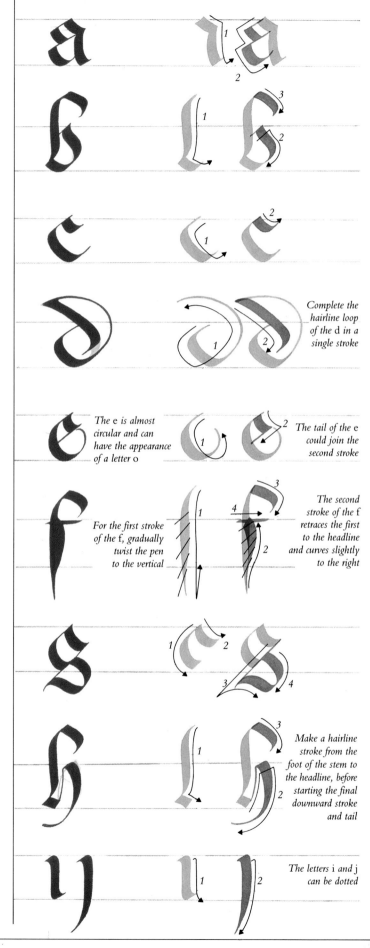

Complete the hairline loop of the d in a single stroke

The e is almost circular and can have the appearance of a letter o

The tail of the e could join the second stroke

For the first stroke of the f, gradually twist the pen to the vertical

The second stroke of the f retraces the first to the headline and curves slightly to the right

Make a hairline stroke from the foot of the stem to the headline, before starting the final downward stroke and tail

The letters i and j can be dotted

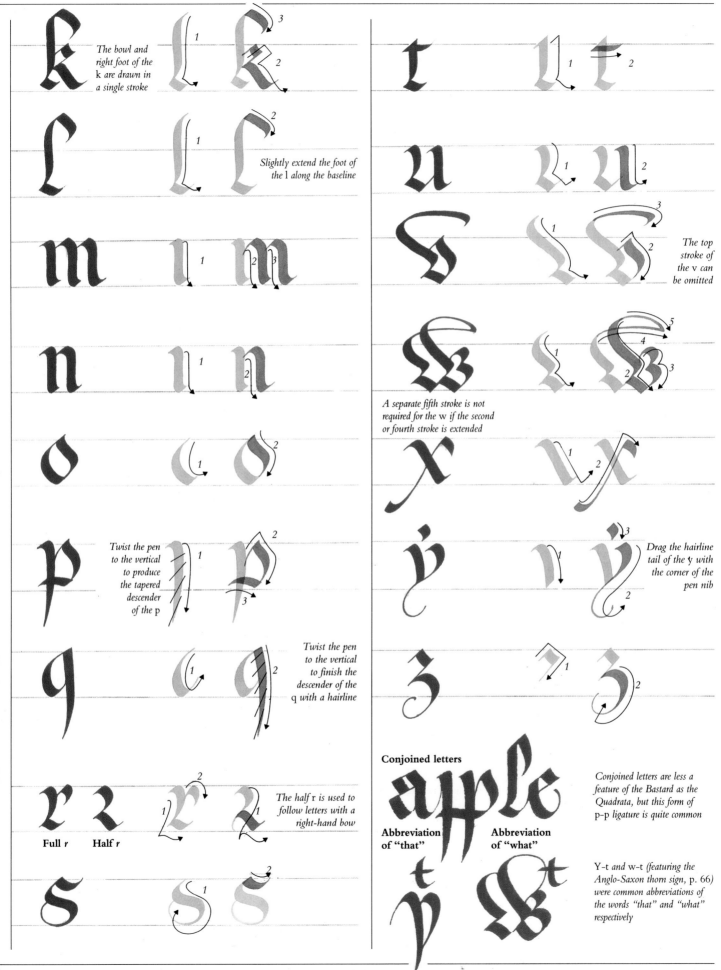

The bowl and right foot of the k are drawn in a single stroke

Slightly extend the foot of the l along the baseline

Twist the pen to the vertical to produce the tapered descender of the p

Twist the pen to the vertical to finish the descender of the q with a hairline

The half r is used to follow letters with a right-hand bow

Full r **Half** r

The top stroke of the v can be omitted

A separate fifth stroke is not required for the w if the second or fourth stroke is extended

Drag the hairline tail of the y with the corner of the pen nib

Conjoined letters

Abbreviation of "that" **Abbreviation of "what"**

Conjoined letters are less a feature of the Bastard as the Quadrata, but this form of p-p ligature is quite common

Y-t and w-t (featuring the Anglo-Saxon thorn sign, p. 66) were common abbreviations of the words "that" and "what" respectively

Bâtarde

THE BÂTARDE (*Lettre Bourguignonne*) is the French equivalent of the English Bastard Secretary (*pp. 66–67*). It was developed at the end of the 13th century and used until the mid-16th century, evolving from a lowly cursive bastard hand into a formal, prestige script in its own right. Bâtarde achieved its most sophisticated appearance in the mid-15th century, an era when the popularity of the printed book was increasing among a whole new section of society. In this deluxe form, it was the hand favored by Burgundian court circles, hence its alternative name.

The tail of the p is pointed and can be drawn either upright or slightly slanted

This baseline cross stroke can be extended when the letter begins a word

BÂTARDE *P*
In constructing the Bâtarde *p*, a series of pen lifts and angle changes is required (*pp. 72–73*).

BY THE MID-15TH century, book illustration in France was moving away from medieval stylization (*pp. 54–55*), becoming less intricate and more naturalistic. The Bâtarde hand used for manuscript books was shedding its own Gothic ancestry — letters were lighter, seeming to dance on the page. This effect was achieved partly by making several changes of pen angle during the construction of each letter. In returning to the major key after each change, the scribe could create a rhythmic harmony across a page of text. This is particularly noticeable in the Froissart Chronicle (*opposite*). However, in other Bâtarde scripts, such as that in the Book of Hours (*right*), the harmony of the text is achieved instead by the maintenance of one constant overall angle.

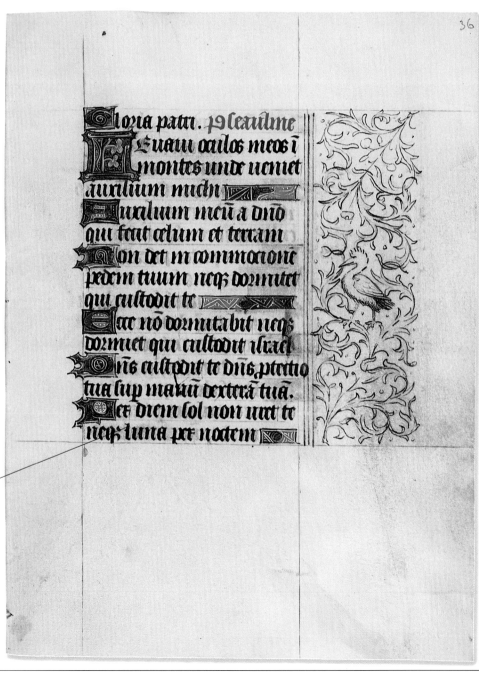

The split ascenders are one of several Gothic Textura characteristics that have survived in this bastard script

BOOK OF HOURS
This page is from a small prayer book written for the wealthy Poligny family in about 1470. The script's Gothic origins are clear: ascenders are split, descenders modest, and minim strokes terminated with feet reminiscent of the Quadrata (*pp. 50–51*). The overall textural effect is closer to the dense authority of the Gothic Textura scripts than to the light harmony of a true Bâtarde, such as that achieved in the Froissart Chronicle (*opposite*).

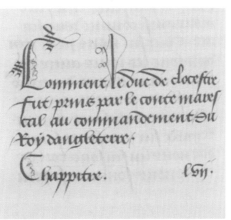

THE FROISSART CHRONICLE

This is a copy of the 14th-century chronicle of Jean Froissart. A delightful book, it has a modern appearance, owing partly to the relationship of text to margins and partly to the restraint shown in the decoration. The feet of the minims end without elaboration and the script is generally more cursive than that used to write the Book of Hours (*opposite*).

DETAIL FROM THE FROISSART CHRONICLE

The initial *C* is decorated with a Cadel (*pp. 80–81*). The horns on the letter *g* are similar to those on the *g* of another Gothic script, the Fraktur (*pp. 76–77*). Both the half *r* and full *r* forms are used in the text.

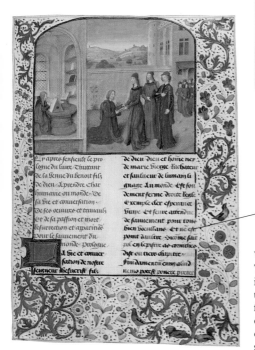

The forward lean of the letter f *is one of the most distinctive characteristics of the Bâtarde*

VITA CHRISTI PAGE

This page from *La Vengeance de la Mort Ihesa* includes the rubricated prologue to the main text, which opens with a Versal. The book dates from 1479 and was written by David Aubert of Ghent, scribe to Philip the Good, Duke of Burgundy. In the illustration, we see the scribe presenting the book to his patron.

Vita Christi

The scribe of the Vita Christi page from *La Vengeance de la Mort Ihesa* (*left*) had arguably lesser skills than his two contemporaries featured here. He does not achieve the harmony of the Froissart Chronicle or Book of Hours, his pen angles are inconsistent, and he is unable to return to any constant pen angle.

Common features

In some examples of Bâtarde, the *f* and long form of *s* lean forward at an angle. By keeping the angles of these two letters absolutely constant, the scribe can create a counterpoint to the main harmony. This textual effect – known as "hot spots" – is a common feature of Bâtarde.

Other frequent characteristics of *Lettre Bourguignonne* are the overlapping strokes reminiscent of Fraktur (*pp. 74–75*), and the delicate hairlines used to join strokes; these seem to add a further sense of movement to a page of text.

Bâtarde

To achieve the most successful Bâtarde letters, the use of a quill is recommended. A sharply cut oblique nib is required to produce the exquisitely fine hairline strokes. The clubbed *f* and long *s* are frequently written more boldly than other letters and have a forward slant (the two letters have the same basic form, with a crossbar added for the *f*). This produces "hot spots" within the written text and makes for a distinctive textural pattern.

Prepare to add the crossbar to the f by turning the quill to 10°

The key letters f and long s should lean slightly to the right

Drawing the f and long *s*
The many changes of pen angle required to draw the Bâtarde *f* and long *s* are typical of this sophisticated hand. Begin about half a minim above the headline and gradually

turn the pen from 30° to the vertical as you pull the pen downward, finishing with a hairline. Retrace the first stroke, looping outward to the right to create a thickened stroke, and return to the original angle of 30°.

The curved hairline stroke at the top of the letter q can be continuous with the descender

Descenders
The descenders of letters *p* and *q* are made by turning the nib counterclockwise from the horizontal to the vertical, finishing with a hairline. The descenders may alternatively slant to the left, echoing the forward lean of the *f* (*above*) and long *s*.

The height of the Bâtarde minim is about four pen widths

Flat feet
Flat feet occur on all leading minims in the script, such as the stem of the *t* and the first leg of the *n*. In a more cursive version of Bâtarde, the minims may terminate with a flick at the end of the downward stroke, as on the second leg of the *n*.

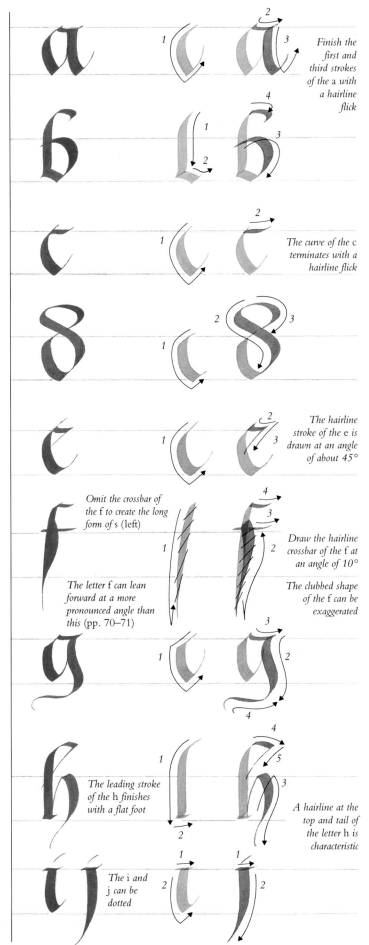

Finish the first and third strokes of the a with a hairline flick

The curve of the c terminates with a hairline flick

The hairline stroke of the e is drawn at an angle of about 45°

Omit the crossbar of the f to create the long form of s (left)

The letter f can lean forward at a more pronounced angle than this (pp. 70–71)

Draw the hairline crossbar of the f at an angle of 10°

The clubbed shape of the f can be exaggerated

The leading stroke of the h finishes with a flat foot

A hairline at the top and tail of the letter h is characteristic

The i and j can be dotted

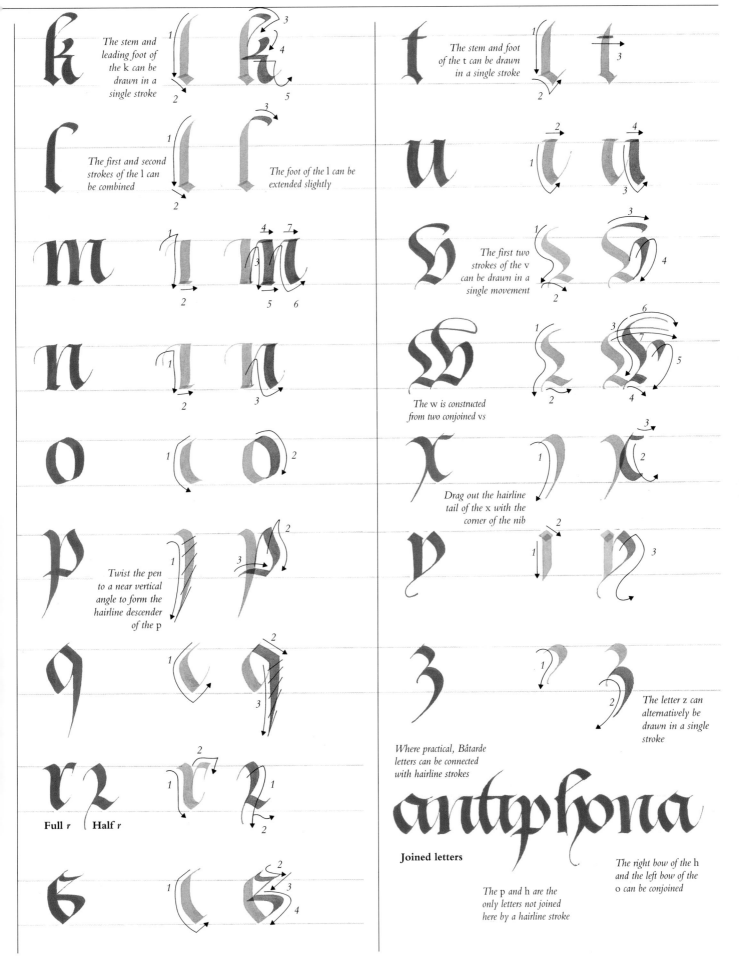

The stem and leading foot of the k can be drawn in a single stroke

The first and second strokes of the l can be combined

The foot of the l can be extended slightly

Twist the pen to a near vertical angle to form the hairline descender of the p

Full *r* Half *r*

The stem and foot of the t can be drawn in a single stroke

The first two strokes of the v can be drawn in a single movement

The w is constructed from two conjoined vs

Drag out the hairline tail of the x with the corner of the nib

The letter z can alternatively be drawn in a single stroke

Where practical, Bâtarde letters can be connected with hairline strokes

Joined letters

The p and h are the only letters not joined here by a hairline stroke

The right bow of the h and the left bow of the o can be conjoined

Fraktur & Schwabacher

FRAKTUR (GERMAN LETTER) is a marriage between German cursive scripts and Textura Quadrata (*pp. 50–51*). Manuscript examples of the hand date from about 1400 and it first appeared as a typeface about a century later. Early type versions of Fraktur, and its more cursive, vernacular cousin, Schwabacher, remained close to their pen-written origins. They were designed by the leading German calligraphers of the day, including Johann Neudörffer the Elder. The two scripts continued to influence calligraphy and type design until the mid-20th century, and had a formative influence on the work of eminent practitioner Rudolf Koch (*opposite*).

FRAKTUR *A*
The distinctive spikes of many Fraktur letters are the product of overlapping strokes (*pp. 76–77*).

The Fraktur a *is always a single-story letter with an enclosed bowl*

THE DIFFERENCES between Fraktur and Schwabacher are difficult to define precisely. Both feature the swollen body and pointed tail of the Bâtarde *f* and long *s* (*pp. 70–71*), as well as curved strokes on the bows of letters *a*, *b*, *c*, *d*, *e*, *g*, *h*, *o*, *p*, and *q*. Diamond strokes reminiscent of Textura letters are a distinctive feature of the hand, but there is a tendency for terminal strokes to be curved. All letters have a rigidly upright aspect.

Generally, the Schwabacher has a broader, more cursive form than the Fraktur, and does not have the forked ascenders and excessive elaboration of that hand. Some of the most striking versions of Schwabacher were penned, centuries after the script first appeared, by the calligrapher and designer Rudolf Koch (*opposite*).

WORKSHEET
This portion of a worksheet (*above*) is possibly the oldest surviving example of Fraktur-related lettering. It was written in about 1400 by Johannes vom Hagen, who refers to the hand as "*Nottala Fracturarum*" ("broken notes"). It is from this term that the name "Fraktur" is believed to have been derived.

The tail of this p, *and that of other letters on the bottom line of text, may have been added by hand after the book was printed*

The illustrations and Versals were added after the the text had been completed

MATTHÄUS EVANGELIUM
In this German text of the Gospel of St. Matthew from 1921, Rudolf Koch combines the features of Fraktur and Textura Quadrata to the ultimate degree – the lines of text appear to have been knitted. Koch classified this style as a version of Schwabacher, and explained: "The page should seem to be stacked with finished rows of lines...especially the space between words must not be broader than that between lines." The Versals have been treated in an equally robust manner, resulting in two beautifully designed pages of text.

In Koch's text, the interlinear space has virtually disappeared, allowing just sufficient white for the eye to scan along the lines horizontally

DETAIL FROM MATTHÄUS EVANGELIUM
The controlled freedom of Koch's letterforms is shown in this detail from Matthäus Evangelium (*above*). Radical in its time, such work gave new meaning to the term "Black Letter" (*pp. 50–51*).

The straight, compressed aspect of the hand betrays its Textura origins: even the letter f has an upright form

PRAYER BOOK
These pages from the prayer book of Emperor Maximilian were published by Schönsperger of Nüremberg in 1514. The Fraktur type was designed by Johann Neudörffer the Elder, father of three generations of calligraphers. The border decoration is equally outstanding, being the work of Albrecht Dürer.

German Letter
By the early 16th century, a further form of Fraktur and Schwabacher had developed that has since come to typify German scripts. It featured "broken" letters created by the overlapping of strokes (*pp. 76–77*). Used only in German-speaking areas, this broken letter is frequently referred to as a "German Letter."

The rejection of Italian scripts
Fraktur and Schwabacher enjoyed longer lives than any other bastard script in Europe; in the early 20th century, half the books printed in Germany still featured Fraktur-based typefaces. This longevity was a direct result of the German rejection of Italic and Humanist scripts (*pp. 90–101*). There were two important factors in this rejection: first, the Reformation caused Protestants in northern Germany to reject Italian hands as a political gesture; second, it was widely believed that a Humanist script did not suit German text.

Fraktur

THE UPRIGHT, COMPRESSED letters of Fraktur are closer in appearance to the Gothic Textura scripts (*pp. 50–57*) than either the Bastard Secretary (*pp. 68–69*) or the Bâtarde (*pp. 72–73*). The hairline spikes, such as those on letters *b*, *g*, *h*, and *q*, are a distinctive feature of Fraktur and do not tend to occur on the rounder Schwabacher letters. The pen angle of about 40° is altered only for drawing the pointed descenders.

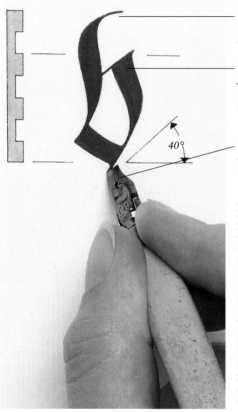

The ascender can be drawn with a single rounded stroke or with a split serif

The minim height is about five pen widths, with two more for ascenders and descenders

40°

The pen nib should be square-cut for drawing Fraktur letters

Rounded strokes
Despite the Fraktur letter's upright aspect, many strokes are actually rounded. Here, the ascender of the letter *b* has been drawn with a curve to echo the rounded stroke of the bowl. Whether you choose straight or rounded letters or split or pointed ascenders, it is important to be as consistent as possible throughout the text.

The crossbar is a common feature of the letter g in both Fraktur and Schwabacher scripts

Spike strokes
The distinctive Fraktur spikes are made by extending one stroke over the previous one. The more pen lifts there are in a letter, the more spikes are created.

Alternatively, the hairline can be drawn as a continuation of the first stroke (see g, opposite)

The spike stroke overlaps the bottom of the rounded stroke of the bowl

The tail of the g can finish with a short hairline, a blob, or a backward sweep; alternatively, it can be looped (see g, right)

Fraktur descenders are restrained, except on the bottom line of a page of text, where additional flourishes can occur

Alternative *a*

Either of these two forms of a can be used

Curl the ascender of the d back to the right to avoid the letter tilting to the left

Twist the pen from 40° to near vertical for the descender of the f

The first and second strokes of the f can be drawn without lifting the pen

The second and third strokes of the g can be drawn in one continuous movement

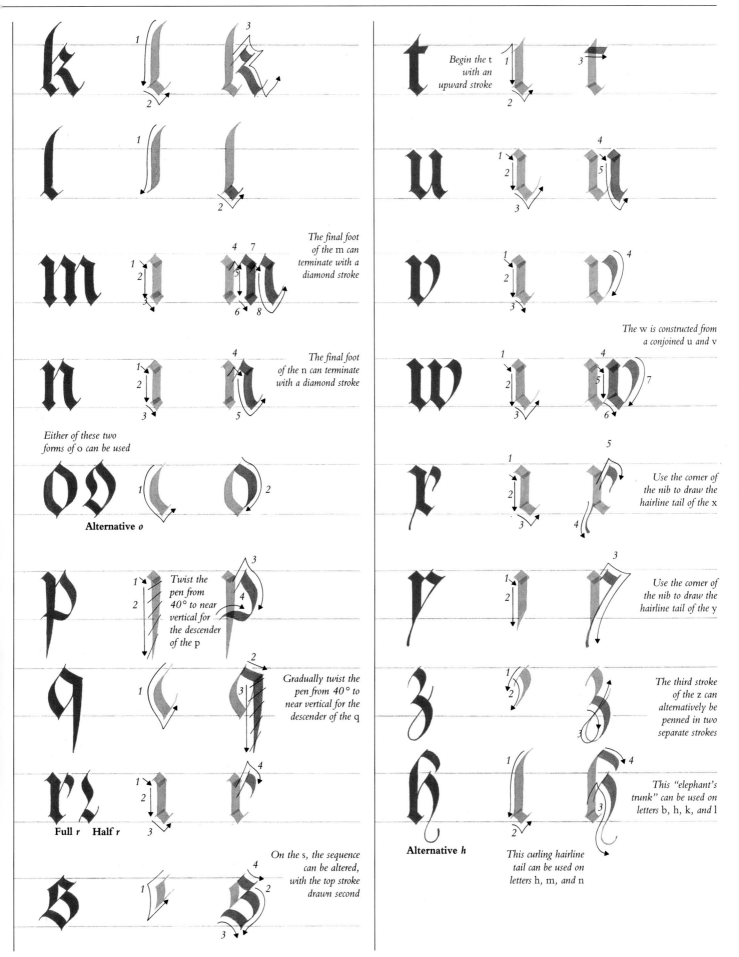

The final foot of the m can terminate with a diamond stroke

The final foot of the n can terminate with a diamond stroke

Either of these two forms of o can be used

Alternative o

Twist the pen from 40° to near vertical for the descender of the p

Gradually twist the pen from 40° to near vertical for the descender of the q

Full r **Half r**

On the s, the sequence can be altered, with the top stroke drawn second

Begin the t with an upward stroke

The w is constructed from a conjoined u and v

Use the corner of the nib to draw the hairline tail of the x

Use the corner of the nib to draw the hairline tail of the y

The third stroke of the z can alternatively be penned in two separate strokes

This "elephant's trunk" can be used on letters b, h, k, and l

Alternative h

This curling hairline tail can be used on letters h, m, and n

Bastard Capitals

Bastard Capitals have the same ductus as the minuscules that they accompany (*pp. 68–77*), and are penned with the same nib. In most instances, they tend to be wide, expanded letters. The thick stem strokes are often supported by a thin vertical slash to the right, and the addition of a diamond stroke in the center of the counter is also common. Like the bastard minuscule hands, the capitals were subject to a range of individual and regional variation. Because of this diversity, the alphabet shown here should be regarded only as a general guide.

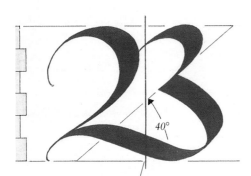

Basic elements
The pen angle of the Bastard Capital is about 40° or the same as the minuscule that it accompanies. The letter height is about six pen widths. The characteristically wide letters, such as the *B*, are a direct product of downward and horizontal arced sweeping strokes.

Draw the hairlines with the corner of the nib

Connecting hairlines
On letters *H*, *M*, and *N*, hairline strokes are often used to connect two main downstrokes. This hairline should spring from the right edge of the baseline serif.

Spurs
Weight can be added to vertical stems in the form of diamond-shaped spurs. Each spur can be sharpened with a short hairline flick.

Limit the number of diamond-shaped spurs to two or three

"Elephant's trunks"
The "elephant's trunk" so characteristic of the Bastard Secretary (*pp. 68–69*) also occurs on capital letters *H*, *K*, *L*, and *X*. Draw the diagonal trunk with the full width of the nib, finishing with a short hairline.

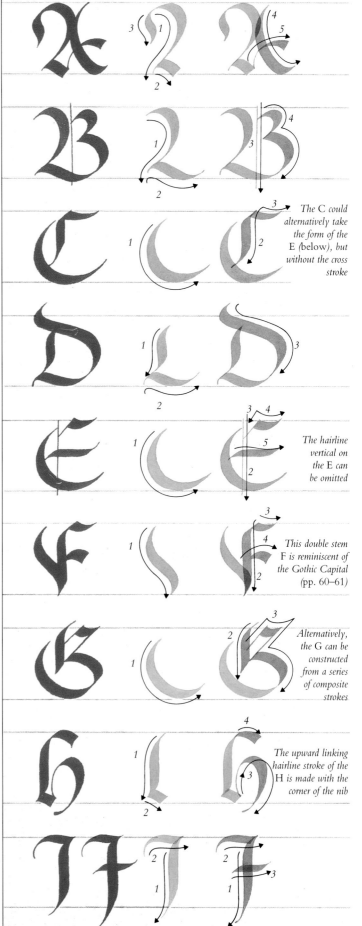

The C could alternatively take the form of the E (below), but without the cross stroke

The hairline vertical on the E can be omitted

This double stem F is reminiscent of the Gothic Capital (pp. 60–61)

Alternatively, the G can be constructed from a series of composite strokes

The upward linking hairline stroke of the H is made with the corner of the nib

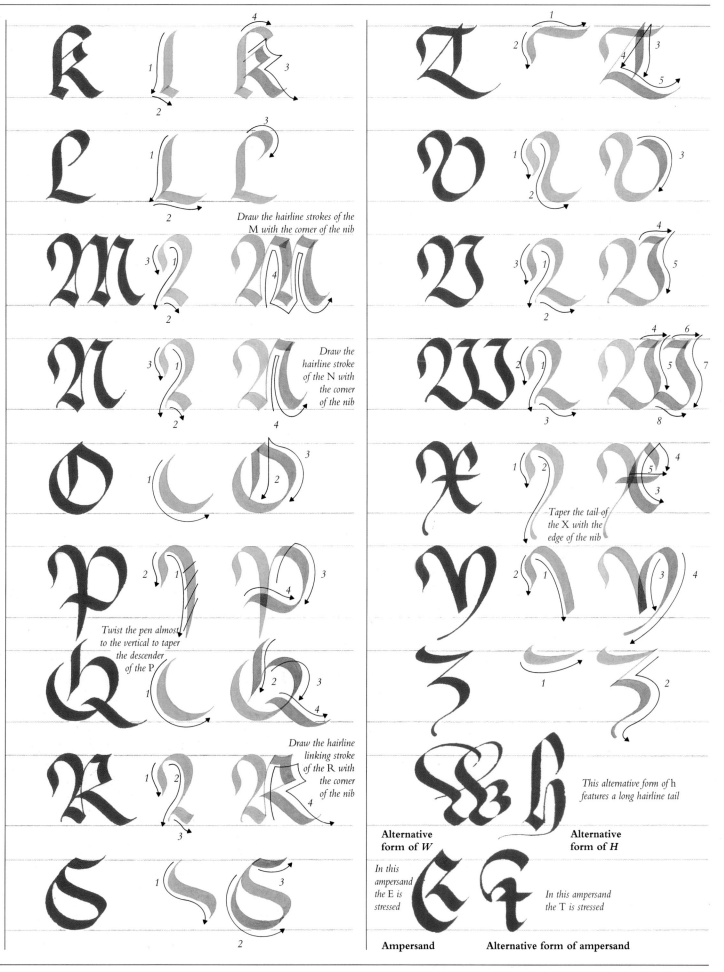

Draw the hairline strokes of the M with the corner of the nib

Draw the hairline stroke of the N with the corner of the nib

Twist the pen almost to the vertical to taper the descender of the P

Draw the hairline linking stroke of the R with the corner of the nib

Taper the tail of the X with the edge of the nib

This alternative form of h features a long hairline tail

Alternative form of W

Alternative form of H

In this ampersand the E is stressed

In this ampersand the T is stressed

Ampersand

Alternative form of ampersand

Le Romant de la Rose

Cadels

THE INVENTION OF the Cadel (*Cadeaux*) in the early 15th century is attributed to Jean Flamel, librarian to the prominent patron of the arts, the Duc de Berry. Flamel used these large, patterned capitals to inscribe the duke's name in the front of each manuscript. By the mid-15th century, Cadels were widely used in northern Europe as single Versals (*pp. 58–59*), mainly in vernacular text written in the various bastard scripts (*pp. 66–79*). During the 16th century, they appeared in Italic text in increasingly elaborate forms.

CADEL *H*
Despite the apparent complexity of this 16th-century Cadel, the main structure of the letter is easily pennable (*pp. 82–83*). The fine internal decoration can be drawn with a flexible steel nib.

BY THE END OF the 16th century, the Cadel was frequently appearing as a Versal in printed form, and the advent of copperplate engraving led to more fanciful elaboration than was achievable with a broad-edged pen. This paralleled the development of the various Italic and Copperplate hands (*pp. 94–107*), with which the Cadel was often incorporated.

Interlace patterning

The Cadel differs from other capitals used as Versals in that it is composed of interlacing strokes rather than built-up strokes (*pp. 58–59*). It is drawn with a constant pen angle – this produces thick and thin strokes that create a pattern with a continuously changing direction of line. In this way, substance is added to an otherwise skeletal letter.

Interlaced strokes can also be used to embellish the ascenders on the top line of a page of text or the descenders on the bottom line.

This Bastard Capital letter D, *with its looped ascender, is a useful model for drawing a Cadel* (pp. 78–79)

CADELS, CAPITALS, AND MINUSCULES
These letters were penned in the second half of the 15th century, possibly by the English scribe Ricardus Franciscus. One basic element of the Cadel contained in the letter *A* is the left foot, which has been constructed from three strokes linked by a series of shorter strokes. This linking system is the key to more complex letters, such as the *H* (*above*).

Cadels were generally used with Bastard scripts: here, the minuscules resemble a German cursive hand (pp. 74–75)

FLAMEL'S CADELS
This page from a manuscript belonging to the Duc de Berry was written by Jean Flamel in about 1409. Although the basic structure of the Cadels is relatively simple, the fact that so many have been used on the same page creates an impressive overall effect.

ENGRAVED ALPHABET
This alphabet of capitals was engraved by Thomas Weston in 1682. Although the main structure of the letters follows that of Bastard Capitals (*pp. 78–79*), the basic forms have been embellished with typical Cadel scrolls and interlaces.

Cadels

THE GREAT VARIETY of existing Cadel models makes it very difficult to assemble a complete alphabet. These examples have been selected to represent a few general principles. Although Cadels can look very daunting to accomplish, in practice they are often a great deal easier than you may think and, when used as Versals, they can look very impressive. The golden rule is to begin at the core of the letter and work outward.

Letter spine
Always begin with the spine of the letter. Here, the spine is composed of downward diamond strokes and straight vertical strokes. The pen angle for both types of strokes is between 35° and 45°.

Use a pencil for the initial planning of the letter's structure

Diamond strokes
A series of diamond strokes is a common feature of the Cadel spine. Move the pen downward in a controlled, zigzagging movement, without altering the pen angle. A pen angle of 45° will give symmetrical diamonds.

Maintain a pen angle of 45° for a series of short, neat diamonds

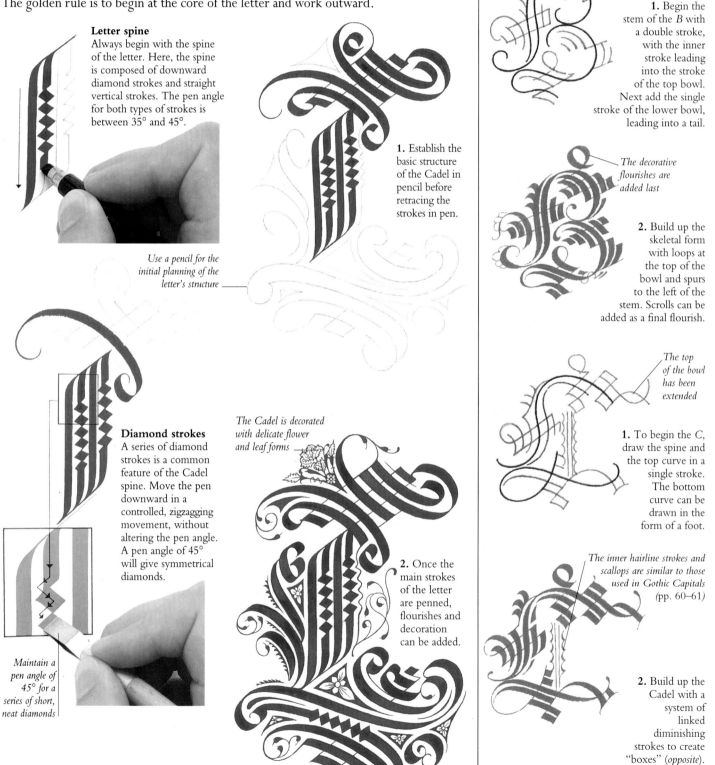

1. Establish the basic structure of the Cadel in pencil before retracing the strokes in pen.

The Cadel is decorated with delicate flower and leaf forms

2. Once the main strokes of the letter are penned, flourishes and decoration can be added.

Cataneo's Cadels
These letters *B* and *C* are based on the initials of Bernardino Cataneo, writing master at the University of Siena, Italy, between 1544 and 1560. In their original form, they were used with text in Rotunda (*pp. 86–87*) and Italic (*pp. 96–97*).

The skeleton B *consists of a spine and two bowls*

1. Begin the stem of the *B* with a double stroke, with the inner stroke leading into the stroke of the top bowl. Next add the single stroke of the lower bowl, leading into a tail.

The decorative flourishes are added last

2. Build up the skeletal form with loops at the top of the bowl and spurs to the left of the stem. Scrolls can be added as a final flourish.

The top of the bowl has been extended

1. To begin the C, draw the spine and the top curve in a single stroke. The bottom curve can be drawn in the form of a foot.

The inner hairline strokes and scallops are similar to those used in Gothic Capitals (pp. 60–61)

2. Build up the Cadel with a system of linked diminishing strokes to create "boxes" (*opposite*).

Drawing a Cadel *A*

This apparently complex *A* can be built up quite quickly in four stages. Diamonds have been drawn into the legs of the *A*, so keep a constant pen angle to ensure an even distribution of thick and thin strokes.

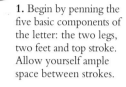

1. Begin by penning the five basic components of the letter: the two legs, two feet and top stroke. Allow yourself ample space between strokes.

Straight horizontal strokes are best avoided, so use curved diagonals for the feet of the A

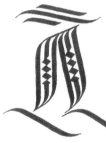

2. Build up the legs of the letter with two complementary upright strokes on either side of the core diamond strokes. As a general rule, the legs should have more weight than the feet.

The lines of the serif echo those of the feet

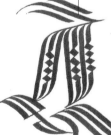

3. Keeping a constant pen angle, build up the feet. Changes of line direction can now be introduced.

Changes of line direction have been introduced

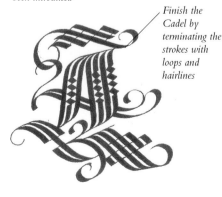

Finish the Cadel by terminating the strokes with loops and hairlines

4. Now add the crossbar, breaking the strokes as they cross the lines of the legs. Finally, add the decorative loops and flourishes.

Cadel ornamentation

In order to build up the weight of a main stroke or to create a change in line direction, various types of ornamentation can be used. The patterns shown below have all been created with the pen at a constant angle. Each involves a series of short strokes that move at 90° to each other in a series of thin and thick "boxes." This simple device can be adapted to form increasingly complex patterns.

A constant pen angle is essential in the creation of "box" patterns

This pattern involves a series of four small "boxes," followed by a line of three "boxes"

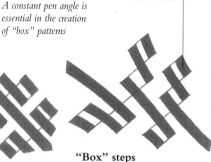

Terminal "boxes"
In this pattern, the use of "boxes" allows strokes to be terminated in different directions.

Basic "boxed" strokes
The basic principle of the "boxed" stroke is that when the pen moves sideways, a thin line is produced, and when it moves upward or downward, a thick line is produced.

"Box" steps
In a principle similar to the basic "boxed" stroke (*above left*), this pattern involves the "boxes" moving sideways in steps. This works best on curved strokes and requires careful planning.

Interlocking loops
A series of interlocking but unjoined loops can be adapted at a terminal stroke or provide an infill.

The semicircular loops interlock without actually touching

Mirror images

This patterning is loosely based on a decorated descender from the 16th-century "Alphabet" of Mary of Burgundy. The two halves of the ornamentation suggest a mirror image. This decoration would work equally well from a top line of an ascender.

Small terminal loops should be drawn complete; this is easier than trying to construct half a loop

1. Begin by folding a sheet of lightweight layout paper in half – the fold will represent the center line of the image. Fold the paper again at a right angle to the original fold – this will represent the arm. Unfold the paper and work out the sequence, loops, and interlaces of half the pattern.

The balance of thick and thin strokes in the left arm will be the exact reverse of those in the right arm

2. Using the right angle fold as a center line, work out the strokes for the arm. When this is complete, fold the paper over the center line and repeat the pattern from the see-through image. Any flaws in the design will become immediately obvious when the pattern is reversed.

Rotunda

THE GOTHIC INFLUENCE on western European scripts between the tenth and 13th centuries was largely resisted in one major country – Italy. The clarity of classical inscriptions, still evident throughout the land, the continued use of a wide, rounded hand called the Beneventan, and the retention of the Caroline Minuscule, were all factors in the emergence of a formal script that differed from its Gothic contemporaries in its round, open aspect. It was known as Rotunda.

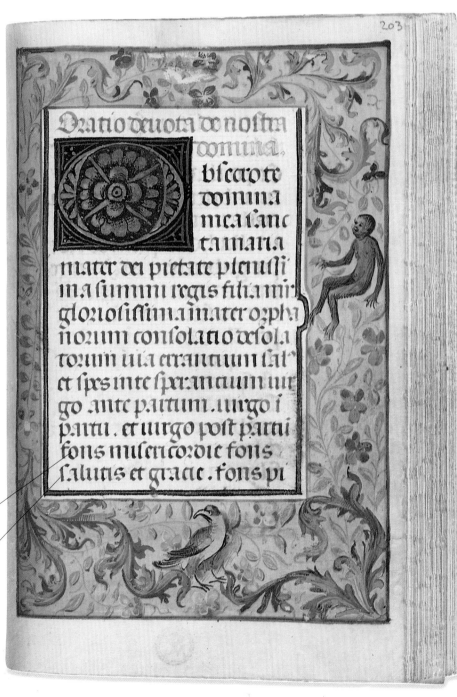

The right half of the o has a smoother semicircular sweep than the left (pp. 86–87)

ROTUNDA O
The roundness of the *o* is the key to Rotunda and is reflected in all the bowed letters.

BY THE 12TH CENTURY, the prestige Rotunda script had developed into an extremely formal and upright version of the Caroline Minuscule (*pp. 38–39*), with slightly shorter ascenders and descenders than its parent script. The hand also embodied elements of the Beneventan, most notably in the rounded strokes on many letters. In contrast, straight strokes were square-cut and rigidly upright.

A legible hand

In general, the Rotunda was bolder than the Caroline Minuscule, but the rounded strokes and modest ascenders and descenders created a clear, legible script that was used for handwritten work long after the introduction of printing. The simplicity of the letterforms made the script equally popular as a model for typefaces, thriving in that form until as late as the 18th century.

The many curved strokes, such as this on the letter o, *helped continue the Italian tradition of open, rounded scripts*

The square baseline foot of the letter f *is a distinctive characteristic of the Rotunda*

BOOK OF HOURS
This small Book of Hours, produced in Bruges in about 1480, shows the evenness and regularity of the Rotunda. The script differs from that used for the Verona Antiphoner (*opposite*) in one significant respect – the upturned feet of the minims. Here, they are a continuation of the minim strokes, which results in slightly more cursive letters than was usual.

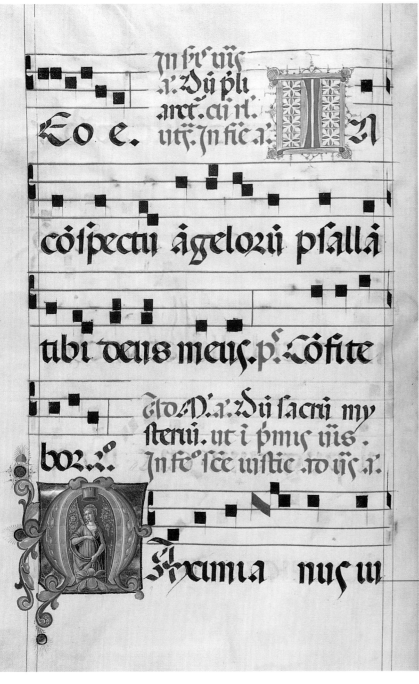

Large-scale letters

As a manuscript hand, the Rotunda was written in a full range of sizes, from very small to very large, and was the chosen script for some of the largest known manuscript books in the world. When written on a large scale, the letters can have a rigid formality and the hairline strokes often seem disproportionately light.

Rotunda Capitals

Accompanying capitals are written with the same pen as the minuscules (*pp. 88–89*). A double stroke can be used for the stem, with a clear gutter between strokes. In some historical instances, the Rotunda Capital developed into a Versal. In others, Gothic or Lombardic Versals were used with Rotunda text script.

A common feature of all Rotunda letters, both minuscule and capital, is the sharpness of the cut of the nib, which gives clear, precise strokes and fine hairlines. In larger versions, the pen should be clearly lifted after the completion of each stroke, while in smaller versions, many strokes can be drawn in one continuous movement.

These large-scale Rotunda letters lack any cursive features: note the angularity with which the ascenders and straight minim strokes have been drawn

Compare the unusual broken forms of the strokes on capitals A, C, *and* E *with the more common form* (pp. 88–89)

THE VERONA ANTIPHONER
This Antiphoner (book of chants and anthems) was written in about 1500 for the monasteries of SS Nazro and Calio in Verona, Italy. This type of book was often written in a large format to enable several choristers to read it at the same time. The Rotunda letters have been drawn with considerable precision, with idiosyncrasies arising only in the unusual broken form of the capitals.

This Caroline form of d *features an upright stem and curved bowl*

ROTUNDA AS A TYPEFACE
The type used in this dictionary was possibly from the founts of the Venice-based German printer Erhard Ratdolt (*pp. 90–91*), who had punches cut for a Rotunda type in 1486. This detail shows two different forms of *d*: the uncial form and the upright Caroline form – both can be seen in the middle of the sixth line.

Rotunda

ROTUNDA IS AN upright, open letter, which works well on both a large and small scale. The characteristic straight stem strokes, such as those on letters *b*, *f*, and *h*, are constructed with the pen held at about 30°. The square foot is then added in one of two ways. The simplest method is to use the corner of the nib to outline the foot, before filling it in with ink. Alternatively, the "dual ductus" technique can be used, which involves turning the pen from 30° to the horizontal in one short movement. Although the latter may seem more complex, it is probably preferable when drawing large Rotunda letters.

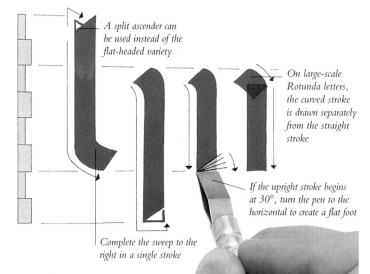

A split ascender can be used instead of the flat-headed variety

On large-scale Rotunda letters, the curved stroke is drawn separately from the straight stroke

If the upright stroke begins at 30°, turn the pen to the horizontal to create a flat foot

Complete the sweep to the right in a single stroke

Sweeping strokes
On letters in which the stem stroke ends in a right sweep, such as *l* (*above*), the sweep is usually completed in a single stroke. On larger letters, two separate strokes are used (see *b*, *l*, and *t*, *right*).

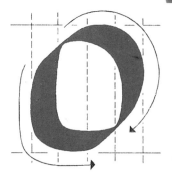

Key letter
The *o* is the key letter of the Rotunda. The bowls of *b*, *d*, *g*, *p*, and *q* closely follow its shape, and its open aspect is also echoed in the *c* and *e*. The first stroke is only slightly curved, closely following a vertical before sweeping vigorously to the right. The second stroke is much more semicircular than the first.

Terminating flicks
As an alternative to the sweeping stroke, letters *m*, *n*, and *u* can terminate with a flick. These are severe and rather mechanical; the stroke is simply executed with a pen angle of 30° and without any directional turn of the pen.

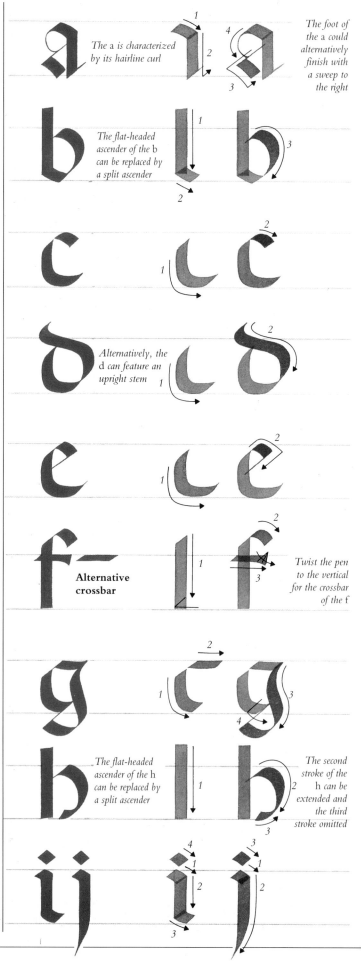

The a is characterized by its hairline curl

The foot of the a could alternatively finish with a sweep to the right

The flat-headed ascender of the b can be replaced by a split ascender

Alternatively, the d can feature an upright stem

Alternative crossbar

Twist the pen to the vertical for the crossbar of the f

The flat-headed ascender of the h can be replaced by a split ascender

The second stroke of the h can be extended and the third stroke omitted

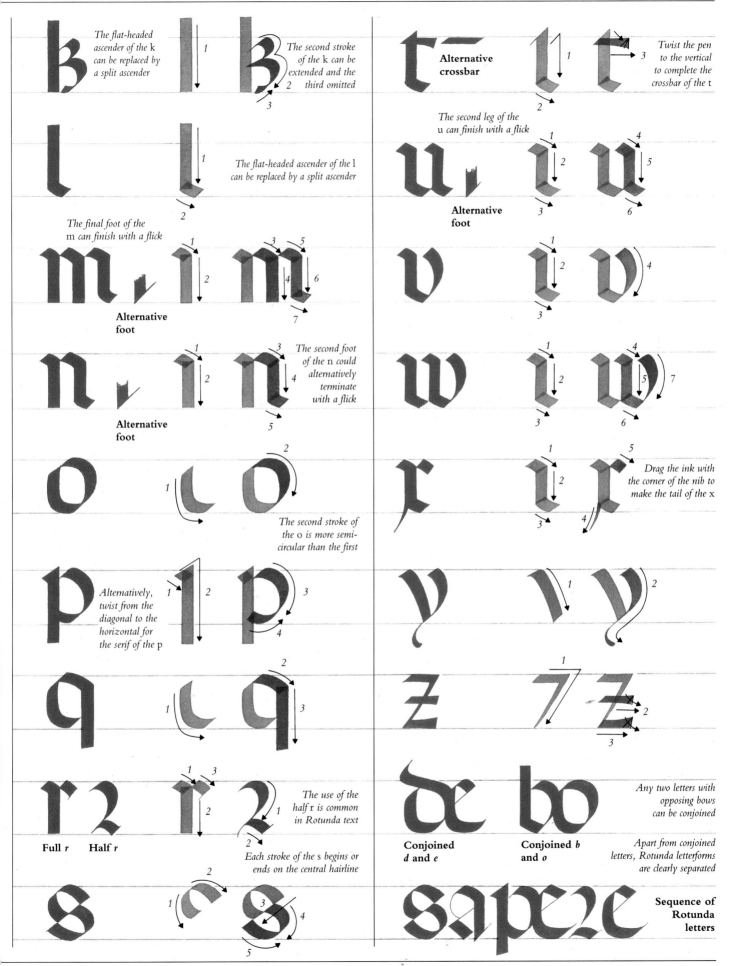

The flat-headed ascender of the k can be replaced by a split ascender

The second stroke of the k can be extended and the third omitted

The flat-headed ascender of the l can be replaced by a split ascender

The final foot of the m can finish with a flick

Alternative foot

Alternative foot

The second foot of the n could alternatively terminate with a flick

The second stroke of the o is more semi-circular than the first

Alternatively, twist from the diagonal to the horizontal for the serif of the p

Full r **Half r**

The use of the half r is common in Rotunda text

Each stroke of the s begins or ends on the central hairline

Alternative crossbar

Twist the pen to the vertical to complete the crossbar of the t

The second leg of the u can finish with a flick

Alternative foot

Drag the ink with the corner of the nib to make the tail of the x

Conjoined d and e

Conjoined b and o

Any two letters with opposing bows can be conjoined

Apart from conjoined letters, Rotunda letterforms are clearly separated

Sequence of Rotunda letters

Rotunda Capitals

T HE STRUCTURE OF the Rotunda Capital is less clearly defined than the minuscule (*pp. 86–87*). Both single and double stem capitals can be used; historically, they were often combined with Lombardic Capitals (*pp. 64–65*). The double stem capitals shown here have been taken from a number of sources and should be regarded only as guide for individual interpretations. As with the Rotunda minuscules, a "double ductus" applies, with all curved strokes and some upright strokes drawn with the pen at 30°, and the remaining strokes drawn with the pen at the horizontal.

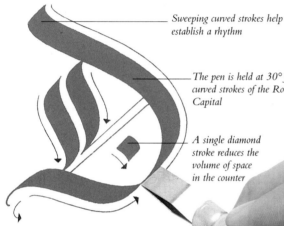

Sweeping curved strokes help establish a rhythm

The pen is held at 30° for the curved strokes of the Rotunda Capital

A single diamond stroke reduces the volume of space in the counter

Counters
The round, open nature of the Rotunda Capital tends to produce generous counters. The expanse of white space can be broken by the addition of spurs, diamonds, double hairlines, or a combination of these elements.

The feet are outlined and filled in with the corner of the nib

Square feet
If the pen is at 30° at the top of the stem, the angle should be maintained for the whole stroke, finishing at the baseline. To create the square foot, use the corner of the nib to trace along the baseline and up to join the right side of the stem. Fill in this triangle of white space with ink.

Alternative form of *M*
In this form of *M*, the double stroke is in the center of the letter and a large sweeping stroke has been incorporated. The volume of space in the counter has been reduced by the double hairline.

The gap between the two stem strokes should be about half a pen width

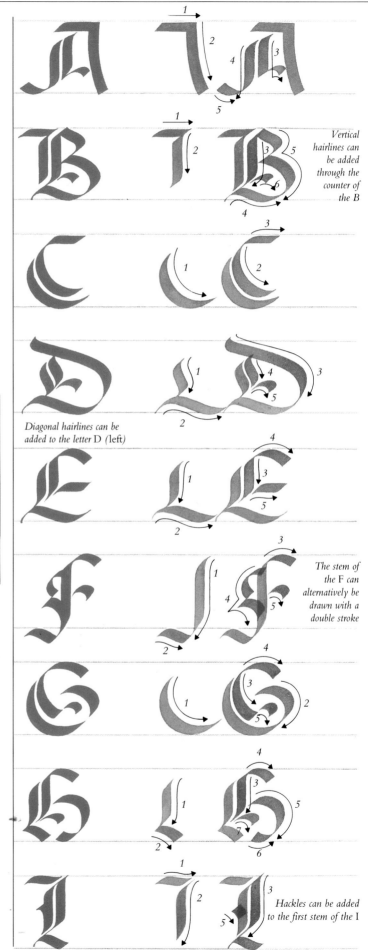

Vertical hairlines can be added through the counter of the B

Diagonal hairlines can be added to the letter D (left)

The stem of the F can alternatively be drawn with a double stroke

Hackles can be added to the first stem of the I

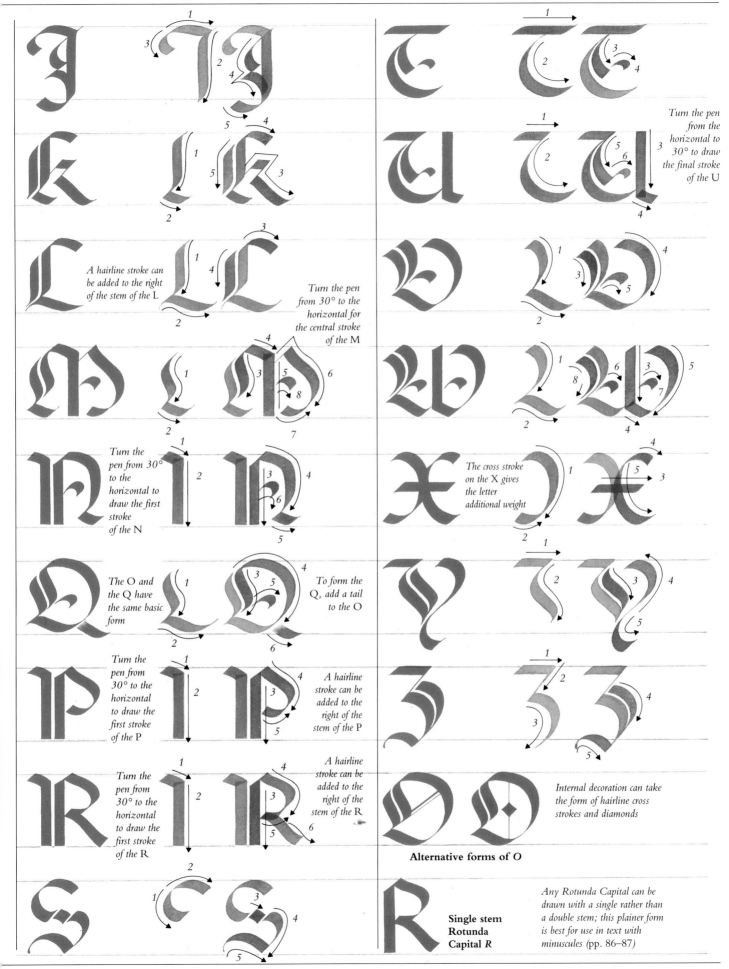

A hairline stroke can be added to the right of the stem of the L

Turn the pen from 30° to the horizontal for the central stroke of the M

Turn the pen from 30° to the horizontal to draw the first stroke of the N

The O and the Q have the same basic form

To form the Q, add a tail to the O

Turn the pen from 30° to the horizontal to draw the first stroke of the P

A hairline stroke can be added to the right of the stem of the P

Turn the pen from 30° to the horizontal to draw the first stroke of the R

A hairline stroke can be added to the right of the stem of the R

Turn the pen from the horizontal to 30° to draw the final stroke of the U

The cross stroke on the X gives the letter additional weight

Internal decoration can take the form of hairline cross strokes and diamonds

Alternative forms of O

Single stem Rotunda Capital *R*

Any Rotunda Capital can be drawn with a single rather than a double stem; this plainer form is best for use in text with minuscules (pp. 86–87)

Humanist Minuscule

T HE HUMANIST MINUSCULE (*Littera Antiqua*) and the Roman Imperial Capital (*pp. 108–109*) are the two historical scripts most influential in our modern society. Between them, they give us the basic constructions of our capital and lowercase letters, both in handwritten and typewritten form. In the Humanist Minuscule, the darker overtones of the Gothic scripts gave way to the lighter style of the Renaissance letter. It would be difficult to envisage a script better suited to the intellectual ideals of the age.

The serifs have been drawn with the pen held at 30°

HUMANIST MINUSCULE *M*
All Humanist Minuscule letters have an upright aspect with clearly defined strokes.

THE HUMANIST Minuscule was essentially a rediscovery of the Caroline Minuscule (*pp. 38–39*). As a clear, unambiguous hand, free from affectation, the Caroline was considered by 14th-century scholars, including the Italian poet Petrarch, to be in harmony with the ideals of the Renaissance.

Although the Humanist Minuscule was to have a profound and formative influence on modern Latin-based writing, acceptance of it was initially slow. The widespread popularity of the script came only after manuscript books were superseded by printed works, and it was adapted as a model for text typefaces, notably by Nicholas Jenson of Venice after 1470 (*pp. 38–39*). It gradually replaced the Rotunda in Italy (*pp. 84–85*) and the Gothic scripts of Britain and southern Europe as the principal model for typefaces.

BOOK OF HOURS
This Book of Hours was written in Bologna in about 1500 for Giovanni II Bentivoglio. Arguably, the sumptuous decoration and bright colors of the Versals detract from the dignity of the text script itself. The flat serifs at the heads of the ascenders are the natural product of a horizontally held pen (*pp. 92–93*).

Note the scrupulous consistency with which these small ampersands have been drawn throughout the text

The book has been handwritten on vellum

The Versals are based on Roman and not Lombardic letterforms (pp. 58–59)

ST. PAUL'S EPISTLE
Written in about 1500, this text combines Italic and Humanist Minuscule hands to dramatic effect. Despite the diminutive size of the letters, reproduced here approximately the same size as they are written, each character remains distinct and clearly legible. At a glance, the manuscript may be mistaken for a printed book.

In this margin annotation, the early use of Arabic numerals is evident

PRINTED TEXT
Fifteenth-century text type was closely modeled on the handwritten letters of the period. The similarities between this typeface (*below*), printed after 1486, and the handwritten Humanist Minuscule of St. Paul's Epistle (*above*) are very clear. The same serif formation has been used for both capitals and minuscules.

THE HANDWRITING OF PETRARCH
The script developed by Francesco Petrarch was probably the first Humanist Minuscule. This annotation by the poet to his copy of Suetonius's *Lives of Caesars*, was made in about 1370 and clearly demonstrates the degree to which he had adopted the Caroline Minuscule as a model for his hand.

These Italic letters were probably cut by the goldsmith Francesco Griffo in 1501

A small letter

Like the Caroline Minuscule, the Humanist Minuscule was an elegant hand that worked most successfully on a small scale. This is evident in the diminutive letters of the Epistles text (*above*). In Italy, the Rotunda (*pp. 84–85*) continued to be used for large-scale book work.

Versals and capitals

Versals, so popular with Gothic scribes, were also used with the Humanist Minuscule, but these were increasingly modeled on Roman forms (*pp. 108–109*). The use of capitals for sentence openings was now universal. Also derived from Roman forms, the Humanist Capitals were drawn with the same ductus as the minuscules and were the same height as the minuscule ascender (*pp. 98–99*). A rigid adherence to ascender and descender lines, along with clear line separation, helps give an ordered aspect to a page of text.

Humanist Minuscule

THE HUMANIST MINUSCULE is a direct descendent of the Caroline Minuscule (*pp. 40–41*). Letters are clearly defined, separate, and open; very close in form to modern letters, particularly those used as typefaces. There is no exaggeration of ascenders and descenders in the script and interlinear spacing is clear and regular. Humanist Minuscule can be written with a square-cut "slanted" or an oblique-cut "straight" pen. The letters shown here have been written with a "straight" pen. In both cases, the letters are upright and usually small in scale, with a minim height of about five pen widths.

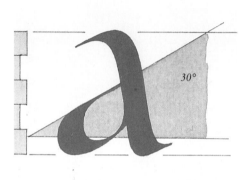

"Slanted" pen
The "slanted" pen Humanist Minuscule is based on the early hand of Poggio and relates quite closely to the Caroline Minuscule. It is written with a pen angle of 30–40°. The *a* is a double-story letter; this distinguishes it from the Italic *a*, which is a single-story letter (*pp. 96–97*).

"Straight" pen
During the latter part of the 15th century, there was an increasing tendency to write the Humanist Minuscule with a "straight" pen. The pen angle for this is shallow (5–15°) and a greater contrast between thick and thin strokes can be produced.

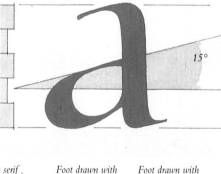

Wedge serif drawn in two strokes

Flat serif

Foot drawn with a "straight" pen

Foot drawn with a "slanted" pen

Serif types
The script features two types of serifs: wedge-shaped and flat. The wedge serif is created either in a single stroke or in two separate strokes (*above*). The flat serif is created with a single horizontal stroke. When using a "straight" pen, the flat serif can also be used to terminate upright minims and descenders (see letters *f, h, k, m, n, p, q, r, opposite*).

Minim feet
When using a "slanted" pen, the tendency is to create a turned foot, produced by terminating the minim stroke with a flick to the right. When using a "straight" pen, this flicking movement is more difficult. Instead, use the flat serif, or finish the stroke with a slight movement to the right along the baseline and then add a separate serif to the left.

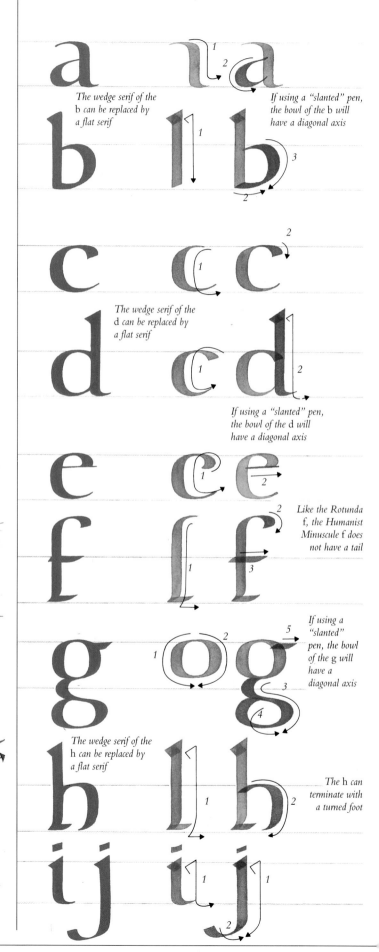

The wedge serif of the b can be replaced by a flat serif

If using a "slanted" pen, the bowl of the b will have a diagonal axis

The wedge serif of the d can be replaced by a flat serif

If using a "slanted" pen, the bowl of the d will have a diagonal axis

Like the Rotunda f, the Humanist Minuscule f does not have a tail

If using a "slanted" pen, the bowl of the g will have a diagonal axis

The wedge serif of the h can be replaced by a flat serif

The h can terminate with a turned foot

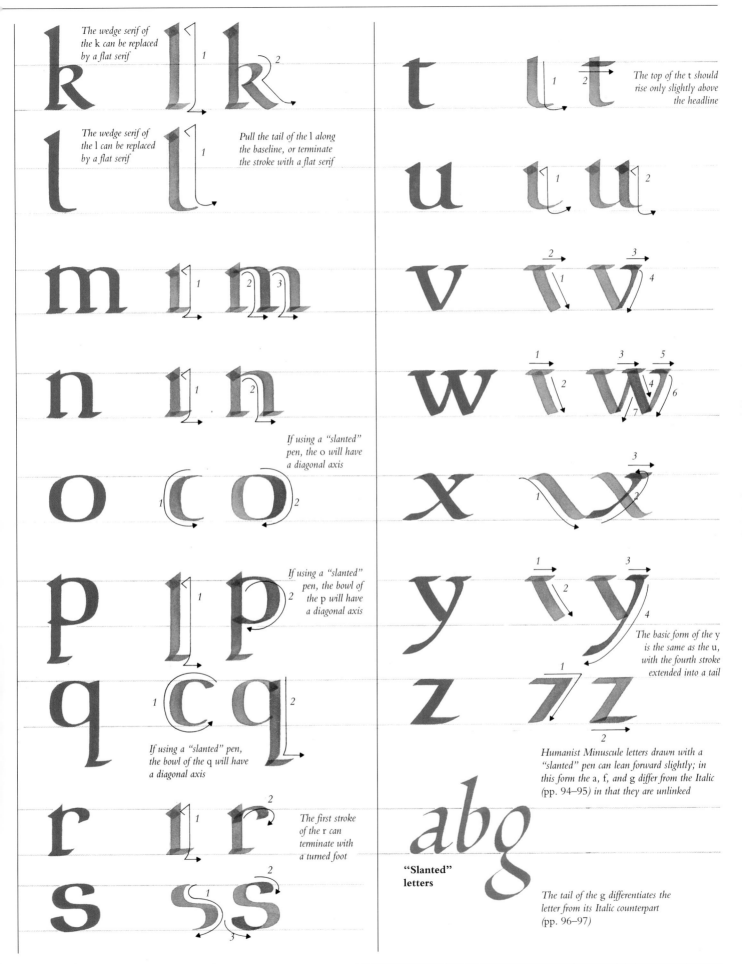

The wedge serif of the k can be replaced by a flat serif

The wedge serif of the l can be replaced by a flat serif

Pull the tail of the l along the baseline, or terminate the stroke with a flat serif

If using a "slanted" pen, the o will have a diagonal axis

If using a "slanted" pen, the bowl of the p will have a diagonal axis

If using a "slanted" pen, the bowl of the q will have a diagonal axis

The first stroke of the r can terminate with a turned foot

The top of the t should rise only slightly above the headline

The basic form of the y is the same as the u, with the fourth stroke extended into a tail

Humanist Minuscule letters drawn with a "slanted" pen can lean forward slightly; in this form the a, f, and g differ from the Italic (pp. 94–95) in that they are unlinked

"Slanted" letters

The tail of the g differentiates the letter from its Italic counterpart (pp. 96–97)

Italic

IN ITS BASIC FORM, Italic script (Chancery Cursive, *Cancellaresca Corsiva, Littera di Brevi*) is a cursive offspring of the Humanist Minuscule (*pp. 90–91*). Over time, it became a distinctive hand in its own right, spawning, in turn, the Copperplate (*pp. 102–103*). The script was invented in 1420 by Niccolo Niccoli, an Italian scholar who found the Humanist Minuscule too slow to execute. By 1440, his new, less labor-intensive script had been adopted as the official hand of the Papal Chancery.

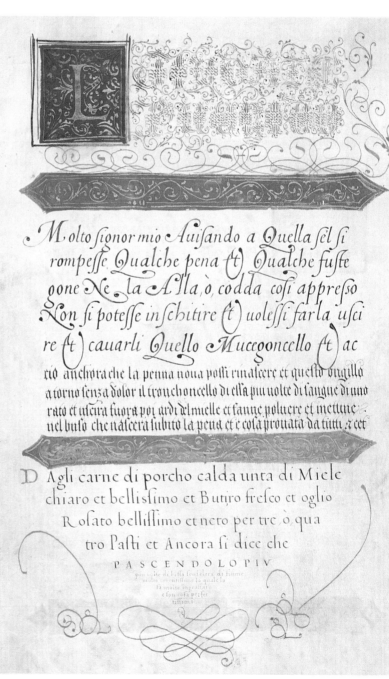

ITALIC A
The Italic *a*, with its fully formed bowl, is the earliest ancestor of our modern lowercase letter *a*.

Letters generally join at the midway point between the baseline and the headline

THE FOUR BASIC characteristics of Italic that were established by Niccoli tend to occur naturally when the Humanist Minuscule is written rapidly and with the minimum number of pen lifts: there is a tendency for the hand to lean to the right; circles become more oval; many letters can be written in a single stroke; and letters are joined to each other with a connecting stroke.

Changing the a

The character altered most significantly by Niccoli was the *a*, which he transformed from a tall two-story letter (*p. 92*) into a single-story letter of minim height (*above right*). His *q* also tended to follow this new form, resembling an *a* with a tail.

The terminals of Italic ascenders and descenders were drawn in one of two forms: the formata (semiformal), in which they were horizontal or wedge-shaped and left-facing, or the corsiva, in which they were rounded and right-facing (*pp. 96–97*).

TREATISE ON HAWKING
This page from a work by the Italian scholar Francesco Moro was penned in about 1560-70 and consists mainly of alphabets and texts in different hands. At the top, in gold, are two lines of Cadels (*pp. 80–81*). Beneath the blue border are the Italics, fully separated and generously spaced. The minuscule hand is a formata, identifiable by the wedge-shaped ascender serifs.
Four lines of Textura Quadrata (*pp. 50–51*) follow and, below the green border, are several lines of Humanist Minuscule (*pp. 90–91*).

SKRIFTKATALOG

The long ascenders and descenders have presented a problem for the scribe where they clash in the interlinear space

In this Italic text, the calligrapher has included both formata and corsiva ascenders; this l is the corsiva type

PRINTING TYPE CATALOGUE
This design from 1990 is by the Norwegian calligrapher Christopher Haanes. He has achieved harmony between the capitals and minuscules by reducing the size of the capitals to just above minim height.

SATURNALIA
This fine Italic script was written by Ambrosius Theodosius Macrobius in 1465. Each letter is clearly defined, reminiscent both of the Humanist Minuscule (*pp. 90–91*) and the earlier Caroline Minuscule (*pp. 38–39*). The capitals are small and restrained compared with those by Moro (*opposite*).

The influence of type

The changing demands brought about by the developing printing industry of the 15th century had an important influence on the Italic script. In 1501, the Venetian printer Aldus Manutius commissioned goldsmith Francesco Griffo to design a small Italic type (*pp. 90–91*) in which most of the characters were clearly separated. From that point, calligraphers began to follow the example of type by separating their penned letters. This led to a loss of some of the Italic's cursive quality and the script quickly reached its full maturity as a carefully crafted text hand. But by the 1550s, the complaint from scribes was that it had become too slow to write. From then, its decline was rapid, eventually being used only for text in parenthesis and for annotation.

Johnston's o

For the modern calligrapher, Italic script remains a constant source of inspiration. However, much new Italic can be traced back not to the 15th century but to the influence of the early 20th-century calligrapher Edward Johnston. The script was subtly modified by his introduction of two pulled strokes for the *o* and related letters, in place of the original single stroke (*pp. 42–43*).

The relative crudity of Morris's capital letters is probably due to his use of a pointed pen nib rather than the more suitable broad-edged nib

Although clearly an Italic script, Morris's letters are noticeably upright compared with a classic Italic such as Francesco Moro's (opposite)

WILLIAM MORRIS
Although Edward Johnston is generally regarded as the father of modern calligraphy (*pp. 42–43*), William Morris had been exploring the methods of medieval scribes two decades before him. This illuminated work of 1874 is an attempt to realize the vision of the Arts and Crafts movement by achieving communion between craftsman and tool (*pp. 42–43*). But since a pointed nib rather than a broad-edged pen has been used to draw the capitals, the attempt is only partially successful.

Italic

THE ITALIC HAND is written with a square-cut "slanted" pen, held at an angle of between 35 and 45°. Letters should be written with the minimum number of pen lifts – most can be written with a single stroke. The two traditional examples shown here are formata and corsiva. Formata letters are distinguished by the wedge serif to the left of the stem, corsiva by the swashes to the right of the stem. Ideally, the two different types should not be mixed. The *o* is the key letter of the script; it establishes the basic ductus of the hand, the curve of other letters, and the letter width (*below*).

Joining strokes
Where strokes spring from the stem of a letter, such as on *h*, *m*, and *n*, the stroke should begin about two pen widths below the headline. The bottom curve of the bowl of the *d*, *g*, and *q* meets the stem stroke about two widths above the baseline. All connecting strokes follow these basic rules.

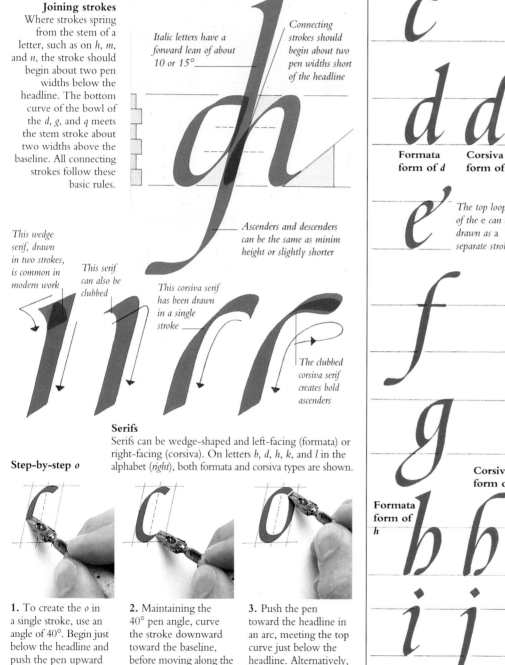

Italic letters have a forward lean of about 10 or 15°

Connecting strokes should begin about two pen widths short of the headline

Ascenders and descenders can be the same as minim height or slightly shorter

This wedge serif, drawn in two strokes, is common in modern work

This serif can also be clubbed

This corsiva serif has been drawn in a single stroke

The clubbed corsiva serif creates bold ascenders

Serifs
Serifs can be wedge-shaped and left-facing (formata) or right-facing (corsiva). On letters *b*, *d*, *h*, *k*, and *l* in the alphabet (*right*), both formata and corsiva types are shown.

Step-by-step *o*

1. To create the *o* in a single stroke, use an angle of 40°. Begin just below the headline and push the pen upward to the headline, before curving down to the left.

2. Maintaining the 40° pen angle, curve the stroke downward toward the baseline, before moving along the baseline and beginning to curve upward.

3. Push the pen toward the headline in an arc, meeting the top curve just below the headline. Alternatively, draw the letter in two strokes (*opposite*).

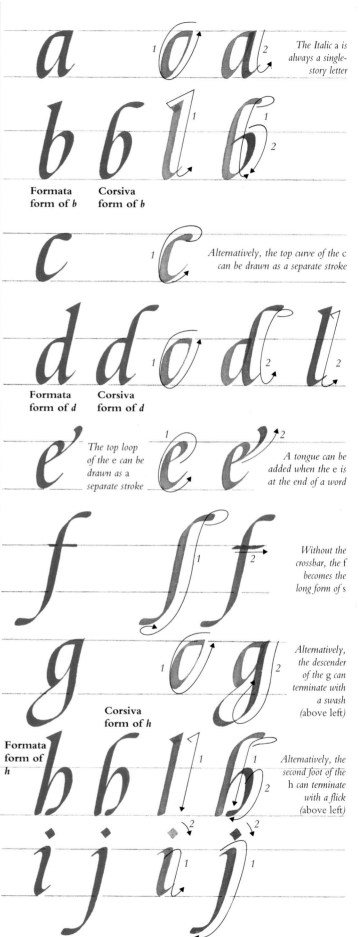

The Italic a is always a single-story letter

Formata form of *b* **Corsiva form of *b***

Alternatively, the top curve of the c can be drawn as a separate stroke

Formata form of *d* **Corsiva form of *d***

The top loop of the e can be drawn as a separate stroke

A tongue can be added when the e is at the end of a word

Without the crossbar, the f becomes the long form of s

Alternatively, the descender of the g can terminate with a swash (above left)

Corsiva form of *h*

Formata form of *h*

Alternatively, the second foot of the h can terminate with a flick (above left)

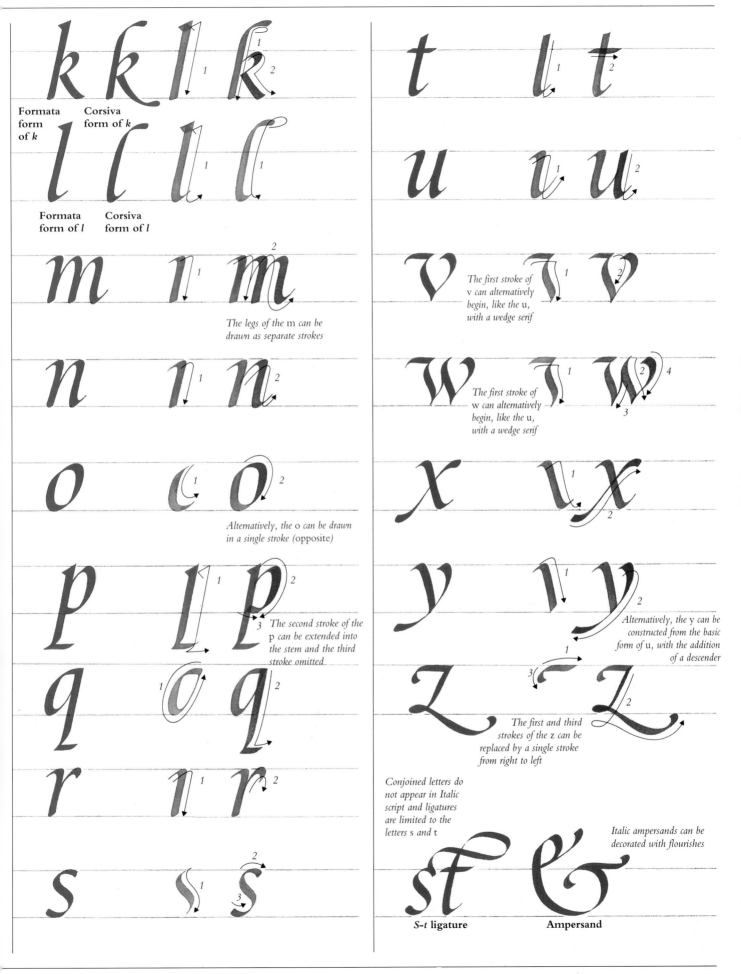

Formata form of *k* **Corsiva form of *k***

Formata form of *l* **Corsiva form of *l***

The legs of the m can be drawn as separate strokes

Alternatively, the o can be drawn in a single stroke (opposite)

The second stroke of the p can be extended into the stem and the third stroke omitted

The first stroke of v can alternatively begin, like the u, with a wedge serif

The first stroke of w can alternatively begin, like the u, with a wedge serif

Alternatively, the y can be constructed from the basic form of u, with the addition of a descender

The first and third strokes of the z can be replaced by a single stroke from right to left

Conjoined letters do not appear in Italic script and ligatures are limited to the letters s and t

Italic ampersands can be decorated with flourishes

***S-t* ligature** **Ampersand**

Humanist & Italic Capitals

HUMANIST CAPITALS ARE closely modeled on Roman Imperial Capitals (*pp. 110–119*) and can be used with the Caroline Minuscule (*pp. 40–41*) and Foundational Hand (*pp. 44–45*), as well as with Humanist Minuscules (*pp. 92–93*). A pen angle of 30° is most likely to produce letters with a similar stroke weight to the stone-cut Roman originals. Italic Capitals are based on the Humanist letterforms but have a distinctive forward lean. There are various possible serif formations (*below*), and any of these can be used on either type of capital.

Humanist and Italic Capitals should never exceed the equivalent of two minims in height

Italic Capitals lean to the right at the same angle as the minuscules (pp. 96–97)

Pen nibs
The same pen nib should be used for capitals as is used for the minuscules that they accompany. The serifs can be drawn with the pen at a slightly shallower angle than that used for the main stem strokes.

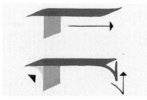

Arm serifs
Draw the arms of *E* and *F* and the top curves of *C*, *G*, and *S* in a single stroke and, if desired, build up the two serifs with the corner of the nib.

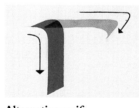

Alternative serifs
Alternatively, the top left serif can simply be the beginning of the stem stroke and the right serif can be created with a slight flick to the left.

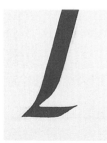

Basic foot serif
Create the basic foot serif by extending the stem to the left and finishing with a baseline stroke.

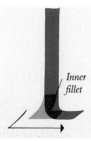

Bracketed serif
Alternatively, finish the stem stroke with a sweep to the right and add the left serif separately.

Inner fillet

Inner fillet
A third option is to draw the basic foot serif (*left*) and add the inner fillet with a short curve.

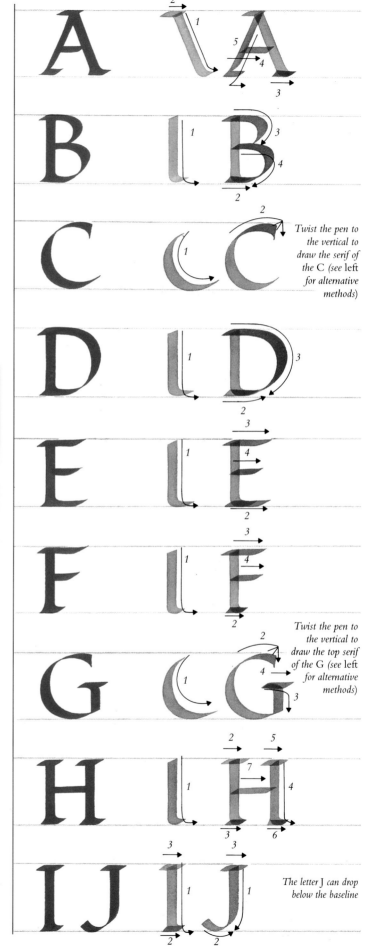

Twist the pen to the vertical to draw the serif of the C (see left for alternative methods)

Twist the pen to the vertical to draw the top serif of the G (see left for alternative methods)

The letter J can drop below the baseline

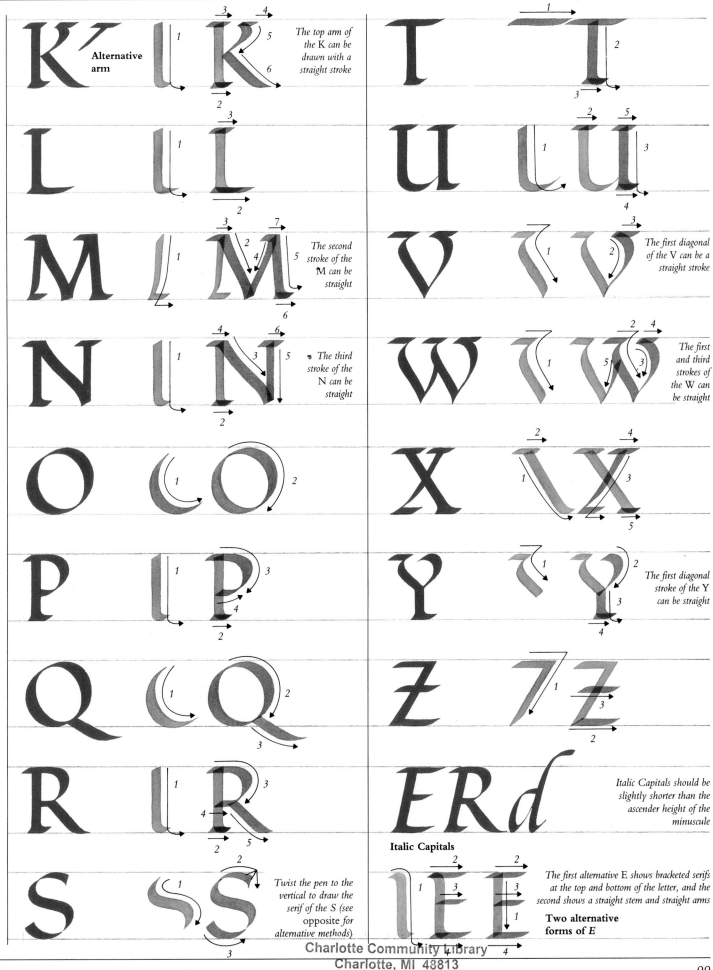

The top arm of the K can be drawn with a straight stroke

Alternative arm

The second stroke of the M can be straight

The third stroke of the N can be straight

The first diagonal of the V can be a straight stroke

The first and third strokes of the W can be straight

The first diagonal stroke of the Y can be straight

Twist the pen to the vertical to draw the serif of the S (see opposite for alternative methods)

Italic Capitals should be slightly shorter than the ascender height of the minuscule

Italic Capitals

The first alternative E shows bracketed serifs at the top and bottom of the letter, and the second shows a straight stem and straight arms

Two alternative forms of E

Italic Swash Capitals

A SWASH CAPITAL IS A flamboyant letter that traditionally served a similar function in Italic text to that of the colored Versal in Gothic text (*pp. 58–59*). It should never be used to write a complete word, but can be combined with standard Italic Capitals (*pp. 98–99*). The Swash Capital's characteristic showiness is created by the extension of stem strokes above or below the capital line and the extension of bowls and horizontal strokes to the left of the stem. These extended strokes terminate with a swash or, instead, can be looped like Copperplate Capitals (*pp. 106–107*).

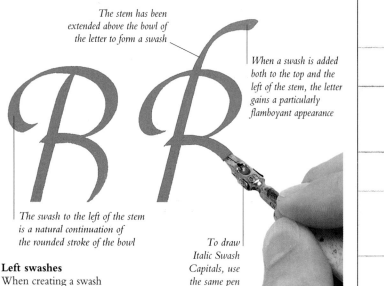

The stem has been extended above the bowl of the letter to form a swash

When a swash is added both to the top and the left of the stem, the letter gains a particularly flamboyant appearance

The swash to the left of the stem is a natural continuation of the rounded stroke of the bowl

To draw Italic Swash Capitals, use the same pen as for Italic minuscules (pp. 96–97)

Left swashes
When creating a swash from the bowl of a letter, such as that of the *B* or *R*, it is important that the swash is a natural extension of the bowl stroke, with the pen pulled in a sweeping movement. The letters in the alphabet (*right*) show the swashes added as separate strokes.

Top swashes
The stem can be extended upward and pulled to the right in the manner of a corsiva ascender on the Italic minuscule (*pp. 96–97*).

Draw the loop in a single movement without altering the pen angle

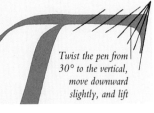

Twist the pen from 30° to the vertical, move downward slightly, and lift

Looped terminals
This clubbed, looped terminal can be used as an alternative to the swash in finishing the stem stroke. It works particularly well on a single stem letter such as an *I* or *P*. Create the loop by crossing back over the stem and pulling the stroke out to the right.

Formal arm serifs
This formal type of serif provides an elegant contrast to the flourishes. In construction, it closely imitates the brush-drawn Imperial Capital serif (*pp. 110–119*). On reaching the end of the arm, begin to twist the pen from 30° to the vertical.

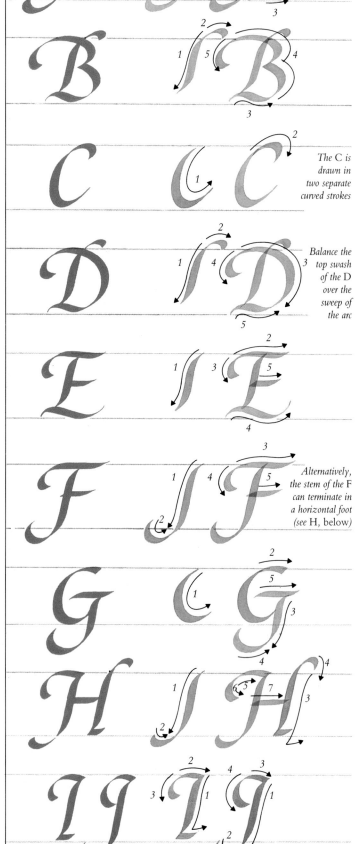

The C is drawn in two separate curved strokes

Balance the top swash of the D over the sweep of the arc

Alternatively, the stem of the F can terminate in a horizontal foot (see H, below)

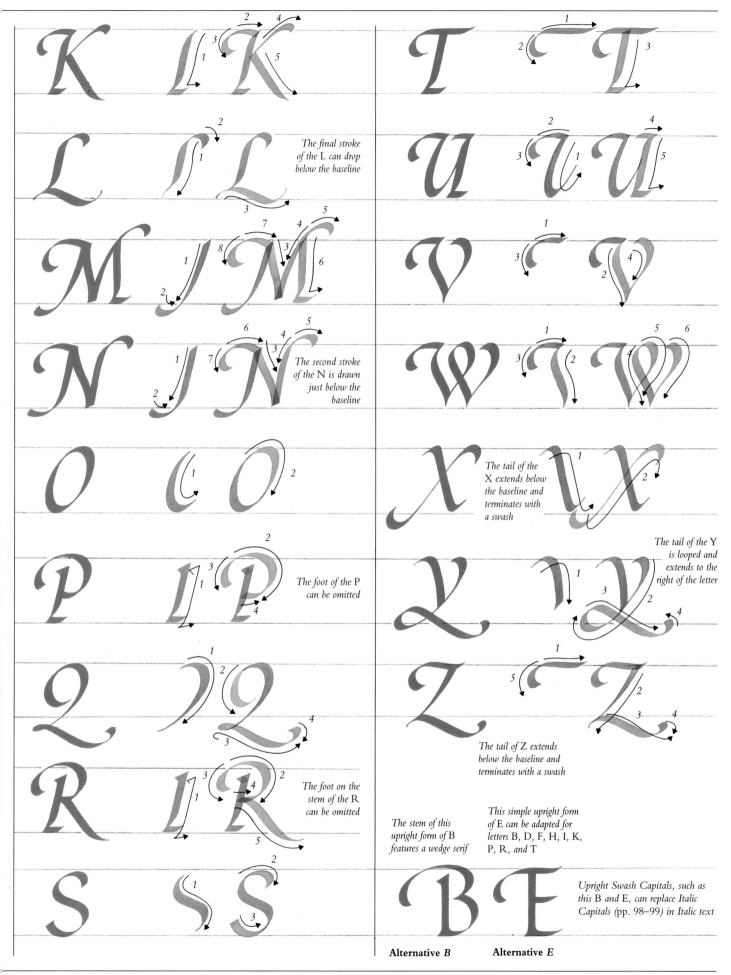

The final stroke of the L can drop below the baseline

The second stroke of the N is drawn just below the baseline

The foot of the P can be omitted

The foot on the stem of the R can be omitted

The tail of the X extends below the baseline and terminates with a swash

The tail of the Y is looped and extends to the right of the letter

The tail of Z extends below the baseline and terminates with a swash

The stem of this upright form of B features a wedge serif

This simple upright form of E can be adapted for letters B, D, F, H, I, K, P, R, and T

Upright Swash Capitals, such as this B and E, can replace Italic Capitals (pp. 98–99) in Italic text

Alternative B **Alternative E**

Copperplate

ALTHOUGH THE ITALIC script began life as a quickly penned, cursive version of the Humanist Minuscule, by the beginning of the 16th century it had become a formal script in its own right with a correspondingly slower ductus (*pp. 94–95*). In 1574, an instruction manual for Italic script was printed from text that had been engraved on sheets of copper with a pointed tool known as a burin. The hand developed for this new engraving method, combined with the narrower pen and slanted writing angle that scribes had begun to favor, led to the emergence of a new handwritten script: Copperplate.

Loops usually terminate with a hairline curl

The stem of the Copperplate Capital usually terminates with a blob

COPPERPLATE CAPITAL *B*
Although written to the same stroke thickness as the minims, Copperplate Capitals tend to be relatively large (*pp. 106–107*). The degree of expansion or contraction should closely echo that of the minim.

THE PRINCIPAL INNOVATION of the Copperplate was that, for the first time, all the letters in a word were linked, making it a fast and practical hand to write. By the mid-18th century, it was the established script of commerce, replacing the various bastard hands that had previously been used for much business and vernacular work in Europe (*pp. 66–79*).

Throughout the 17th and 18th centuries, Copperplate writing also acquired the status of an art form suitable for gentlefolk, who used the impressive script for both private and business correspondence. Eventually, Copperplate replaced the Humanist hands – including the Italic itself – altogether.

THE UNIVERSAL PENMAN
This version of an instructional text by Samuel Vaux is from *The Universal Penman*, a celebrated volume of engraved work by the calligrapher and engraver George Bickham. Published in 1743, the book epitomized the elegant writing manuals of the 18th century. The engraved letters, written with very few lifts of the tool, closely follow pen-drawn Copperplate letterforms.

WALPURGIS NIGHT
This handwritten text of a poem by the artist Richard Dadd dates from about 1840. The letters closely follow the approved "school" hand of the period: the minims are small, ascenders are relatively large and unlooped, and the hand is written at a very steep angle of nearly 40°.

Good Sense and Good-Nature are never separated, tho' the ignorant World has thought otherwise; Good-Nature, by which I mean Beneficence and Candor, is the Product of right Reason, which of necessity will give allowance to the Failings of others, by considering that there is nothing perfect in Mankind.

THE UNIVERSAL PENMAN
This engraving of an instructional text by W. Kippax is also from George Bickham's *Universal Penman*. Notice the looped and unlooped forms of ascenders used; on the third line, the word "which" includes both types.

W. Kippax Script

"COMMAND OF HAND"
In order to maintain their status as teachers, the 18th-century writing masters often produced a series of virtuoso calligraphic performances that were each known as "striking" or "command of hand," in which increasingly complex baroque flourishes were produced without the removal of pen from paper. This ornate work is one such example.

The strokes cross each other at the most acute angle possible

The loops, drawn to varying sizes, would have been carefully planned in advance

COPPERPLATE WORKSHOP
In letterpress printing, the raised surface of the type is inked and impressed onto paper. In copperplate (intaglio) printing, this process is reversed. Ink is applied to the inscribed surface and wiped from the face of the plate. Dampened paper is then pressed onto the plate, picking up the ink from the recesses. In this engraving, we can see the paper being forced onto the plate, while, in the background, printed sheets are drying on the racks.

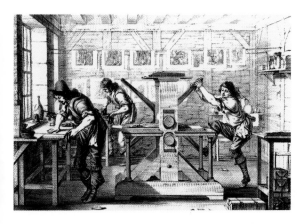

DAVID HARRIS
In the past, the production of Copperplate script from type was a very limiting process – joins did not fully connect and ascenders and descenders were atrophied. This 1984 design for a Copperplate typeface shows smoothly linked letters that are very close in form to the engraved script.

A preview of three typefaces designed by David Harris currently in course of development and production by Fonts

The calligrapher has broken with Copperplate convention by looping the letter d

Copperplate in education

The adoption of Copperplate script occurred remarkably rapidly, a phenomenon due partly to the role in education of the writing master. In the past, writing skills had been taught by university academics, but by the late 17th century, increasing literacy and the demands of business created the need for a teacher who taught writing exclusively. Examples of writing masters' work were reproduced by copperplate engraving, and schoolbook manuals began to supersede the elegant writing manuals – such as *The Universal Penman* – that previously had been widely favored.

Technical skill

By the 19th century, Copperplate was the standard school hand in Europe and the United States, and students were judged as much on writing technique as the content of their work. This emphasis on technical skill lasted well into the 20th century, when the Copperplate pen was usurped by the ballpoint pen, typewriter, and word processor.

Copperplate

THIS ELEGANT SCRIPT is probably the most cursive of all hands. Most letters can be written in one stroke and there are few pen lifts between letters. Minims can be slightly compressed and the characteristic loops of the ascenders and descenders can be drawn either open or enclosed. The best effects are often achieved by using compressed minims with enclosed loops. The fine lines of the burin engraving (*pp. 102–103*) are difficult to replicate with a steel nib but, with practice, impressive results can be achieved.

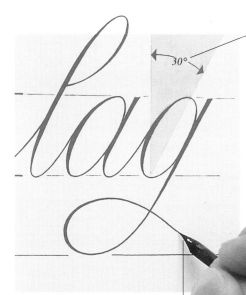

The forward lean of the Copperplate letter is about 30°

30°

Tool selection
Always use a pointed nib for Copperplate letters. A flexible drawing nib or made-to-order Copperplate nib will ensure the best variation of thick and thin strokes.

When strokes overlap, keep the pen angle as close to 90° as the script will allow

Adjusting the pressure
The pressure is adjusted twice on the average minim stroke. Begin with a gentle pressure to produce a fine line, increase it to thicken the stroke at the center of the minim, then relax it again at the bottom of the stroke.

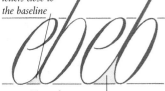

Avoid joining letters close to the baseline

Try to leave a neat triangle of space between each letter

Linking letters
Link letters wherever possible, ensuring that the link is as high up the stem as is practicable. Do not join letters near their base.

Internal spaces
Once you have decided whether to use compressed or expanded minims, make sure each counter contains the same amount of space. The inter-letter space should be approximately half the internal space.

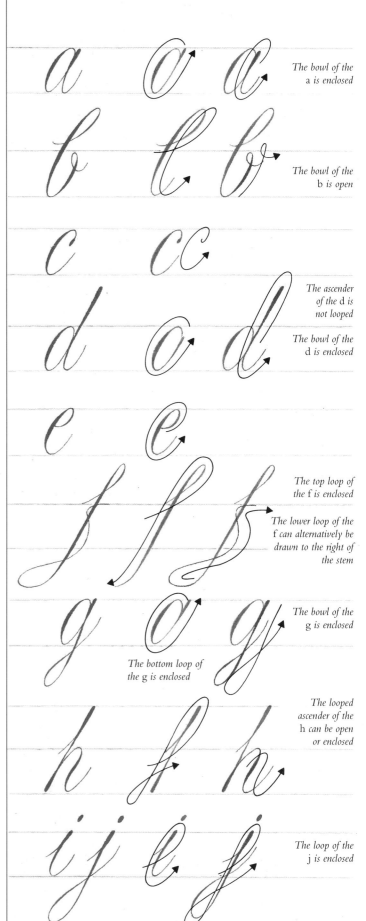

The bowl of the a is enclosed

The bowl of the b is open

The ascender of the d is not looped

The bowl of the d is enclosed

The top loop of the f is enclosed

The lower loop of the f can alternatively be drawn to the right of the stem

The bowl of the g is enclosed

The bottom loop of the g is enclosed

The looped ascender of the h can be open or enclosed

The loop of the j is enclosed

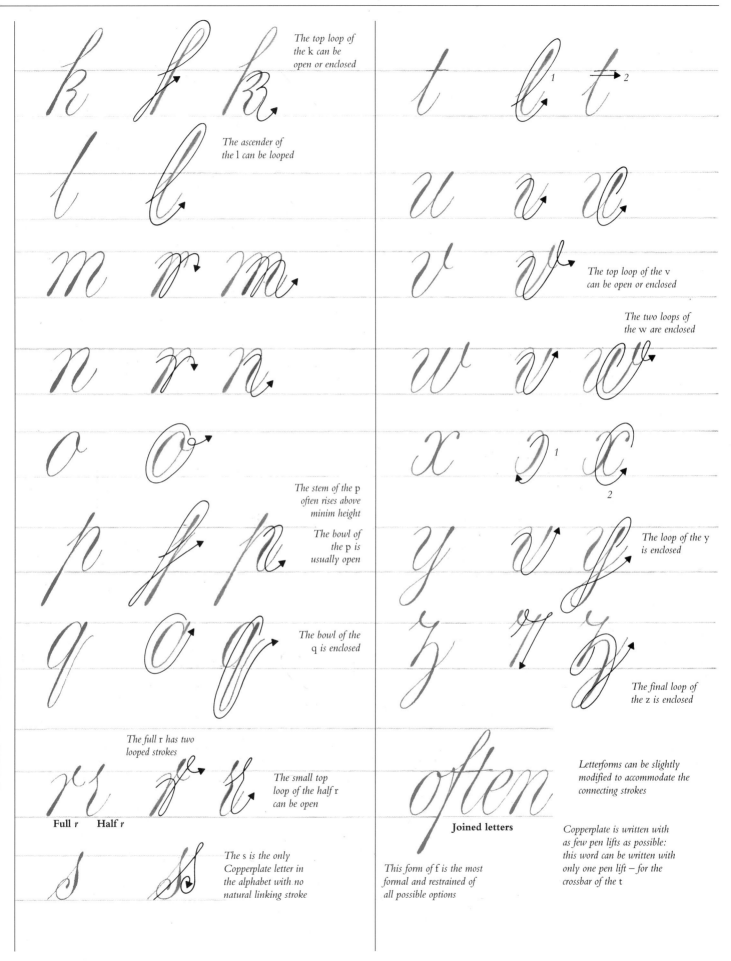

The top loop of
the k can be
open or enclosed

The ascender of
the l can be looped

The top loop of the v
can be open or enclosed

The two loops of
the w are enclosed

The stem of the p
often rises above
minim height

The bowl of
the p is
usually open

The loop of the y
is enclosed

The bowl of the
q is enclosed

The final loop of
the z is enclosed

The full r has two
looped strokes

The small top
loop of the half r
can be open

Full r **Half r**

The s is the only
Copperplate letter in
the alphabet with no
natural linking stroke

Joined letters

This form of f is the most
formal and restrained of
all possible options

Letterforms can be slightly
modified to accommodate the
connecting strokes

Copperplate is written with
as few pen lifts as possible:
this word can be written with
only one pen lift – for the
crossbar of the t

Copperplate Capitals

AMONG THE MORE useful practical advice offered in the Copperplate manuals of the 19th century (*pp. 102–103*) is this tip from writing masters James Lewis and Joseph Carstairs: "The writing hand should be lightly supported by the tip of the little finger and the forearm free to move in a circular movement." This can very helpfully be applied to the drawing of Copperplate Capitals, a script in which the precise control of pressure on the pen is central to the execution of each letter.

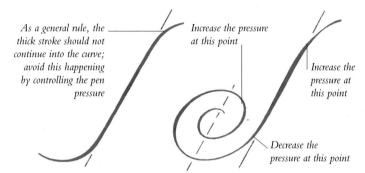

As a general rule, the thick stroke should not continue into the curve; avoid this happening by controlling the pen pressure

Increase the pressure at this point

Increase the pressure at this point

Decrease the pressure at this point

Incorrect S
This *S* shows how the letter will look if the pressure on the pen is not meticulously controlled. The stroke should only increase in weight when following the angle of the italic slope.

Correct S
To draw the *S* correctly, begin the stroke with light pressure, increasing it when reaching the italic slope angle. Decrease the pressure when moving away from the italic slope angle.

Loops
Loops should balance over the upright axis and, when used spirally, should diminish proportionately, rather like a snail's shell.

Crossing strokes
As a rule, thin strokes can cross both thick strokes and other thin strokes. However, thick strokes should never be crossed with other thick strokes.

Capitals and minuscules
Never use Copperplate Capitals to write a whole word. Where several capitals have to be used, such as for initials, plan the letters very carefully. When used to begin a word (*pp. 104–105*), the features of the Copperplate Capital can be adapted to complement the minuscules.

All the loops should closely relate to each other in proportion

Here, the tail of the L has been elongated and lowered to complement the minuscule letters

When terminating a stroke, finish with a hairline or apply pressure on the pen to leave a blob

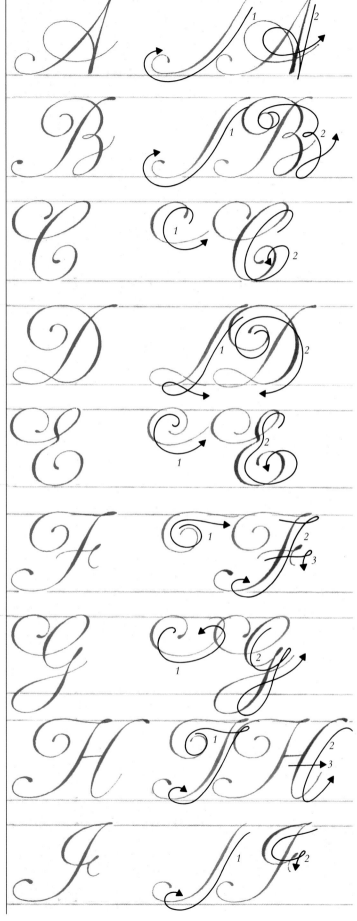

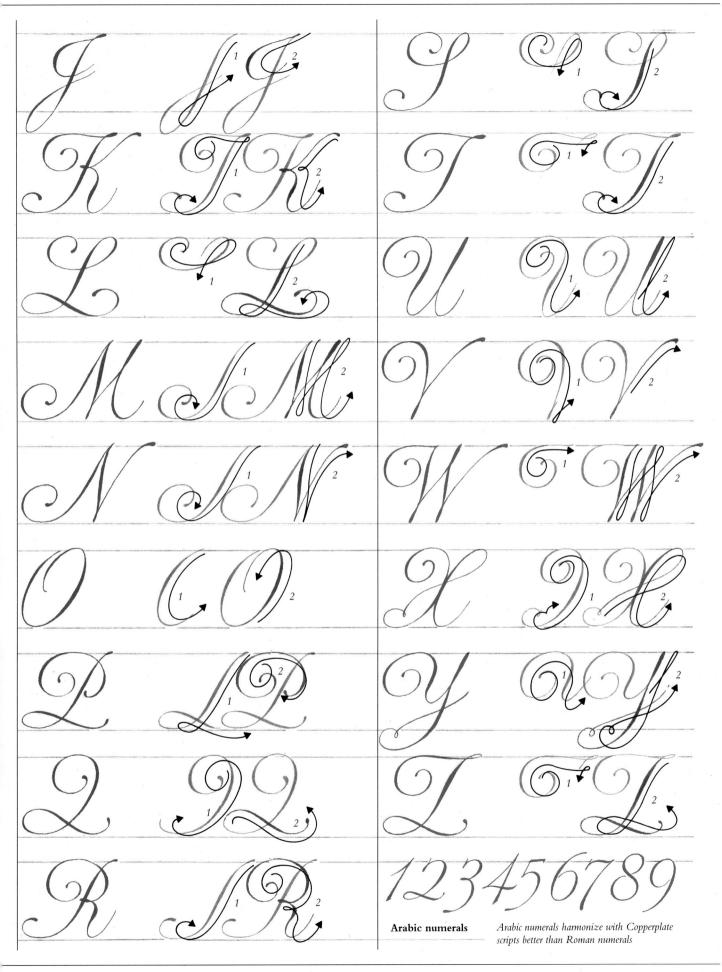

Arabic numerals *Arabic numerals harmonize with Copperplate scripts better than Roman numerals*

Imperial Capitals

T HE IMPERIAL CAPITAL (*Capitalis Monumentalis*) was the letter used on the monuments of Ancient Rome to proclaim the might of the Roman Empire, and is indisputably the most stately of all scripts. The earliest examples of a mature Imperial letter date from the first century BC, and some of the finest models are inscribed on the base of the Trajan Column in Rome (*opposite*). These stone-cut letters were carved directly on top of brush-drawn forms (*pp. 110–111*), their proportions dictated by the natural movement of the hand.

The proportions of Dürer's letter A are based on a subdivided square, with the serifs based on compass-drawn circles

DÜRER'S CLASSICAL A
The analysis and rediscovery of antique letters was a matter of great industry for Renaissance scholars and artists. This Imperial Capital, drawn by Albrecht Dürer in 1525, demonstrates the widespread belief that the key to understanding classical letters lay in geometric dissection.

CAPITAL LETTERS with serifs had been written by the Greeks from the fourth century BC. However, it was only when the Romans developed a springy, broad-edged brush from the hairs of the red sable that it became technically possible to draw serifs and other letter parts quickly and with precision. When used within the natural compass of the hand, this tool proved crucial in determining the shape of the Imperial Capital itself.

A key function

In a society with a high degree of literacy but without the benefit of the printed word, Roman scribes and signwriters performed key functions. Although what remains of their work is fragmentary, we do know, from one small painted section of an election poster in Pompeii, that – by simplifying some strokes – the Imperial Capital was adapted from the prestige letters of state for use in everyday documentation.

The Imperial Capital has become the most enduring of all scripts. More than 2,000 years after it was first used, its form remains virtually unchanged, as the capital letters in the type print of this book testify.

The frequency of the occurrence of Q in Latin text provides a distinct design advantage, with the tail gracefully descending below the baseline

The regulation of space between letters, words, and lines was of primary concern to the Roman scribe

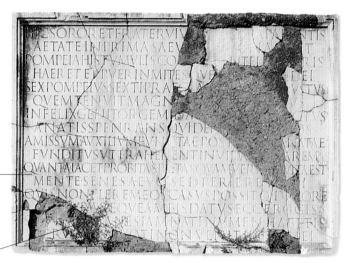

DETAIL FROM THE VIA APPIA MONUMENT
In this inscription on the Via Appia Monument, the interlinear space is equal to about half the height of a letter. Were the spacing any tighter, as it is on the Arch of Constantine (*opposite*), the ease of horizontal scan would be reduced and the letters would become jumbled.

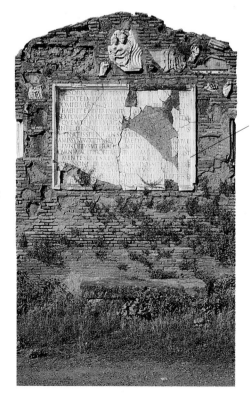

Compare the interletter spaces of the eleventh line with those of the twelfth to see how the spaces have been compressed to accommodate the allocation of text

VIA APPIA MONUMENT
The beautiful proportions of the letters on this monument in the Via Appia, Rome, compare very favorably with those on the base of the Trajan Column (*opposite*). Such a large amount of text would have required considerable advance planning. The initial allocation of words to each line may have been calculated on a wax tablet or slate, before working rules were drawn to letter height on the marble. Once the position of the letters was marked in chalk between the rules, the letters were painted with a brush. Only then were the words actually carved into the stone.

SENATVSPOPVLVSQVEROMANVS
IMPCAESARIDIVINERVAEFNERVAE
TRAIANOAVGGERMDACICOPONTIF
MAXIMOTRIBPOTXVIIIMPVICOSVIPP
ADDECLARANDVMQVANTAEALTITVDINIS
MONSETLOCVSTANE ... IBVSSITEGESTVS

THE TRAJAN COLUMN
This inscription on the base of the Trajan Column in Rome, cut in AD 112-3, is 9 feet (2.74 meters) wide and 3 feet 9 inches (1.15 meters) high. The inscription, commemorating the battles of Trajan against Germany and Dacia, begins with the phrase "*SENATVS POPVLVS QVEROMANVS*" ("The Senate and People of Rome"). The letters were originally colored red so that they would stand out from the background. Words are separated by a medial interpoint and the horizontal stroke over certain letters indicates their use as numerals.

The letters on the top line are 4¹/₂ inches (11.5 centimeters) high, reducing to 3³/₄ inches (9.6 centimeters) on the bottom line — probably indicating the relative importance of the words

The letter A, like the N and M, has a pointed apex, a form of Imperial Capital more difficult to construct than the common serifed or flat-headed letter (p. 113)

THE ARCH OF CONSTANTINE
This monument dates from AD 315, some 200 years after the Trajan Column (*above*). In some ways, it marks the degeneration of Rome, since many of the statues and reliefs on the column have been scavenged from earlier work. The letters are square-cut in shallow relief. Originally, the grooves would have housed bronze letters – the circular fixing holes can still be seen inside each letter.

The words "SENATVS POPVLVS QVEROMANVS" have been abbreviated to "S.P.Q.R." and relegated to the second line

Father Catich
Since the Renaissance, Imperial Capital letters have been studied, analyzed, improved, and recreated by countless scholars and calligraphers. However, it is only through the pioneering work of a modern scholar, the late Father E.M. Catich, that we can now fully understand the ductus of the hand. His analysis of Roman letter construction was demonstrated on 19 letters of the alphabet in his definitive work, *The Origin of the Serif*, published in 1968. These methods are interpreted for all 26 letters in the following pages (*pp. 110–119*).

Spontaneous letters
The great strength and beauty of the Imperial Capital lies in the fact that the letters can be written with spontaneity, the tool and hand determining the form, and one letter part relating naturally to the next. In much modern work, excessive preplanning can have the effect of making the letters appear labored. However, the methods explained in the following pages will enable the modern scribe to work in the same way as his or her Roman forebears and produce spontaneous letters for our own time.

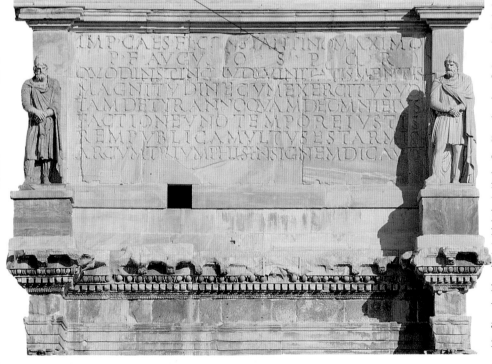

Imperial Capitals: Brush Strokes

IN ORDER TO RECREATE authentic Imperial Capitals, it is essential to use a broad-edged brush. This should be made from sable or synthetic hairs, which are fine enough to create a sharp clean edge when wet. Imperial Capitals are constructed either from "pulled" or "manipulated" strokes, or from a combination of both. In both types of stroke, the angle between the brush and the work surface is equally as important as the angle of the brush edge on the letter. When drawing letters with a brush, differences in stroke thickness are created by many factors, including changes in rhythm and tempo, and the increase or decrease of pressure on the tool. This sensitivity is generally most apparent on "manipulated" strokes (*opposite*).

A mahlstick is useful for keeping the hand clear of the writing surface

Brush movement for "pulled" strokes
With the hand resting directly on the work surface, the movement of the brush will be very small for a "pulled" stroke – about one inch (two or three centimeters). With the right hand resting on a mahlstick, the movement can be increased.

The basic "pulled" stroke
The "pulled" stroke is used in the majority of Imperial Capital letter strokes. The basic "pulled" stroke is the vertical stem stroke. For this, the hand moves only slightly, with the index finger drawn toward the palm of the hand, causing the brush to be pulled downward.

A movement of about two inches (five or six centimeters) can be achieved with the hand resting on a mahlstick

The index finger should be positioned on the ferrule of the brush

3. Continue pulling the brush downward, slightly reducing the pressure as you reach the center of the stem; this will give the stroke a slight waist. Increase the pressure again and, at the bottom of the stem, begin to lift the brush while moving to the right.

4. On letters *B, D, E,* and *L,* the vertical stem stroke is continued into the bottom horizontal arm. In these instances, the angle of the brush edge on the letter should be about 30°.

Adjust the brush angle to 30° for the addition of a thicker stroke to the right

1. Begin the stroke with the brush at a fairly flat angle to the surface. Gently edge the brush to the right and begin the downward sweep of the stroke.

2. As you move downward into the stem, gradually pull the brush toward the palm of your hand, until it is almost upright.

Other "pulled" strokes
The brush is held in a similar way on curved strokes as on vertical strokes, but instead of drawing the brush toward the palm of the hand, the hand moves in a semi-circular movement to the right or left. To make this movement smooth and easy, the angle of the brush edge on the letter should be about 15°.

Basic "pulled" stroke

The center stroke of the S is both "pulled" and sweeping

Letters A, M, and N always begin with a pointed apex

This is an alternative left serif for A, M, and N

This sweeping stroke is used on C, G, O, and Q

Opposing sweep for letters D, O, and Q

Small semicircular sweeps occur on B, P, and R

This tail stroke of K, R, and Q is executed with the brush turned to 30°

Letters M, N, V, and W have a diagonal stroke that turns upward at the baseline

The "manipulated" stroke

To draw "manipulated" strokes, you need to be able to twirl the brush through 180°. To make this possible, hold the brush between thumb and index finger with an angle of about 90° between the brush and the work surface. "Manipulated" strokes are used to create the four main types of serifs in Imperial Capitals: the top left serifs and arms of letters *T* and *Z* (*above right*); the top serifs that terminate the arms of letters *C, E, F, G, S,* and *T* (*right*); the bottom serifs and arms of *C, E, L,* and *Z* (*below*); and the bottom left serif of the *S* (*below right*). Although the top strokes of *C, S,* and *G* are curved, the principle remains the same as for the straight top arms of the *E* and *F*. For the bottom arms of *E, L,* and *Z*, the brush is positioned so that the angle of the edge on the letter is about 150°. The strokes of the top serifs are known as "forward" and those of the bottom serifs as "reverse." The bottom serif of the *S* is unique in that the brush begins rather than ends at the serif tip.

Top left serif on *T* and *Z*

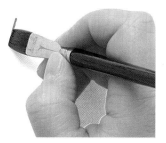

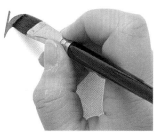

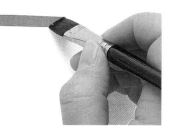

1. Begin the top left serif on the *T* and *Z* by bringing the brush downward in a short stroke.

2. Twirl the brush to 30° to create the left serif, slightly increasing the pressure as the brush twirls.

3. Without adjusting the angle of the brush edge on the letter, move the brush horizontally to create the arm.

Top right serif on *C, E, F, G, S,* and *T*

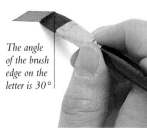

The angle of the brush edge on the letter is 30°

Rotate the brush, pivoting it at the top right corner

Finish the arm with the left corner of the brush

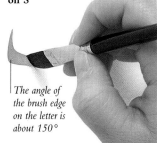

1. To create the top right serif of *C, E, F, G, S,* and *T*, hold the brush in an upright position and begin the horizontal stroke with the brush edge on the letter at 30°.

2. Continue moving the brush horizontally, maintaining the angle of 30° until the brush approaches the end of the arm. At this point, begin to rotate the brush on its right corner.

3. Continue to rotate the brush on its left corner until the edge is 90° to the arm. Finally, move it downward slightly and "edge off," gently lifting the brush from the surface.

Bottom arm and right serif on *C, E, L,* and *Z*

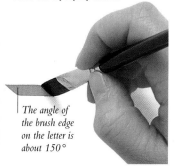

The angle of the brush edge on the letter is about 150°

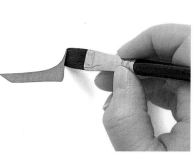

Bottom serif on *S*

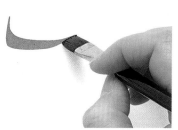

The angle of the brush edge on the letter is about 150°

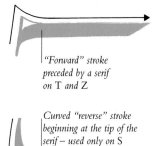

1. To create the bottom arm and right serif on *C, E, L,* and *Z*, begin with the angle of the brush edge on the letter at about 150°, and move to the right.

2. On reaching the end of the stroke, twirl the brush to the vertical, then move upward and edge off, finishing on the left corner of the brush.

1. The bottom serif of the *S* is the only bottom serif on the left side of a letter. Begin at the tip of the serif, moving the brush downward.

2. Twirl the brush to 30° and curve to the right and upward. Work carefully, for the first part of the stroke will be obscured by your hand.

Straight and curved "manipulated" strokes

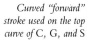

"Forward" stroke used on the top and center arms of the E *and* F

Curved "forward" stroke used on the top curve of C, G, *and* S

Curved "reverse" stroke used on the bottom curve of C

"Forward" stroke preceded by a serif on T *and* Z

"Reverse" stroke used on the bottom arm of E, L, *and* Z

Curved "reverse" stroke beginning at the tip of the serif – used only on S

Imperial Capitals: Construction

THE 26 CHARACTERS constructed in the following pages are based on the 19 letters included in the inscription on the base of the Trajan Column in Rome (*pp. 108–109*). The two Greek-derived letters, *Y* and *Z*, are based on other Roman sources, and the remaining three letters, *J*, *U*, and *W*, are modern characters, which, as such, are open to individual interpretation. In principle, the letters adhere to the ductus described by Father E.M. Catich in his book *The Origin of the Serif*. Each letter is individually demonstrated by stroke sequence and brush angle. The pressure on the brush and the speed at which the strokes are drawn will vary from the brush of one calligrapher to another, and the rhythm that suits you best will be acquired with practice.

White lines indicate a change of brush angle, in this instance from 30° to the vertical

The first stroke – the key to the letter – is drawn in pink

One stem width

Five stem widths

Six stem widths

Seven stem widths

Nine stem widths

Nine stem widths

Ten stem widths

9½ stem widths

Color coding
Each letter has been constructed from a series of color-coded strokes: pink indicates the first stroke, purple the second, green the third, and yellow the fourth. The frequently changing brush angles are represented by a series of white lines across the stroke.

Letter weight
It is generally assumed that the weight – the relationship between stem width and stem height – of the Trajan letter is 10:1. A balance of 11:1 is generally considered acceptable, although the actual letter weight is about 9.5:1.

The H is created from two Is joined with a crossbar

The fillet between the serif and stem of an Imperial Capital can be slightly fuller than this

Letter proportions
When writing a series of Imperial Capitals, it is essential to know the relative width of one Imperial Capital to another. The width of a letter – including serifs – is measured in stem widths. The apparent discrepancy in weight between rounded and straight letters is optical; rounder letters appear lighter than straight ones. To our modern eyes, this can be displeasing and the effect is "corrected" by the addition of extra weight to the curved strokes. Arguably, the original weight differences give the Imperial inscriptions a more natural rhythm than that achieved in more formal modern work.

Arabic numerals

Numerals
Although Arabic numerals were not introduced into Europe until the 13th century, avoiding their use in favor of Roman numerals can be an encumbrance in modern calligraphy. Arabic numerals can be drawn using a similar ductus to the Imperial Capital letters and can be contained within the capital height. The *0* is usually a narrow numeral, but if used singly, it can be made wider, resembling a letter *O* (*p. 116*).

Stroke order for numerals

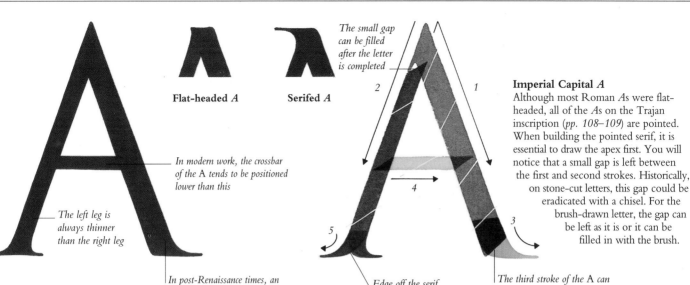

Flat-headed *A*　　　**Serifed** *A*

The small gap can be filled after the letter is completed

In modern work, the crossbar of the A tends to be positioned lower than this

The left leg is always thinner than the right leg

In post-Renaissance times, an inner serif was included on the right leg of the A – this is omitted in modern work

Edge off the serif with the tip of the brush

The third stroke of the A can alternatively be drawn as a continuation of the first stroke

Imperial Capital *A*

Although most Roman *A*s were flat-headed, all of the *A*s on the Trajan inscription (*pp. 108–109*) are pointed. When building the pointed serif, it is essential to draw the apex first. You will notice that a small gap is left between the first and second strokes. Historically, on stone-cut letters, this gap could be eradicated with a chisel. For the brush-drawn letter, the gap can be left as it is or it can be filled in with the brush.

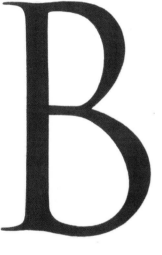

The right axis of the arc is above the horizontal

The second and third strokes of the B can be combined in a single sweeping stroke

Turn the brush from the horizontal to 30° and move along the baseline

Imperial Capital *B*

On the *B*, the fillet between the stem and curve of the lower bowl is an important characteristic, which only occurs on the brush-drawn letter. It will only occur at the bottom of the stem, never at the top. The top bowl is always smaller than the bottom and the joining stroke always above the stem's center. The bottom bowl can alternatively be constructed with a single sweep.

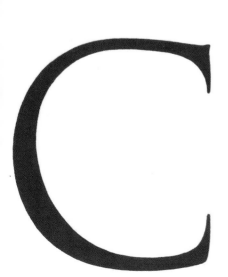

Twist the brush from 30° to 90° to draw the top serif of the C

The axis of the left of the arc is below the horizontal

Turn the brush over and twist from 150° to the vertical to draw the bottom serif

Imperial Capital *C*

The top and bottom strokes of the *C* are pulled out horizontally and do not curve inward. The two serifed arms are very similar in construction to those on the *E* (*p. 114*), which should be used as a model. The only difference is that the arms on the *C* are curved, not straight. Remember to turn the brush over to 150° for the bottom stroke.

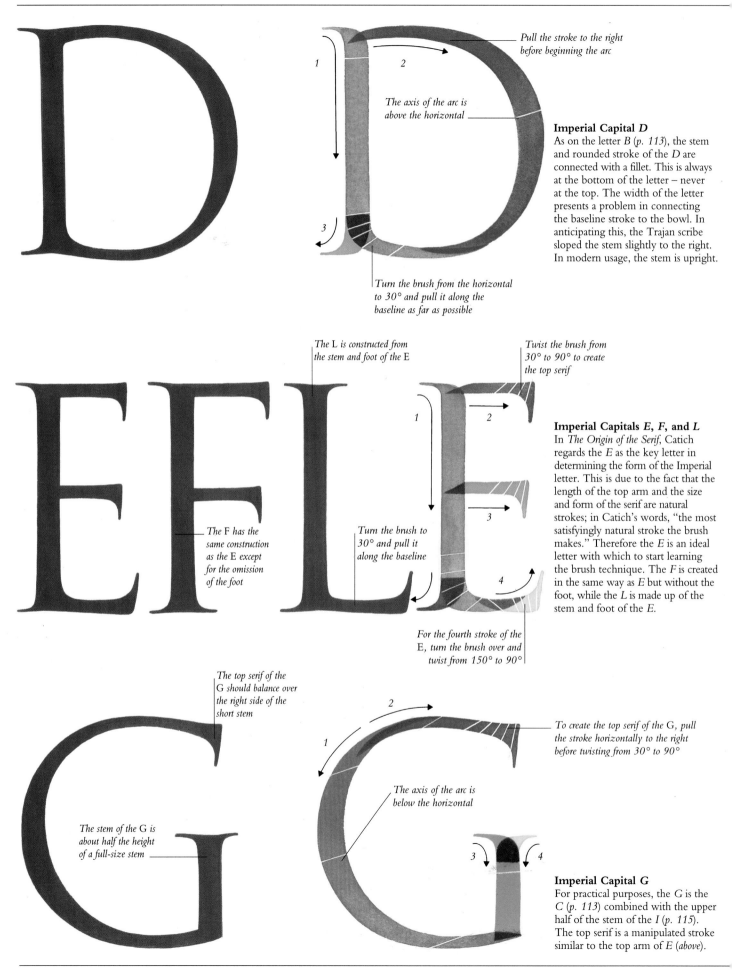

Pull the stroke to the right
before beginning the arc

The axis of the arc is
above the horizontal

Imperial Capital *D*
As on the letter *B* (*p. 113*), the stem
and rounded stroke of the *D* are
connected with a fillet. This is always
at the bottom of the letter – never
at the top. The width of the letter
presents a problem in connecting
the baseline stroke to the bowl. In
anticipating this, the Trajan scribe
sloped the stem slightly to the right.
In modern usage, the stem is upright.

Turn the brush from the horizontal
to 30° and pull it along the
baseline as far as possible

The L is constructed from
the stem and foot of the E

Twist the brush from
30° to 90° to create
the top serif

The F has the
same construction
as the E except
for the omission
of the foot

Turn the brush to
30° and pull it
along the baseline

Imperial Capitals *E*, *F*, and *L*
In *The Origin of the Serif*, Catich
regards the *E* as the key letter in
determining the form of the Imperial
letter. This is due to the fact that the
length of the top arm and the size
and form of the serif are natural
strokes; in Catich's words, "the most
satisfyingly natural stroke the brush
makes." Therefore the *E* is an ideal
letter with which to start learning
the brush technique. The *F* is created
in the same way as *E* but without the
foot, while the *L* is made up of the
stem and foot of the *E*.

For the fourth stroke of the
E, turn the brush over and
twist from 150° to 90°

The top serif of the
G should balance over
the right side of the
short stem

To create the top serif of the G, pull
the stroke horizontally to the right
before twisting from 30° to 90°

The axis of the arc is
below the horizontal

The stem of the G is
about half the height
of a full-size stem

Imperial Capital *G*
For practical purposes, the *G* is the
C (*p. 113*) combined with the upper
half of the stem of the *I* (*p. 115*).
The top serif is a manipulated stroke
similar to the top arm of *E* (*above*).

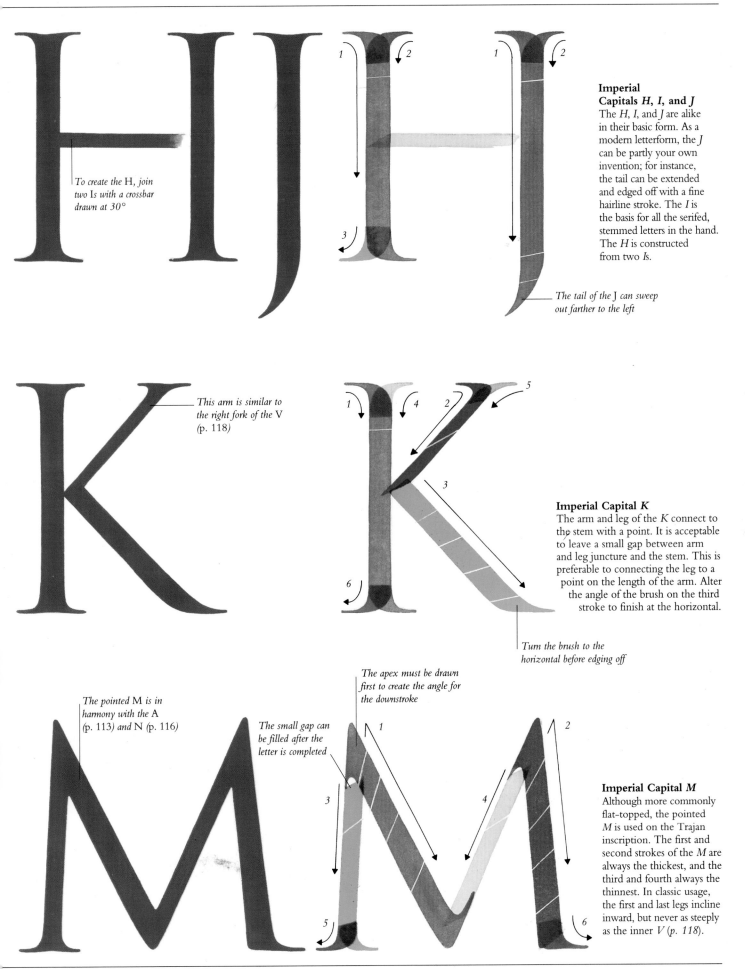

To create the H, join two Is with a crossbar drawn at 30°

Imperial Capitals *H*, *I*, and *J*

The *H*, *I*, and *J* are alike in their basic form. As a modern letterform, the *J* can be partly your own invention; for instance, the tail can be extended and edged off with a fine hairline stroke. The *I* is the basis for all the serifed, stemmed letters in the hand. The *H* is constructed from two *Is*.

The tail of the J can sweep out farther to the left

This arm is similar to the right fork of the V (p. 118)

Imperial Capital *K*

The arm and leg of the *K* connect to the stem with a point. It is acceptable to leave a small gap between arm and leg juncture and the stem. This is preferable to connecting the leg to a point on the length of the arm. Alter the angle of the brush on the third stroke to finish at the horizontal.

Turn the brush to the horizontal before edging off

The pointed M is in harmony with the A (p. 113) and N (p. 116)

The small gap can be filled after the letter is completed

The apex must be drawn first to create the angle for the downstroke

Imperial Capital *M*

Although more commonly flat-topped, the pointed *M* is used on the Trajan inscription. The first and second strokes of the *M* are always the thickest, and the third and fourth always the thinnest. In classic usage, the first and last legs incline inward, but never as steeply as the inner *V* (p. 118).

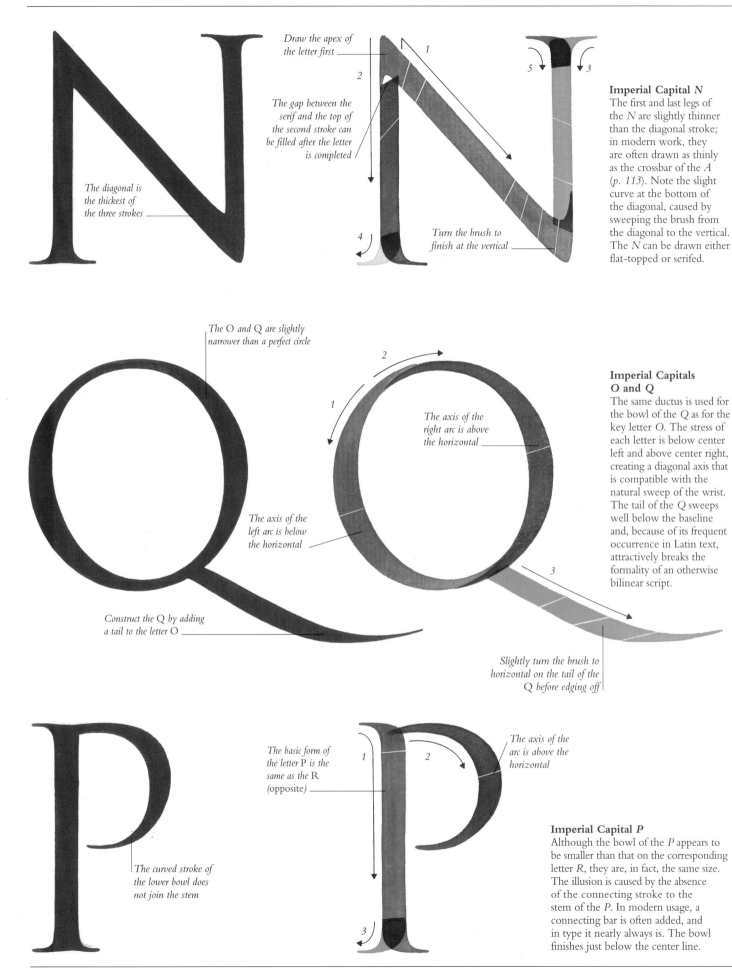

Draw the apex of the letter first

The gap between the serif and the top of the second stroke can be filled after the letter is completed

The diagonal is the thickest of the three strokes

Turn the brush to finish at the vertical

Imperial Capital *N*
The first and last legs of the *N* are slightly thinner than the diagonal stroke; in modern work, they are often drawn as thinly as the crossbar of the *A* (p. 113). Note the slight curve at the bottom of the diagonal, caused by sweeping the brush from the diagonal to the vertical. The *N* can be drawn either flat-topped or serifed.

The O and Q are slightly narrower than a perfect circle

The axis of the right arc is above the horizontal

The axis of the left arc is below the horizontal

Construct the Q by adding a tail to the letter O

Slightly turn the brush to horizontal on the tail of the Q before edging off

Imperial Capitals *O* and *Q*
The same ductus is used for the bowl of the *Q* as for the key letter *O*. The stress of each letter is below center left and above center right, creating a diagonal axis that is compatible with the natural sweep of the wrist. The tail of the *Q* sweeps well below the baseline and, because of its frequent occurrence in Latin text, attractively breaks the formality of an otherwise bilinear script.

The curved stroke of the lower bowl does not join the stem

The basic form of the letter P is the same as the R (opposite)

The axis of the arc is above the horizontal

Imperial Capital *P*
Although the bowl of the *P* appears to be smaller than that on the corresponding letter *R*, they are, in fact, the same size. The illusion is caused by the absence of the connecting stroke to the stem of the *P*. In modern usage, a connecting bar is often added, and in type it nearly always is. The bowl finishes just below the center line.

The bowl of the R is the same size as that of the P (opposite)

The tail of the R continues an imaginary diagonal line across the letter that begins at the top serif

The axis of the arc is above the horizontal

Imperial Capital *R*

The *R*, together with the *E* (p. 114), is a useful letter on which to practice brush-drawn Imperials because it contains more elements of other letters than any other character. The juncture of the bowl and connecting stroke is a valuable indicator of the brush-drawn origins of the script. This has systematically been removed by scribes in an attempt to "improve" the letter. The tail is a very satisfying stroke to draw, producing a gradual thickening of the tail near the baseline.

Flatten the brush to the horizontal before edging off

Twist the brush from 30° to 90° to complete the serif

Imperial Capital *S*

The curved strokes of the *S* often present a rather awesome prospect to the beginner. In fact, once the *E* has been mastered (p. 114), the *S* should not prove difficult. The Trajan *S* has a forward lean, which slightly interferes with the flow of the script. The tail serif is the only part of the letter that may require additional practice. It is the only arm serif that is constructed tip first, and aggravated by the hand obscuring the first stroke. For this reason, it is essential to draw the tail of the serif as the second stroke, while the hand "remembers" where the first stroke finished.

Commence at the tip of serif, twist the brush backward, and pull it along the baseline

Each arm is the same length as the arms of the E and F (p. 114)

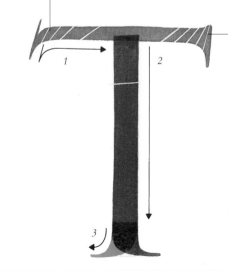

The right arm of the T is exactly the same as the top arm of the E (p. 114)

Imperial Capital *T*

The cross stroke of the *T* is an extremely elegant shape with subtle changes of angle between serifs, and a gradual swelling of the arm leading into and away from the serifs. The arm starts with a slight downward movement with the edge of the brush twisting back to 30° before moving along the arm and finishing at 90°. On an inscription, the initial juncture would be filled in by the chisel.

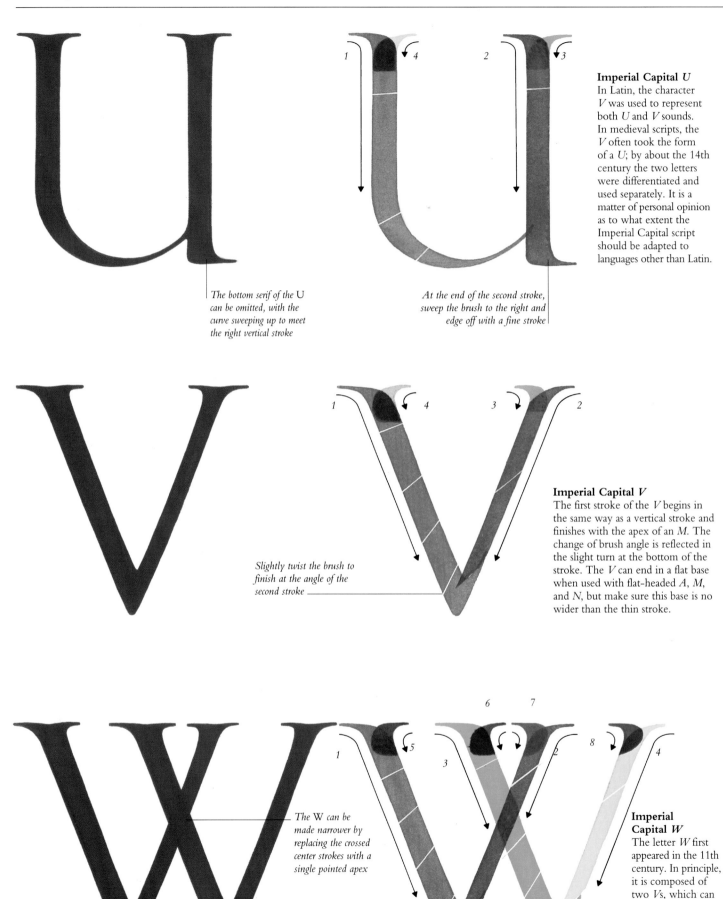

Imperial Capital U
In Latin, the character *V* was used to represent both *U* and *V* sounds. In medieval scripts, the *V* often took the form of a *U*; by about the 14th century the two letters were differentiated and used separately. It is a matter of personal opinion as to what extent the Imperial Capital script should be adapted to languages other than Latin.

The bottom serif of the U *can be omitted, with the curve sweeping up to meet the right vertical stroke*

At the end of the second stroke, sweep the brush to the right and edge off with a fine stroke

Imperial Capital *V*
The first stroke of the *V* begins in the same way as a vertical stroke and finishes with the apex of an *M*. The change of brush angle is reflected in the slight turn at the bottom of the stroke. The *V* can end in a flat base when used with flat-headed *A*, *M*, and *N*, but make sure this base is no wider than the thin stroke.

Slightly twist the brush to finish at the angle of the second stroke

The W *can be made narrower by replacing the crossed center strokes with a single pointed apex*

Imperial Capital *W*
The letter *W* first appeared in the 11th century. In principle, it is composed of two *V*s, which can either cross one another or join in a single apex in the center of the letter.

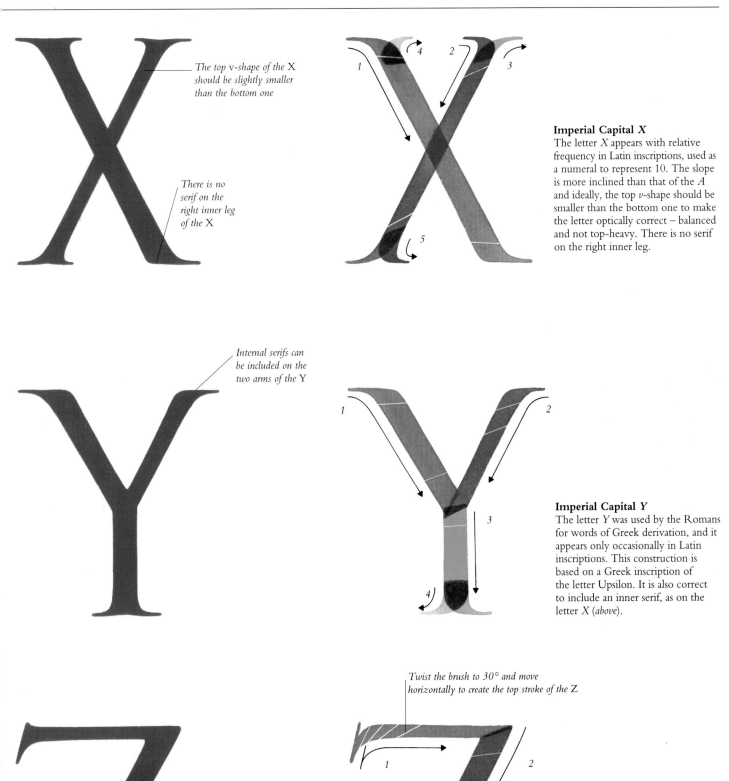

The top v-shape of the X should be slightly smaller than the bottom one

There is no serif on the right inner leg of the X

Imperial Capital X
The letter X appears with relative frequency in Latin inscriptions, used as a numeral to represent 10. The slope is more inclined than that of the A and ideally, the top v-shape should be smaller than the bottom one to make the letter optically correct – balanced and not top-heavy. There is no serif on the right inner leg.

Internal serifs can be included on the two arms of the Y

Imperial Capital Y
The letter Y was used by the Romans for words of Greek derivation, and it appears only occasionally in Latin inscriptions. This construction is based on a Greek inscription of the letter Upsilon. It is also correct to include an inner serif, as on the letter X (*above*).

Twist the brush to 30° and move horizontally to create the top stroke of the Z

The second stroke is thicker than most diagonal strokes in the script

Turn the brush over and twist from 150° to 90° to draw the bottom stroke

Imperial Capital Z
The Z is an interesting construction, which combines the top arm of the T and the bottom arm of the E, separated by an awkward diagonal stroke – awkward in the sense that a stroke moving to the left is naturally thin (see A, *p. 113*). However, a thin stroke would make the letter appear inordinately light, and so the brush is held near to the horizontal to create a thick diagonal.

Script Reference Chart

		A	B	C	D	E	F	G	H	I		K	L	M	N	O
ROMAN & LATE ROMAN SCRIPTS	Imperial Capitals															
	Rustic															
	Uncial															
	Square Capitals															
	Half Uncial															
INSULAR & NATIONAL SCRIPTS	Insular Majuscule															
	Insular Minuscule															
CAROLINE & EARLY GOTHIC SCRIPTS	Caroline Minuscule															
	Early Gothic															
GOTHIC SCRIPTS	Textura Quadrata															
	Textura Prescisus															
	Gothic Capitals															
	Lombardic Capitals															
	Bastard Secretary															
	Bastard Capitals															
	Bâtarde															
	Fraktur															
ITALIAN & HUMANIST SCRIPTS	Rotunda															
	Rotunda Capitals															
	Humanist Minuscule															
	Italic															
	Humanist Capitals															
POST-RENAISSANCE SCRIPTS	Copperplate															
	Copperplate Capitals															

Notes on scripts

Prestige Roman hand used in brush-drawn and carved forms; the letterforms are the basis of many modern capitals

First-century script used in manuscript, signwritten, and carved forms; later used only for chapter headings

Latin version of the Greek Uncial with rudimentary ascenders and descenders; used by the early Christian Church

Late Roman capitals reserved for non-Christian deluxe manuscripts; a time-consuming letter to pen

A more cursive form of Uncial incorporating ascenders and descenders; the letterforms are the basis of minuscule letters

Combines Uncial and Half Uncial elements; developed by Irish-Northumbrian Celtic monks

Cursive form of the Insular Majuscule used for documentary work; continued to be used in Ireland into the 20th century

Reformed Half Uncial; established hand of the Frankish Empire; the model for 15th-century Humanist Minuscule

Compressed version of the Caroline Minuscule used in the 12th century; presaged later Gothic scripts

Fully compressed Gothic letter from the early 13th century; characterized by diamond terminals of minims

Twin script of the Quadrata; characterized by flat feet on minims; used for prestige manuscript work

Accompanying capitals for Textura minuscules

A built-up, prestige display and Versal capital; usually used in conjunction with Quadrata or Prescisus scripts

A cursive Gothic script used only for vernacular and documentary work

Capital letters used with bastard minuscules, including those in the Bâtarde and Fraktur hands

French version of the Bastard Secretary

German, late bastard script with many Textura features; with Schwabacher, it remained in use until the mid-20th century

Italian hand; contemporary with Gothic scripts; rounder and more open than other northern European hands

Accompanying capitals for Rotunda minuscules

Renaissance hand influenced by the Caroline Minuscule; the letterforms are the basis for much modern printing type

Cursive form of the Humanist Minuscule; used in modern type for text in parenthesis and annotation

Accompanying capitals for Humanist and Italic minuscules; pen-drawn derivatives of Imperial Capitals

Extreme form of cursive script with most letters linked; derived from Italic and influenced by copperplate engraving

Accompanying capitals for Copperplate minuscules

Glossary

Ampersand The character & denoting the word "and."

Anthropomorphic decoration A style of letter decoration that incorporates imagery of human forms.

Apex The pointed tip of a letter, as in *A*.

Arch The portion of a lowercase letter formed by a curved stroke springing from the stem, as in *h* and *n*.

Arm A horizontal stroke touching the letter at only one end, as in *E* and *F*.

Ascender The upper stem of a lowercase letter, as in *b*, *d*, and *k*.

Ascender line A writing line to which the upper stems of letters rise.

Axis In Roman Imperial Capitals, this is the imaginary line that passes through the thickest points of a letter. Also known as the "stress" of the letter.

Baseline The writing line on which the main body of the letter sits.

Bastard script A Gothic script of mixed Textura and cursive elements.

Bilinear The term used to describe a script that is written between, and adhering to, two imaginary writing lines.

Black Letter See **Textura**.

Bookhand The generic term for scripts used in books before the age of printing. Bookhands include Uncial and Caroline Minuscule.

Bowl The curved stroke attached to the letter stem that creates an enclosed space (counter), as in letters *b*, *d*, and *g*. Also known as "bow."

Bracketed serif A type of serif that forms a fillet with the stroke of a letter.

Built-up letters Letters that are outlined and filled, or constructed one section at a time.

Burin A pointed tool used in copperplate engraving.

Cadel An ornate Gothic capital letter constructed from a series of interlacing pen strokes written with the minimum number of pen lifts.

Capital height The height of a majuscule (capital) letter.

Cadels are ornate Gothic Capital letters that were originally used with bastard text scripts

Capital letter See **majuscule**.

Capital line The writing line to which uppercase letters rise. The capital line is often slightly lower than the ascender line.

Capsa A container for storing scrolls.

Compressed letter A style of lettering in which the characters and interletter spaces are narrower than is usual.

Conjoined A term used to describe letters that are joined together.

Copperplate An extremely slanted script with distinctive flourishes that developed from letter engraving on thin plates of copper.

Counter Any space within a letter, either fully or partially enclosed.

Crossbar The horizontal stroke on a letter, as in *t* and *H*. Also known as the "bar."

Cross stroke A horizontal mark essential to the letter, made either from left to right or right to left, such as on the letters *E*, *F*, and *T*.

Cursive A rapid form of writing, using elements such as linking and loops.

Deluxe A term used to describe the highest grade of manuscript writing.

Descender The lower stems of letters such as *p*, *q*, and *f*.

Descender line The line on which a letter's descender should rest.

Display capitals Decorated capitals used in the introductory word or words of a text but not singly as versals.

Downstroke A stroke that is directed downward.

Ductus The direction and order of the strokes used to construct a letter.

Ear A small stroke that projects from the top of the letter *g*.

Edge off A term used with reference to brush-drawn letters to describe the technique of removing the edge of the brush from the writing surface, with the left corner lifted last.

Edge on The technique of gradually placing the full edge of the brush onto the surface, with the right corner touching the surface first.

Hairlines are drawn with the corner of the pen nib and often taper from a thicker stroke

"Elephant's trunk" A broad, sweeping stroke that hangs from the ascenders in certain bastard scripts, such as the English Bastard Secretary.

Expanded letter A style of lettering in which the characters and interletter spaces are wider than usual.

Filigree Elaborate decoration in the form of fine, curved lines.

Fillet The name given to the filled angle that is formed between a stroke and its serif.

Floriated Decorated with images of flowers.

Folio A leaf of a manuscript. Also refers to the page number.

Fret patterns Ornamental designs that can be used to form the border of a page or can be woven into the text. The simplest fret patterns are composed solely of straight lines.

Gilding The application of gold leaf to the writing surface.

Gothic scripts The generic term for hands written between about 1200 and 1500.

Gouache Watercolor mixed with a type of chalk to achieve an opaque effect.

Hairline A fine line used to link letters, terminate strokes, fill large counters, and decorate letters.

Half r A form of the letter *r*, the spine of which is provided by the previous letter.

Headline The line to which the uppermost point of a letter – excluding its ascenders or descenders – rises. Also known as the "waistline."

"Hierarchy of scripts" The name given to the code of practice whereby different scripts

Italic script is characterized by linked letters with a distinctive forward slant

appearing in the same manuscript adhere to a strict order of use: the most regal hand is used for the titles and important details, the next most formal script for the first sentence, and so on.

Historiated The term used to describe initial letters that are decorated with the human figures described in the text.

Illumination Originally, the term referred only to gilded decoration, but it is now used to describe any form of text decoration.

Insular Originating from the Latin word for "island," this term is applied by paleographers to indicate a shared culture between Ireland and northern Britain, free from Continental influence.

Interlace A form of decoration in which lines weave in and out of each other.

Interletter space The space between characters.

Interlinear gloss Words written in the interlinear space of the main text to provide a commentary on the text or a translation of its contents.

Interlinear space The space between the baseline of one line of text and the headline of the line below it.

Italic A Humanist style of writing in which the oval-shaped, linked letters slant to the right.

Leading minim The name given to the first minim of a letter, as in *m* and *n*.

Letterform The shape of a letter.

Ligature The linking of letters by one or more strokes.

Where the bowls of letters are combined, the letters are referred to as "conjoined"

Link The stroke that connects the top and bottom of the minuscule *g*.

Loop The enclosed space in an ascender or descender, as in *g*.

Lowercase See **minuscule**.

Majuscule A bilinear script in which the letters are of equal height. A capital letter.

Manuscript A handwritten book or document predating the invention of printing. Can be abbreviated to "ms."

Minim A downstroke that is as tall as the body height of the script.

Minim height The height of a minuscule letter, excluding the ascender and descender. Also known as "x height" or "body height."

Minuscule Any noncapital letter. Minuscule scripts contain letters of uneven height because of the ascenders and descenders.

Movable type Individual letters made from metal that can be inked and printed in any order.

Paleography The study of the history of handwriting and documents.

Papyrus The earliest form of paper; made

A manuscript is a book or document written by hand

from the stem of the papyrus plant.

Parchment A writing surface made from mammalian skin, usually sheepskin or goatskin.

Quill A writing implement made from the tail or wing feather of a bird, such as turkey or goose.

Reed pen A writing tool made from a hollow-stemmed marsh plant.

Roman The Latin alphabet. The term is also used to describe any plain, upright letter.

Rubricated Originating from the Latin word *ruber* for "red," this describes letters in a heading or within a passage of text that are colored red.

Rune Any letter in the ancient Germanic alphabet. The characters contain no curved strokes and very few horizontal strokes.

Sable A very fine pointed brush, made from the tail hairs of the sable, a dark-furred mammal of northern Asia.

Serif A short, decorative stroke used to finish off the stroke of a letter. Many different types exist, including the bracketed serif and the wedge serif.

Skate The technique of gently pulling the wet ink from one stroke to create another stroke, often a hairline.

"Slanted" pen A pen with the nib cut at right angles to the shaft. Held at an angle, the position of the nib is "slanted" to the stem.

Spur A small projection off a main stroke.

Stem The main vertical stroke of a letter. It can be drawn at an angle for a slanted script, and can be the main diagonal stroke of the letter, as in *N* and *Z*.

Stipple To engrave, paint, or write in dots.

"Straight" pen A pen with the nib cut obliquely to the shaft, facilitating the drawing of an upright stem. When positioned horizontally, it will produce a greater contrast in thick and thin strokes, an effect known as "shading."

Stroke Any straight or curved line that has been penned or painted.

Tail A diagonal line that connects to the letter at one end, as in *Q* and *y*.

Terminal A stroke that does not end with a serif.

Text script A script that is particularly suitable for pages of text, due to its clarity and lack of decoration. Also known as "body text" or "text hand."

Textura From the Latin word for "woven," this is the name given to a style of Gothic script characterized by dense, compressed characters and minimal interlinear space.

Thorn sign The Anglo-Saxon sign resembling a *y* that was used to represent the "th" sound.

Uncial A late Roman script with rudimentary ascenders. The name means "inch high."

Uppercase See **majuscule**.

Vellum A type of writing surface made from calfskin.

Versal A built-up ornamental capital letter used to open verses and paragraphs.

Decorative abbreviated strokes known as "serifs" can be drawn in a variety of different styles

Waistline See **headline**.

Weight The relationship of a letter's nib width to its height.

Word space The amount of space between words.

Zoomorphic decoration A style of decoration incorporating imagery of animal forms.

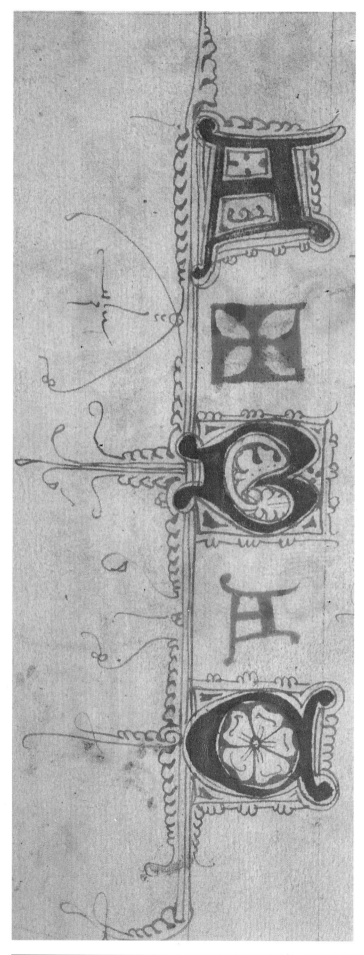

Bibliography

The Decorated Letter, J.J.G. Alexander/Thames and Hudson, London, 1978

The Winchester Bible, Clare Donovan/British Library, Winchester Cathedral, 1993

Manuscripts at Oxford – R.W. Hunt Memorial Exhibition, Edited by A.C. de la Mare and B.C. Barker-Benfield/Bodleian Library, Oxford, 1980

Eyewitness Guide to Writing, Karen Brookfield/Dorling Kindersley, British Library, London, 1993

The Golden Age of English Manuscript Painting 1200-1500, Richard Marks and Nigel Morgan/Book Club Associates, London, 1981

Anglo-Saxon Manuscripts, Michelle P. Brown/British Library, London, 1991

A Book of Scripts, Alfred Fairbank/Penguin Books, London, 1949

Writing, David Diringer/Thames and Hudson, London, 1962

Das Schreib-Büchlein von Rudolf Koch, Johannes Stauda Verlag Kassel, 1984

Thesauro de Scrittorio 1535, Ugo da Carpi, introduction by Esther Potter/ Nattali and Maurice, London, 1968

Writing and Illuminating and Lettering, Edward Johnston, originally published 1906, reprinted by A. & C. Black, London, 1983

English Handwriting 1400-1500, Jean F. Preston and Laetitia Yeandle/State University, New York, 1992

A Guide to Western Historical Scripts from Antiquity to 1600, Michelle P. Brown/British Library, 1990

The Book of Kells, Selected and introduced by Peter Brown/Thames and Hudson, 1980

The Lindisfarne Gospels, Janet Backhouse/Phaidon, Oxford, 1981

The Universal Penman, Engraved by George Bickham, 1743/Dover Publications Inc., New York, 1954

The Art of Calligraphy, Western Europe and America, Joyce Irene Whalley/ Bloomsbury Books, London, 1980

The Story of Writing, Donald Jackson/Studio Vista, 1981

Medieval Calligraphy, Its History and Technique, Marc Drogin/George Prior Associated Publishers Ltd., London, 1980

Calligraphy: The Art of Written Forms, Donald M. Anderson/Dover Publications Inc., New York, 1992

The Origin of the Serif, Edward M. Catich/Catich Gallery, St. Ambrose University, Iowa, 1968

Masters of the Italic Letter, Kathryn A. Atkins/Penguin Press, London, 1988

The Italic Calligraphy Handbook, Carolyn Knudsen/Stemmer House Publishers Inc., Maryland, 1985

Calligraphy, Inspiration, Innovation and Communication, David Harris/Anaya, London, 1991

Books of Hours and their Owners, John Hartham/Thames and Hudson, 1977

Lettering Old and New, Translated by Dr. W.E. Walz/Batsford, London, c.1930

Ornamental Alphabets and Initials, Alison Harding/Thames and Hudson, 1983

Celtic Knotwork, Iain Bain/Constable, London, 1986

Index

Beatus vir qui non abiit in consilio impi-
orum et in via peccato-
rum non stetit et in cathedra

Verba mea auribus
percipe domine intel-
lige clamorem meum
Intende voci orationis mee

Nottula simplex

vnde willighe begherlichett vlitlich toventm Alle leueste
rod here vnde here wy bidden iw vnde ermanen in dusser
digen schrifft dat gy den be ghonden krych willen aff laten
vnsen willen den gy an ghe hauen hebben wyrt heren b
vnder erfoset iw twene erbar vnde van kunsten riche wise
alle wy ok twene kesen de twissen vnven gnaden vnde syner
to beidentsyden eyn myddel moge vinden Dit schal ganz

Notula acuta

vnsen luttren grot mit vlitliker begherlichen alle tyd toventm
herde borne vorste here vnde here dry bidden iwke hochwerdighen
edelicheit vlitlichen in dussem reghenswardigh breue dat gy wolde
myt willen laten van dine lande dat gy an ghenomen hebben van
heren ol. Dat wir myt vnser edelicheit nicht dat dar vinne
domen vnwilligen wente wir to rade sint ge worden vnde besundin
myt wolbedachtem rechtverdighen rade vnser oldesten alle de seckelt
vnser lantheesten vnse rechtes sind dine male dat wy nicht andere

Semi quadratus

Dum invocarem exaudivit me
deus iustitie mee in tribula
tione dilatasti michi Miserere
et exaudi orationem meam

Textus Rotundus

Quare fremuerunt gentes et populi
meditati sunt in ania disterunt
reges terre et principes convenerunt
in unum adversus dominum et adver

Nottula fracturarum

eth in luttr gemichert Wolleliker begherlicheit
herrn toventm ghenen heren vnde Besundern frunde
mer dr wy bidden vnde ermanen vnde alle ghe
dat gy dricken vnde baren rades ... wy ghe
mogen willen ... de vrstoren den gnaden
den kesen dar dot ... gy gheret vor nunte

Nottula aslauata

Vnsen ghe strenghen edelen wol ghe bornen nanne che ...van g
nen vruntliken ginner sal desse breff tectera. Vnsen
begheliken truwen wyllen in rechtem vlite toventm leue here her
vnde, vnse eghentike ghunner vns vnde den vnsen to dusse

deus secundum magnam misericordiam tuam ... secundum multitudinem
tuarum dele iniquitatem meam ... lava me ab iniquitate
a peccato meo munda me Quoniam iniquitatem meam
peccatum meum contra me est semper Tibi soli peccavi et
... fecisti ut iustificeris in sermonibus tuis et vincas cum iudi

Acknowledgments

PICTURE CREDITS
Every effort has been made to trace the copyright holders and we apologize in advance for any unintentional omissions. We would be pleased to insert the appropriate acknowledgment in any subsequent edition of this publication.

Key: *t:* top *b:* bottom *c:* center *r:* right *l:* left

Abbreviations:
AA: Ancient Art and Architecture Collection
BL: By Permission of the British Library, London
BN: © Cliché Bibliothèque Nationale de France, Paris
BO: The Bodleian Library, Oxford
IK: Ikona, Rome
VA: By Courtesy of the Board of Trustees of the Victoria and Albert Museum, London

Jacket: Calligraphy by Carol Kemp **back jacket:** *tl:* Add 4213 f 73, BL; *lc:* Worksheet, Author's own copy; *tr:* Harl 2904 f36, BL; *rc (detail):* Reid MS 64 f. 33, VA; *b: Historia Ecclesiastica Genis Anglorum,* COTT T1b CII f 5v, BL

Pages 2–3
p2: Reid MS. 64 f. 33, VA **p3:** Metz Pontifical, early 14th century, MS. 298.f.138v/Fitzwilliam Museum, University of Cambridge

Pages 4–5
pp4–5: Add 42130 201v (detail), BL

Pages 6–7: Introduction
p6: *tl:* Beatus of Liebana, Spain, c.1220, Scriptorium in the Tower of the Monastery of Tavara, The Pierpont Morgan Library, New York, M.429, f.183

Pages 8–11: The Development of Western Script
p8: *r:* Terracotta Marker, inscribed with Oscan script, Italy, The Trustees of the British Museum, London; *b (detail):* Inscription on the Base of the Colonna Traiana, Monti, Rome/IK **p9:** *t:* Charlemagne with Alcuin, Mary Evans Picture Library; *b:* Msc. Patr. 5 f.1v, Staatsbibliothek Bamberg **p10:** *t (detail):* M 102, f.1v-2, The Pierpont Morgan Library, New York; *b:* Frontispiece of translation of Pliny's Natural History, 1473, Biblioteca Medicea Laurenziana, Florence **p11:** *t:* Ms.Lat 9474, BN; *b: Phoenix,* Denis Brown, 1993

Pages 16–17: Rustic Capitals
pp16–17: *tr, l (detail), b (detail):* VAT 3867 f.3v, Vergilius Romanus Ecloga 11 & 4, Biblioteca Apostolica Vaticana/IK; *c:* Ms. Bodl. 218, fol.62r, BO **p17:** *bc:* Peter Halliday, Quotation from Virgil: Eclogue VII, 43 x 31.5 cm, 1983, black ink on cream paper, translation by the scribe

Pages 20–21: Square Capitals
p20: *tc:* The Parchment Maker, Dover Publications Inc., New York; *c:* Inscription at San Sebastiano/IK **pp20–21:** *b (detail):* Pontificia Commissione de Archeologia Sacra/IK **p21:** *t:* Pontificia Commissione de Archeologia Sacra/IK

Pages 24–25: Uncial & Artificial Uncial
p24: *r:* MS E Museo 100 f7v/BO; *b:* Ceolfrid Bible, AA **p25:** *t, b (detail):* COTT VESP A1 30v–31, BL

Pages 28–31: Insular Majuscule
p28: The Book of Kells MS 58 fol. 40v, The Board of Trinity College, Dublin **p29:** *br (detail):* The Book of Kells MS 58 fol. 179v, The Board of Trinity College, Dublin **p30:** *tl:* Tara Brooch, National Museum of Ireland, Dublin; *b, tr (detail):* Lindisfarne Gospels f29 COTT Nero DIV f29, BL **p31:** *t:* MS COTT Nero DIV f5v, BL; *b: Cultural Decomposition,* Denis Brown, 1993

Pages 34–35: Insular Minuscule
p34: *tr:* Lindisfarne Priory, photo: Andy Williams; *cr (detail):* Bedes Commentary on the Book of Proverbs, MS 819 folio 29/BO; *bcr, bcl (detail), b (detail):* Royal 2 Axx f17 Prayer-book, English Mercian, BL **p35:** *t (detail), tcl, bcl (detail): Historia Ecclesiastica Genis Anglorum* COTT T1B C11 f5v, BL; *bcr: The Spirit of Men* 11.71– end, *Widsith,* 11.1–13 fol 84b, Reproduced by Permission of the Dean and Chapter of Exeter

Pages 38–39: Caroline Minuscule
p38: *b:* Arch. S. Pietro D182 fol. 159v, Bascicicanus D182 f 159v/Foto Biblioteca Vaticana/IK **p39:** *tl:* Sally-Anne Reason; *tr: Cloud Conceptions from Above,* 1st verse, Sheila Waters; *b:* Moatiev Grandval Bible ADD/MS 10546 f 25 B-26, BL

Pages 42–43: Foundational Hand
p42: *br, l (detail):* Harl 2904 201v, BL **p43:** *tl:* Worksheet, Author's own copy; *tr:* Photograph of Edward Johnston, Holburne Museum and Crafts Study Centre, Bath; *b:* Edward Johnston's Winchester Formal Writing Sheet C.778, Holburne Museum and Crafts Study Centre, Bath

Pages 46–47: Early Gothic
p46: *c:* Winchester Bible, AA; *br:* CO7 6Bv1, BL **p47:** *bl: Moralia in Job,* Lib XVII–XXXV, MS 173, fo 41, Bibliothèque Municipale de Dijon; *tr:* The Paper Maker, Dover Publications Inc., New York

Pages 50–51: Textura Quadrata
p50: *b:* Metz Pontifical, Early 14th century, MS 298 f138v/Fitzwilliam Museum, University of Cambridge **p51:** *t, l (detail):* Chichester Cathedral, Henry VIII (Bishop Sherbourne asking Henry VIII to confirm the charter for Chichester Cathedral), Fotomas Index; *b:* MS Rawl liturg.e. 40 fol 40v/BO

Pages 54–55: Textura Prescisus
p54: Judgement of Solomon, The Pierpont Morgan Library, New York, M.102, f.1v-2 **p55:** *cl (detail):* Add 42130 201v, BL; *c:* MS Douce 366 fol 154r/BO

Pages 58–59: Gothic Capitals & Versals
p58: MS 2981, Sets of Capitals, Magdalene College, Cambridge **p59:** *tl:* MS 55 G vol3 F52V, Bible of St. Vaast, Bibliothèque Municipale d'Arras; *r (detail):* MS 2981, Sets of Capitals, Magdalene College, Cambridge; *bl:* MS.83-1972 f1r, Fitzwilliam Museum, University of Cambridge

Pages 62–63: Lombardic Capitals
p62: *b (detail):* Winchester Bible, Ezekiel, 12th century, AA **p63:** Latin 12048 f 1v, BN

Pages 66–67: Bastard Secretary
p66: *cr:* Kane Medieval MS 21 folio 6r, Grenville Kane Collection of Medieval Manuscripts, Manuscripts Division, Department of Rare Books and Special Collections, Princeton University Libraries; *bl:* E Mus 35 f 98/BO **p67:** English Genesis, MS Bodley 596 f2r/BO

Pages 70–71: Bâtarde
p70: *b:* MS Douce 267 f.36r/BO **p71:** *t, c (detail):* Jean Froissart's Chronicle, 14th century, BL; *bl:* Roy 16 GIII f8, BL

Pages 74–75: Fraktur & Schwabacher
p74: *cl (detail):* MS Lat 2° f384 v, Berlin, Staatsbibliothek zu Berlin – Preußischer Kulturbesitz – Handschriftenabteilung **pp74–75:** *b:* MS 64/35v & 36r, Bayerische Staatsbibliothek, München **p75:** *t, r (detail):* Rudolf Koch, Gospel of St. Matthew, 1921, Offenbach/Klingspor-Museum der Stadt Offenbach am Main

Pages 80–81: Cadels
p80: D54/107 fr380 Page de Garde, BN **p81:** *l:* MS Ashmolean 789 fol. 4v/BO; *tr:* Initial Letter, Speedball Textbook 1952, Ross F. George; *br:* An example of fine initials from a book by Thomas Weston in 1682, Speedball Textbook 1952, Ross F. George

Pages 84–85: Rotunda
p84: *b:* MS.L.4929-1866 f.27r Verona Antiphoner, mid-15th century, VA **p85:** *t:* L.2384-1910 f.203r Epistle Book, Italian Book of Hours, VA; *b:* Sheet of printed Rotunda, Author's own copy

Pages 90–91: Humanist Minuscule
p90: *b:* Reid MS 64 VA **p91:** *t:* MS L1721-1921 f96v-97v, VA; *c:* MS 186 fol 21r, The Rector and Fellows of Exeter College, Oxford; *b:* Petrarch's Annotation, Author's own copy

Pages 94–95: Italic
p94: *b:* MS L1485-1946 Francesco Moro: Alphabet Page, VA **p95:** *tl:* Skrift Katalog, Christopher Haanes, Oslo; *tr (detail):* MS L1769-1952 f.113r, VA; *b:* Lat Class E38, William Morris manuscript, BO

Pages 102–103: Copperplate
p102: *c, b: The Universal Penman,* Dover Publications Inc., New York **p103:** *t, cr: The Universal Penman,* Dover Publications Inc., New York; *cl:* Copperplate workshop, Fotomas Index; *b:* Copperplate typeface design, David Harris

Pages 108–109: Imperial Capitals
p108: *t:* Lettering from *On the Just Shaping of Letters,* Albrecht Dürer, Dover Publications Inc., New York; *b, c (detail):* Appian Way: Inscription, De Luca, Rome/IK **p109:** *t:* Inscription on the Base of Colonna Traiana, Monti, Rome/IK; *b:* The Arch of Constantine, De Luca, Rome/IK

Pages 124–127: Bibliography & Index
p124: *l (detail):* MS 2981, Magdalene College, Cambridge **p126:** MS Lat 2° f384 v, Berlin, Staatsbibliothek zu Berlin – Preußischer Kulturbesitz – Handschriftenabteilung

Special photography:
Michael Dunning: **p6:** *tr*
Peter Hayman: **p17:** *br*

Author's acknowledgments:
To my wife Nancy who untiringly typed and corrected my manuscript pages. To Miss Pemberton and the staff of the Bodleian Library for their kind help beyond the call of duty, and to Liz Brown and Louise Candlish of Dorling Kindersley who stopped me straying too far from the chosen path. And finally to family and friends who have also suffered a little with me over the last years.

Dorling Kindersley would like to thank:
Janos Marffy and Sally-Anne Reason for their artworks; Richard Bird for the index; Jane Carter, Stephen Croucher, and Mark Johnson Davies for design assistance; Lol Henderson and Helen Castle for editorial assistance; Jo, Simon, Liz, and Louise for their hands; and Morag Hislop for all her help.